Rudy Pozzatti

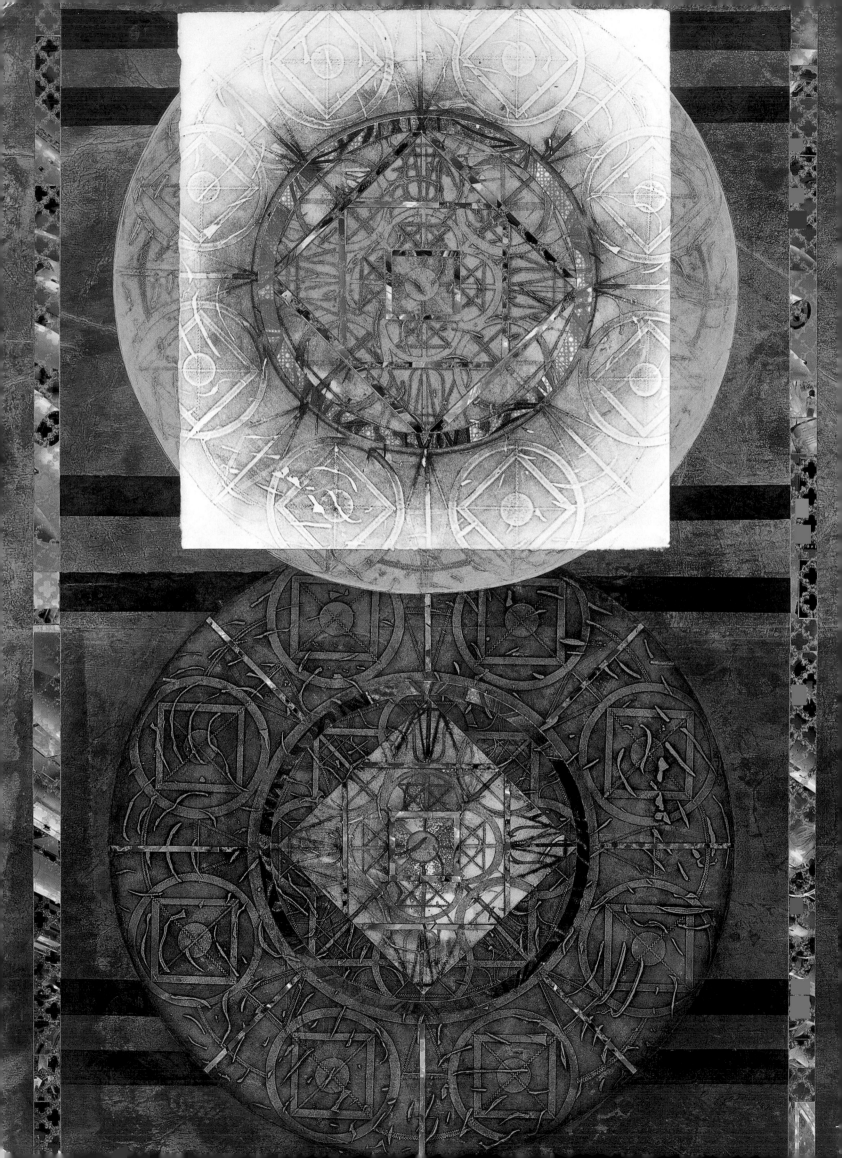

Rudy Pozzatti

A PRINTMAKER'S ODYSSEY

ESSAY BY
Norman A. Geske

INTRODUCTION BY
Pegram Harrison

CATALOGUE ENTRIES BY
Nanette Esseck Brewer

INDIANA UNIVERSITY ART MUSEUM
IN ASSOCIATION WITH
INDIANA UNIVERSITY PRESS
BLOOMINGTON AND INDIANAPOLIS

Published on the occasion of the exhibition,
Rudy Pozzatti: A Printmaker's Odyssey,
organized by the Indiana University Art Museum.

Norman A. Geske, Guest Curator
Nanette Esseck Brewer, Exhibition Coordinator

Indiana University Art Museum
March 2–May 5, 2002

Evansville Museum of Arts, History and Science
November 10–December 29, 2002

The catalogue and exhibition were made possible with support from the
Indiana University Foundation; the Richard Florsheim Art Fund; the
Bloomington Area Arts Council, Inc.; the Indiana Arts Commission,
a state agency; the National Endowment for the Arts, a federal agency; the
Office of the Vice President for Research and the Dean of the University
Graduate School; and the Lucienne M. Glaubinger Curatorial Endowment.

Edited by Linda Baden
Designed by Brian Garvey
Photographs by Michael Cavanagh and Kevin Montague
Printed by Metropolitan Printing Service, Inc., Bloomington, Ind.

Library of Congress Cataloging-in-Publication Data

Pozzatti, Rudy, 1925-
 Rudy Pozzatti, a printmaker's odyssey / introduction by Pegram
Harrison ; essay by Norman Geske ; catalogue entries by Nanette Esseck
Brewer.
 p. cm.
Includes bibliographical references.
 ISBN 0-253-21540-4 (alk. paper)
 1. Pozzatti, Rudy, 1925---Catalogs. I. Title: Rudy Pozzatti. II.
Title: Printmaker's odyssey. III. Harrison, Pegram. IV. Geske, Norman A.
V. Brewer, Nanette Esseck. VI. Title.
 NE539.P6 A4 2002
 769.92--dc21
 2001008362

ISBN 0-253-21540-4

Distributed by Indiana University Press
601 North Morton Street
Bloomington, Indiana 47404-3797
http://iupress.indiana.edu
Telephone orders: 800-842-6796
Fax orders: 812-855-7931
E-mail orders: iuporder@indiana.edu

cover: Rudy Pozzatti, *Moon Landscape* (detail), cat. no. 49
p. ii: Rudy Pozzatti, *Double Circle I* (detail), cat. no. 57
p. vi: Rudy Pozzatti, *Computer Person* (detail), cat. no. 32
p. 2: Rudy Pozzatti, *Spring Medusa* (detail), cat. no. 68
p. 6: John Ahlhauser, *Rudy Pozzatti*, 2001, gelatin silver print. Photograph © 2001 John
Ahlhauser, reproduced with permission of the photographer.
p. 15: Rudy Pozzatti, "Gossamer" (detail), from *Darwin's Bestiary*, cat. no. 51
p. 76: Rudy Pozzatti, *Bugs* (detail), cat. no. 17
p. 92: Rudy Pozzatti, *Belgrade III* (detail), cat. no. 23

ARTS IN INDIANA

INDIANA ARTS COMMISSION
REGIONAL PARTNERS
Connecting people to the arts

Provided with support from Bloomington
Area Arts Council, Inc., the Indiana Arts
Commission, a state agency, and the
National Endowment for the Arts, a
federal agency.

Contents

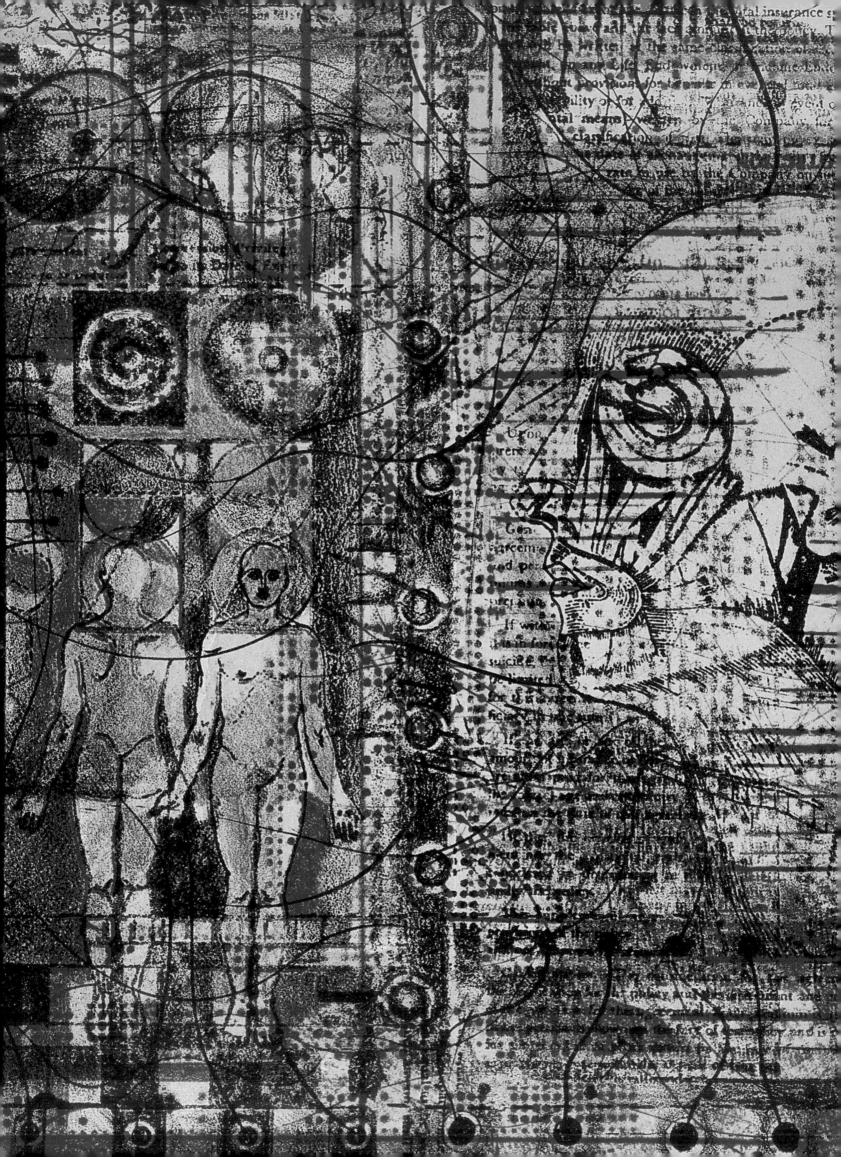

Preface and Acknowledgments

The Bloomington community and Indiana University have been beneficiaries of Rudy Pozzatti's remarkable gifts as an artist and a teacher for many years, and his fame as well as the affection and esteem people have for him continue to grow. He is truly one of Indiana's living legends. We at the Art Museum are so happy to host Rudy's retrospective here in Bloomington and to co-publish, with IU Press, this companion publication.

A number of people deserve credit for their help with this project. Norman A. Geske, our guest curator and catalogue essayist, and Pegram Harrison, who wrote the introduction, both were enthusiastic about the project and generous with their time, as was John Ahlhauser, who took the wonderful photograph of Rudy used in the book. Nan Brewer, the Lucienne M. Glaubinger Curator, did an exemplary job of organizing this exhibition and preparing the catalogue entries and the artist's chronology and bibliography; in these tasks she was ably aided by Heather A. Hales, the museum's Fess Fellow; Charles P. Pietrazewski, museum volunteer; and Jennifer McComas, museum graduate assistant. Linda Baden, editor; Brian Garvey, designer; and Michael Cavanagh and Kevin Montague, photographers, convey their respect and admiration for Rudy Pozzatti through their fine work on this book. Anita Bracalente and Kathy Taylor are thanked for their work on registration; David Carroll and Joanna Davis, for getting the word out. Jerry Bastin and Dennis Deckard, along with Brian Garvey and Linda Baden, assisted by Katy Ellis, IUAM Glaubinger Fellow, and Trish Rose, Art Museum graduate assistant, crafted a great installation. Ed Maxedon, curator of education, assisted by Lisa Schue, education intern; Kathleen Quigley, graduate assistant; and Matt Backer, Friends of Art Fellow, created a series of imaginative pre-college programs in conjunction with the exhibition. At the IU Archives, Brad Cook facilitated access to the Pozzatti papers.

Funding for this project came from many sources. Our thanks go to Curt Simic and the IU Foundation; Lucie and Larry Glaubinger through their support of the Lucienne M. Glaubinger Curatorial Endowment; the Richard Florsheim Art Fund; and the Bloomington Area Arts Council, Inc.; the Indiana Arts Commission, a state agency; and the National Endowment for the Arts, a federal agency. Also offering pivotal support for this project was the Office of the Vice President for Research and Dean of the University Graduate School.

Doti Pozzatti is thanked for her gracious hospitality and her invaluable support. Last but not least, our thanks go to Rudy Pozzatti for sharing his impressive lifetime of creative work, his insightful commentaries, and his personal recollections with us. His friendliness, generosity, and tireless assistance are all proof of why he is so well loved and so greatly admired.

Adelheid M. Gealt
Director, Indiana University Art Museum

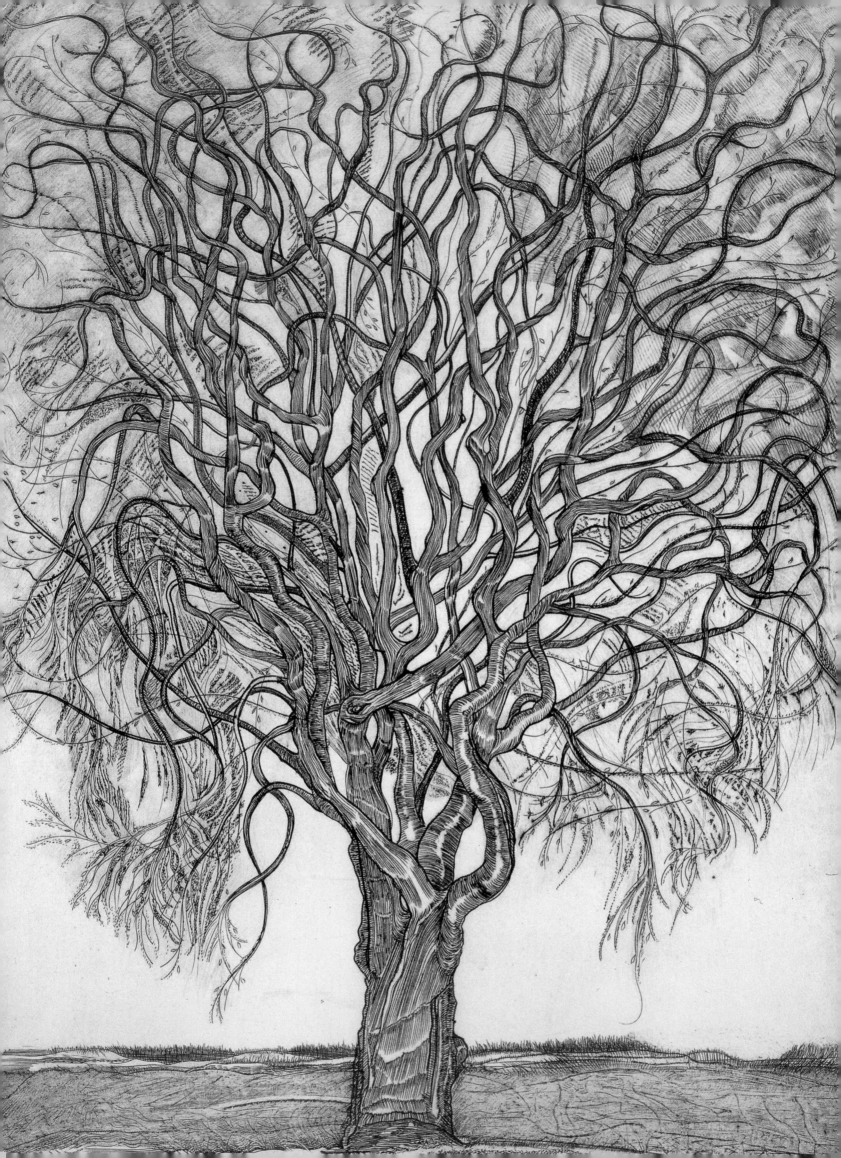

Introduction

PEGRAM HARRISON

T here has not been a time in the thirty years that I have worked with prints that Rudy Pozzatti has not been with me in some form or fashion, beginning with my first gallery job in Atlanta. I had just graduated from Indiana University with a degree in the history of art, and the gallery owner insisted that Rudy had sent me to interview with them. Even as I protested that,"yes, I know who Professor Pozzatti is, but I have never had the pleasure of meeting him," I was offered the job. I remained there for two years and received my first commission for selling *Homage to Brunelleschi,* Rudy's exquisite 1968 etching.

Once I returned to Bloomington I sought him out to thank him, and we began a friendship and a learning experience that for me continues to this day. As he has been for many others before and after me, Rudy is an open and willing teacher who has freely shared his printmaking expertise, his eye, and his extraordinary knowledge of art.

In 1979, Pozzatti and David Keister, one of his MFA graduates and a former master printer at Landfall Press in Chicago, founded Echo Press in Bloomington. Pozzatti looked to his experiences at other collaborative workshops such as Il Torcoliere in Rome, Tamarind Lithography Workshop in Los Angeles, and of course, Landfall, as models for Echo. He also drew on his experiences with the artist-in-residence program at the University of Colorado, Boulder, which had afforded him the opportunity to know and work with artists of the caliber of Max Beckmann and Ben Shahn. Echo was to be a combination of these experiences, a professional workshop that was also to be an open learning experience for the art students at Indiana University. Pozzatti was not interested in any specific look to the pieces published at Echo, but rather wanted the work to be dedicated to technique and professionalism. All had to be "done with great commitment and care, using the best materials, patience, and the objective of meeting the highest levels of professional standards."[1]

Among the many hats Pozzatti has worn over the years has been as an "artistic ambassador" for the Department of State on cultural exchanges to South America and the Soviet Union and as a representative of the United States to international

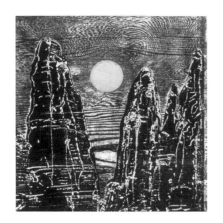

conferences and trade shows on the arts in Budapest and Belgrade. It was while performing these duties for his country that he met fellow notable artists Jimmy Ernst and Sam Gilliam. Once Echo began, Pozzatti invited these internationally known artists together with Miriam Schapiro (a friend of many years) to help establish the reputation of the young press. Sam Gilliam's monoprint, *Rudy Doti Budapest,* created on his first of three visits to Echo Press in 1986, was so named to honor his friendship with Rudy and his wife, Doti. When asked recently about his experience at Echo Press, Gilliam said, "I think of Rudy Pozzatti as a friend. I respect him as the fearless leader of the Echo Press concept."

Pozzatti, however, was not only interested in bringing established artists to Echo, but he was also interested in young or mid-career artists, for he wanted a diverse, but well-rounded experience for the students at the university. There was always an excellent exchange of ideas between the artists and Pozzatti, and if you happened to be there, as well, then, you too, might benefit greatly. Around 1993, while the artist Georgia Marsh was working at Echo, Pozzatti was creating a number of small silver-point drawings. This was something that I had never seen and neither had Marsh. For me, it was a fascinating look at the technical aspects of yet another medium that Pozzatti shared with me, but for Georgia—after a trip to the local art store to buy the supplies that she would need—it was a whole new world of drawing.

Steven Sorman, an artist of great talent who loves to experiment with a multitude of techniques in his printmaking, was probably the most frequent visiting artist to Echo Press, coming twice in the early days to teach for a month at a time in order to give Pozzatti some well-deserved time to do his own work. Over the years they have developed a mutual admiration. "Rudy Pozzatti is a man who is in all aspects generous. He is a good artist, teacher, craftsman, and friend. Enthusiastic as he is about his own work he has always embraced and encouraged the work of others. He is among the first people I would call with a technical question, knowing his instruction would be most thorough. More importantly he is among those I most hope to emulate."[2]

Pozzatti's knowledge of printmaking techniques and his exquisite craftsmanship in their execution are revered not only by other artists, but also by fellow master printers. Among many stories that could be told I sought one I remembered from Jack Lemon, the owner and master printer at Landfall Press:

Rudy Pozzatti is a person of unusual quality. He combines virtues of personal character with professional skills as an artist and printmaker. He is a trusted friend and colleague.

Several years ago I visited Rudy and brought along my friend, the artist Jeanette Pasin Sloan. We brought with us to Bloomington a copper etching plate created in New York by Jeanette, which nobody seemed able to successfully proof. The plate was complicated, involving many stop-outs created by the artist to achieve many subtle gradations of blacks and grays.

After the plate was made, several printers in New York tried to pull a decent print to no avail. My last resort was to see if Rudy, one of the best etching printmakers ever, could make a proof that would express the true nature of the plate and salvage the project. He did, and we were able to edition the print, Binary, *which is one of the best prints Jeanette ever created.*

Rudy is a master printmaker and he has brought that talent to his own rich body of work. Finally Rudy is a rich man full of personality that is often expressed by his kindness and sense of humor. He has shared these qualities with his family, students, and his friends.

We are all enriched by knowing Rudy Pozzatti.[3]

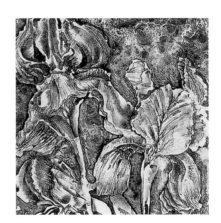

Ultimately, Rudy Pozzatti is the consumate printmaker, one who mastered the techniques of intaglio, woodcut, lithography, and silkscreen, and one who learned to work with the inherent qualities of each so that they complemented and enlivened his own artistic pursuits. His abilities have earned him an international reputation as an artist and as a master printer. His charms and his generosity have earned him untold respect and too many enduring friendships to ever count. We are all, indeed, enriched by the man and his art.

NOTES
1. Rudy Pozzatti, "The History of Echo Press," *Echo Press: A Decade of Printmaking* (Bloomington: Indiana University Art Museum, 1990), p. 11.
2. From a letter to Pegram Harrison, September 2001.
3. From a letter to Pegram Harrison, October 2001.

Rudy Pozzatti: A Printmaker's Odyssey

Norman A. Geske

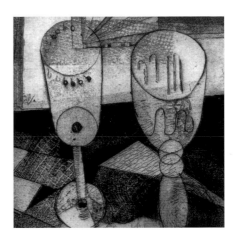

In a monograph published in 1971, I had an opportunity to review Rudy Pozzatti's work as a printmaker from its beginning through his early years at Indiana University.[1] It was obvious even then that this was a body of work of more than ordinary range and quality. But only now, after an additional thirty years of creative activity, is it possible to see the full scope of Rudy Pozzatti's achievement. The history of his ideas and the creation of the means of their expression are impressive to a degree that was hardly more than suggested in that earlier review.

Pozzatti's work, from that earlier vantage point, could be seen as a reflection of an important period in the history of American graphic arts. During his student years at the University of Colorado at Boulder, he studied under Wendell Black, who was a graduate of the famous printmaking workshop established by Mauricio Lasansky at the University of Iowa. An impassioned exponent of affective expression as well as a rigorous technician and dedicated teacher, Lasansky, through the graduates of his program, fostered a printmaking renaissance at universities throughout the region. Arthur Deshaies, who was for a time in charge of the printmaking workshop at Indiana University, was a graduate of Iowa City. Other Lasansky pupils were David Bernard at Kansas State, LeRoy Burket at Nebraska, Lee Chesney at Illinois, Malcolm Myers at Minnesota, and John Talleur at the University of Kansas.

Of his teaching, Lasansky once remarked: "I look upon each student as an artist. I assume that he is sensitive. By sensitive I do not mean temperamental, but responsive to the passionate aspects of art."[2] Pozzatti has carried the mantle of his pedagogic lineage well, from his first position at Nebraska in 1950 (where his teaching and example left a considerable and enduring impact), through the establishment of an internationally admired printmaking department at Indiana. His assumption of the leadership of the graphics workshop at IU in 1956 called upon his very considerable skills as a teacher, and from that point to his retirement in 1991, the roster of outstanding graduates of his program includes Edward Bernstein, Cima Katz, John Whitesell, and Jane Abrams, to name only a few. The admiration and loyalty of his students makes clear the quality of his guidance—open to every student's inspiration and insistently dedicated to the fullest realization of such inspirations.

Pozzatti's impact on the world of printmaking has extended beyond the university arena. In 1979, in company with David Keister as master printer, he established Echo Press, an independent fine print workshop, to provide a venue in Bloomington for visiting artists wishing to undertake special graphic arts projects. Under Pozzatti's guidance, in the sixteen years of its operation Echo Press became an important presence in the printmaking community, producing 191 editions, in addition to 400 monotypes, by 47 artists. Among the artists invited to work at the Echo Press were the painters James

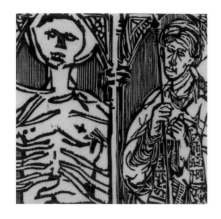

McGarrell, Sam Gilliam, Jimmy Ernst, Stanley Boxer, and Steven Sorman, working in the graphic media for the first time.

A major aspect of Lasansky's influence was his fanatic devotion to the copper plate and the techniques involved in its exploitation—etching, engraving, mezzotint, drypoint, aquatint—that were included in the single term "intaglio." If there is one overriding stylistic characteristic of the prints produced at Iowa City, it is a rich, sensuous, indulgence in the physical development of the plate.

Thus, it comes as no surprise that from the outset of his career, Pozzatti demonstrated an immediate and seemingly instinctive command of the intaglio process. The bite of the burin into the metal plate is unhesitating. In Pozzatti's early work on copper, zinc, or aluminum plates, his direct and vigorous use of the engraver's burin transforms his subjects into something more than simple representations. Witness two brilliant engravings, *Carp* (no. 2) and *Venetian Domes* (no. 8). Both prints are images of pure movement. The fish, caught instantaneously, crowds his way off the edge of the paper. The domes, obviously inspired by San Marco in Venice, seem to swim in the space they occupy.

Although Pozzatti has never abandoned subject matter for pure abstraction, there are instances when the physical act of working the plate attains a kind of subliminal frenzy that all but overwhelms the subject. For example, there are two prints, *Burning Bush* (no. 7) and *Temptation of Saint Anthony* (no. 15), which project their meaning by empathy rather than recognition.

Etching in its pure state has occurred infrequently in Pozzatti's work. In *Baptistry* (no. 19) the intricate repetitions of Italian Gothic are suggested rather than described in the lavish inking of the plate. Unlike the domes of San Marco, this voluminous dome of Pisa, viewed at close range, has a massive upthrusting dignity, very much the "Church Trimphant."

There is an evident affinity as well for the yielding accommodation of the wood block. It would almost seem that the material contains the image, so natural and immediate is its release by Pozzatti's hand. The challenge of the flat surface, the penetration of a space of infinitesimal depth, is the true locus of his creative impulse.

Pozzatti's early and continuous interest in the woodcut has set him somewhat apart from the mainstream of American printmaking, where, until recently, it has not enjoyed the popularity of the intaglio print. It is, after all, the primal method, calling upon an imaginative response of the utmost simplicity. This simple conjoining of image and ground is the very essence of graphic art.

His first woodcuts, *Uomo e Falco* (no. 3) and the imposing *Twelve Saints* (no. 5) are charged with an urgency that fills the block from edge to edge. The *Ecce Homo* (no. 9) and the *Flagellation* (no. 12) have an emotional intensity that is clearly rooted in personal belief. His affection for the creatures of nature has also produced some marvelous woodcuts: *The Grasshopper* (no. 6) and *Turtle* (no. 10) are unexpectedly face-to-face encounters with fellow creatures not common to everyday experience.

Pozzatti's first serious involvement with lithography took place in 1963, during the three months he spent at the Tamarind Workshop in Los Angeles. Earlier, in his student

days in Boulder, he had made the acquaintance of Emilio Amero, the Mexican lithographer; that contact did not produce any work of his own, but surely made him aware of the potentials of the medium. At Tamarind, where he worked for the first time with a team of master printers, his principal production was the portfolio, *XII Romans* (no. 18), portraits of a mixed bag of Caesars, generals, and the orator, Cicero.

The most interesting thing about this series is Pozzatti's taking on the challenge of portraiture. He has said that his choice of this subject matter was in response to the news that he had just been awarded a Guggenheim Fellowship, affording him a period of work in Italy. His choices among the possible subjects were made, quite deliberately, to mix the great and famous with the less than admirable—Marcus Aurelius with Caligula. In Pozzatti's hands they are alike, evidence of a point of view that men are, indeed, more alike than different. These are all ravaged faces, worn almost to the state of obliteration by their historic experience. This is a physiognomy that shows no trace of the classical ideal. Similarly, a view of Roman ruins (no. 16) is a fantasia on a theme without a trace of archaeology.

Also at Tamarind he produced a suite of ten lithographs, *Bugs* (no. 17), depicting a subject of no great import except that it offered an opportunity to look closely at creatures of the natural world and to exercise his skill as a draftsman, an exercise that for Pozzatti is as easy as breathing.

Pozzatti has always relished the synergistic energy of a creative team working together. His arrival at Indiana University had put him into the company of a faculty of extraordinary and varied talent. The Department of Art, chaired by Henry Hope, included painters James McGarrell and Leon Golub; photographer Henry Holmes Smith; metal craftsman Alma Eikerman; ceramist Karl Martz; and the art historians Albert Elsen, Roy Sieber, and Diether Thimme, who was of particular importance to Pozzatti in his expertise in the history of the graphic arts.

In this rich artistic milieu, Pozzatti thrived. His personal exploration of all the standard techniques, each for their maximum potential, was taken to a new level of performance. His commitment to whatever artistic problem was at hand remained total. He luxuriated, and luxuriates still, in an intuitive sense of design and the spontaneous interplay of texture and color that are the essential qualities of his art.

Reaching beyond the art department, Pozzatti found at Indiana University an atmosphere of collegiality that gave birth to a number of collaborative projects. One of Pozzatti's major accomplishments is the *Bishop Theobaldus Bestiary* (no. 20), translated by Willis Barnstone, designed by George Sadek, and published by Indiana University Press in 1964. The thirteen creatures— 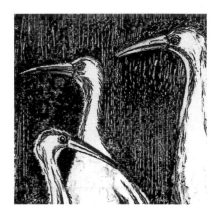 lion, eagle, serpent, ant, fox, stag, spider, whale, siren and honocentaur, elephant, turtle dove, and panther—are depicted with a veracity (even the fictive honocentaur!) that is made certain in the virtuoso handling of the lithographic medium.

In that same year, Pozzatti illustrated a volume of poems by Philip Appleman, *Darwin's Ark*.[3] This led to *Darwin's Bestiary* (no. 51), published by Echo Press in 1986, containing a selection of the poems and beasts from the earlier publication. There are eighteen images in woodcut and lithograph. Unlike the

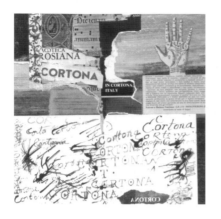

Theobaldus *Bestiary,* this time the roster of creatures (except for the griffin) was drawn from sources closer to home, with the only repetition being the ant. The griffin on the frontispiece is Pozzatti's version of a mythological beast, lacking the usually prescribed wings, but intimidatingly fierce. The ant, unlike the image in the Theobaldus, where we see the underground world of the ant in all its labyrinthine darkness, is bigger than life. The worm (a recollection of the night crawlers necessary to boyhood fishing in Colorado) is as close to primal life as it is pleasurable to get. The rabbit (again, remembered as a childhood hobby) is seen in seven utterly charming beasts, about whom the poet says "you needn't be brainy, benign or bizarre to be thought a great prophet. Endure. Just endure." The gossamer is surely one of Pozzatti's most beautiful conceptions, an abstract invention, to be sure, but instinct with life. The tortoise is ugly as sin against a gorgeous gray green background. The black-footed ferret is sinuous, cunning, and endangered. The iguana (the greenhouse pet of a university colleague) is a real creature from the black lagoon. And lastly, there is a company of six baboons lost in aimless interaction.

Pozzatti's mastery of the woodblock, the metal plate, and the lithographic stone has been fueled by his natural love of color. His palette is as personal as his handwriting. It is generally a dark palette tending to an opulent richness. The reds have a purple overtone; the yellows burn toward orange; the pinks are shadowed with mauve; the whites are ivory.

An early example of his use of color, *Inventions of Nature* (no. 11), is a simple enrichment of the basic pattern of the intaglio with an umber ink. In *Trees in Autumn Light* (no. 13), the umber is contrasted with a sky of Prussian blue.

In the prints of the sixties there is an increasing complexity in Pozzatti's use of color. The woodcut, *Carnevale* (no. 14), is printed from three blocks and utilizes ten colors to achieve the festivity of the image. *Tyrrhenian Cult* (no. 21) is an elaborate construction of eighteen separate plates using four colors. *Summon Out the Spirit* (no. 28), combining lithograph in blue and etching/aquatint in red, ochre, green, and white, is one of his most compelling images, inspired by a single line from Dante's *Inferno.*

Throughout the seventies and eighties, Pozzatti often uses his saturated, earth-toned palette as an enhancement or amplification of the thematic content of his prints. The golds, ochres, inky grays, and sienna reds of *Hawaii II* (no. 29), for example, reinforce the zones or registers of the composition, separating the horizontal bands of shells and coral, mountains, fishing nets, waves, and lava. His palette for *Cosmorama* (no. 33), with its earthy tans, bruised purples, and watery blues, suggests a lonely planet floating in a vast universe, while the clear, sunlit color of his beautiful collage, *Remembrances of Cortona* (no. 52), is a fresh breath of Tuscany.

In the decade of the nineties, Pozzatti's work takes a turn away from thematic complications toward a simpler, but no less exhaustive research into the phenomena of color. Travel in Egypt and Morocco has resulted in what might be called studies of the cultural color of these places. More particularly, he has engaged the problem of the formal containment of color in prints that explore the symbiotic union of Gothic architecture and stained glass. He has paid his homage to the Sainte Chapelle and

Chartres in *Gothic Inventions IX* (no. 55), *Window 17* (no. 53), and again in *Double Circle 1* (no. 57) and the series of Chapel Windows (nos. 59–61). His *Moroccan Inventions X* (no. 62) brings an exotic, Middle Eastern flavor to the window theme. It should be noted, however, that these mixed-media works, which combine relief prints with collage, are by no means replications of their sources. Their framing is architectural and their color is translucent fantasy. They have an abstract independence of their own.

The expressive content of Pozzatti's printmaking derives not only from his early exposure to the deep introspection of Lasansky and his followers, but also from the tradition of their role models: Mantegna, Rembrandt, Goya, and Lasansky's contemporaries, Pablo Picasso and Stanley William Hayter. This is a kind of printmaking that is expressionist in the fullest sense of the word.

Yet, allowing for Pozzatti's relationship (even if once removed) to the methods and thematic repertory of the Lasansky studio, it is also clear that from the very start he conceived of printmaking in a strikingly individual way. Some of this independence of spirit may well have been stimulated by contact with Ben Shahn and Max Beckmann, who were artists-in-residence at Boulder during Pozzatti's time there. The work of these masters of expressionist art must surely have verified for him the rightness of honest self-expression. By his own admission, it was this influence that determined his decision to devote his energies to art; and it was Shahn's urging, in particular, that led him to explore his own cultural heritage.

In truth, Pozzatti—the man and the artist—is at once both innovative and independent, and yet deeply rooted in tradition. Despite the fact of his birth in Telluride, Colorado, Pozzatti is, in a sense, an Italian artist. (Admittedly, this is a notion on my part, brought on by the prolonged immersion in the contents of his studio and the warmth of his home in preparation for this essay.) It is, however, evident that his Italianism is something more than his talent. Born of immigrant parents, his sense of family deeply ingrained, he has actively sought his roots in the Italian Tyrol and has returned to Italy at every opportunity with his wife, Dorothy, also of Italian parentage. He has a family of four daughters and a son, all of them possessing his talent for living. There is a warmth and generosity in this family bond that constitutes the primary source of the expressive confidence that is the stimulus to his creativity.

In addition, there is Pozzatti's Catholicism, which is intrinsic to every aspect of his life. He has, from the very beginning, revealed his reverence for the art and religion of his ancestry. His use of the iconography of the church indicates a commitment of belief that is rarely seen in contemporary printmaking, or in contemporary art, for that matter. Most significant in this regard is the fact that his religion has nothing in it of the pietistic or sentimental. There is, instead, an emotional realism that reflects his understanding of contemporary experience. For example, his suite of black and white lithographs depicting the Stations of the Cross (no. 36) is filled with an almost tangible pathos that most surely reflects Pozzatti's own spiritual journey.

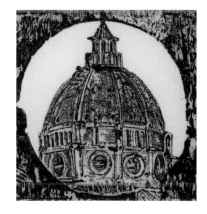

The dynamic tension between tradition and innovation has enlivened Pozzatti's work throughout his career. It can best be seen in the prints he has created as "homages" to various historical people and events.

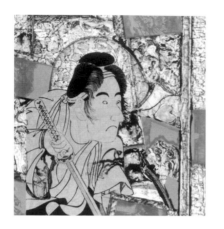

An early series of such prints was conceived as a tribute to four masters of the tradition: Vesalius, Brunelleschi, da Vinci, and Sharaku. *Homage to Vesalius* (no. 26), which uses a direct translation by Pozzatti of a figure from the *De Humanis Corporis Fabrica* as well as a portrait of Vesalius, is his acknowledgment of the principle of structure in natural forms. Interestingly, this concern for structure, which is so brilliantly demonstrated in his depictions of animals, insects, and birds, is rarely seen in his depictions of human form. This difference is probably due to the fact that natural forms are usually the result of discerning observation of living specimens or, at least, objective representations, whereas the human images are Pozzatti's own conception of homo sapiens, shaped by all the variations of circumstance.

There are three images that pay homage to the architect Filippo Brunelleschi, creator of the dome of the cathedral in Florence. A very early engraving of the Duomo (no. 4) signals the upward thrust of the building with the dome itself largely out of sight. *Homage to B* (no. 24) is a black-and-white lithograph in which the dome appears in a frame oculus like those on the base of the dome itself. The surround, with portraits above and below, is developed in a very free and suggestive fashion. Finally, as though the challenge of the subject was asserting itself in a final test, *Homage to Brunelleschi* (no. 25) is carried through in a more disciplined way. This time the surround is filled with the bands of portraits, top and bottom, and a pattern of walls, gates, and stairways, with the dome seen against the sky as the climax of the composition.

In his *Homage to da Vinci* (no. 30), Pozzatti chose to use one of the best known of all artistic cliches. It would appear that he might have felt it unthinkable that he should try to reshape the face of Mona Lisa in his own way: sacrilege or travesty could be the result. With a gesture that not only preserves the respect due the image but also brings her into the context of our own time, he presents her as a computer printout collage surrounded by a portrait of her creator and a selection of his many concerns, scientific and sociological. The lady herself is cool as can be.

The last of the homage prints is one that contains his praise of an artistic ancestor from a non-European culture, the Japanese woodcut master Sharaku. The construction of the *Homage to Sharaku* (no. 38) reaches a new level of complication, possibly inspired by a stay at the Adachi Print Institute in Tokyo. The central image was cut out of Japanese gold tissue, collaged onto the paper and overprinted in black. Printed from the original cherry woodblock, it is surrounded by six of Pozzatti's own portraits of the artist in his various roles as actor. The images were drawn and printed in a sanguine red and overprinted with metallic gold. The whole is set against an abstract background of extravagantly visceral color.

Another group of prints is devoted to the more unusual aspect of Pozzatti's art: commentary on the social and political worlds around him. *Papal Bull* (no. 35), while it does not refer to contemporary matters, does indicate that the artist is attuned to history as a source of ideas for visual expression. Suggested by E. R. Chamberlin's book *The Bad Popes*,[4] his print includes portraits of Leo X, Alexander VI, and Clement VII, and adds,

on his own, popes Paul IV and Innocent X. The portraits float on a morbidly red ground in a kind of purgatory, and they are vulgarized with the addition after printing of patterned mylar to their papal regalia. This is commentary of a very sophisticated kind.

Other works reflecting Pozzatti's engagement with contemporary issues—*Vietnam* (no. 27), *Computer Person* (no. 32), *Mr. President* (no. 34), and *Crisis in Iran* (no. 41)—have a comparable tone of pained concern. *Mr. President* features Richard Nixon in his most dour aspect and surrounds him with other presidential portraits that are also somewhat less than flattering. Pozzatti's view of his fellow man is, shall we say, sympathetically realistic.

Throughout the work of fifty years, Pozzatti also has responded to his physical environment in landscapes of extraordinary quality. It is not a pastoral world. Instead, it is a world filled with incessant drama. He sees the relationship of land to sky as profoundly meaningful. It is not surprising that the American southwest has inspired some of his most impressive prints. A residency at the Roswell Museum and Art Center in 1979 produced a series of astonishing images, approaching abstraction for the first time. Among them are *Eclipse* (no. 39), a color etching, and *Blue Totem* (no. 40), a color relief woodcut and collage of awesome simplicity.

Later, also inspired by New Mexico, he produced landscapes that seem to be of another world. *Moon Landscape* (no. 49) and *Night in Sedona* (no. 45) recall the haunted landscapes of Max Ernst. A real tour de force of color printing is his *Enchanted Land/Seven Views* (no. 50) that sums up the incredible character of that landscape in a way that surely stands alone among all the records of that place.

Quite apart from everything he has done are his prints and watercolors of the temples at Paestum. This series documents his return to Greece and the islands of the Aegean, which first inspired him twenty years earlier. The blindingly white column seen against an electric blue sky of *Temple at Paestum I* (no. 56), echoing *Blue Totem* (no. 40) of the Roswell series, confirms the impact of the experience. However, the other prints and watercolors from Paestum are surprisingly literal in character, more records of the experience rather than personal responses to it.

In 1990 Pozzatti worked with students at the University of South Dakota to produce the latest of his portfolios. *Israel: Words and Images* (no. 54) consists of ten color intaglio-relief images, each accompanied by a poem by either one or the other of his daughters Mia and Illica. Unlike the bestiaries, devoted to prescribed subjects, this series records the Pozzattis' direct experience of the place. "Under the Mystical Sky" is a red skyscape above a black city, heavy with history. "Sun," in its true abstract state, burns with an acidic glare. "Flower Power" is a portrait of the heat of germination. "Landmark" is very likely the Judas Tree itself. The final plate, "The Wall," comes as something of a visual shock. It is a collage of lead foil that gives the entire set an emotional thrust well beyond the visual elements of the landscape. As a whole, this portfolio is perhaps the simplest and at the same time one of the most complete expressions of Pozzatti's art. The total circumstance of its creation, the sensory

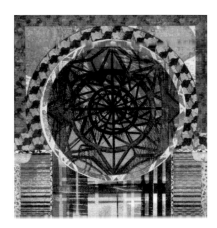

reality of the place, the collaboration of his daughters, the innate responsiveness of the artist himself to the light, color, and space, together with his awareness of the historical dimension, are combined in a work of exceptional quality.

The work of the nineties, including the strikingly beautiful print/collages of his Window series (see nos. 53, 55, 59–62), are refined, intricate essays that please through their luscious colors and decorative, accessible designs. If there is an implication in these recent works that the artist is moving away from the more overtly challenging content of earlier years, a work from the year just past, *Sinners All* (no. 66), will correct that impression and serve as an indication of his never-ending engagement with new ideas—which is Pozzatti's way of life.

Pozzatti's career is extraordinary in several ways. First of all, he has been prolific, almost beyond belief. His own estimate of the extent of his archive is in the neighborhood of three thousand separate images in the media of drawing, printmaking, monotypes, collages, oils, watercolors, and sculpture. There has never been a noticeable period of creative inactivity. He has engaged himself in every form of artistic activity with the possible exceptions of film and photography. At the beginning and until the mid sixties he produced, in addition to his printmaking, a considerable number of paintings and exhibited in national exhibitions, as well as in New York dealers galleries. He is represented as a painter in a number of public collections. He has also worked as a sculptor. His chess set (no. 37) is evidence of a remarkable sense of three-dimensional design.

His activity as a recognized presence in the public sphere is equally impressive. Recipient of every prestigious award—Fulbright, Guggenheim, Ford, Rockefeller—he also has received an honorary degree from the University of Colorado and has been named a Distinguished Professor at Indiana University. He has served the Department of State as an official representative of the United States in Yugoslavia and the Soviet Union, and he spent six weeks in Brazil, also under the auspices of the State Department, giving workshops and lectures and exhibiting his work in Rio de Janiero, Sao Paolo, and Brasilia.

More important as regards the character and quality of his achievements as an artist has been his associations with his contemporaries, whether as student, teacher, or colleague. Yet, despite his extraordinarily engagement with the world of printmakers and printmaking over the last half-century, his own vision has remained intact throughout. That vision, deeply rooted in tradition, but blossoming forth from an adventuresome and independent spirit, continues to inform his art and to shape his life.

NOTES
1. Norman Geske, *Rudy Pozzatti: American Printmaker* (Lawrence: University Press at Kansas, 1971).
2. *A New Direction in Intaglio: The Work of Mauricio Lasansky and His Students*
(Minneapolis: Walker Art Center and Colorado Springs Fine Arts Center, 1949).
3. Philip Appleman, *Darwin's Ark: Poems*, with illustrations by Rudy Pozzatti
(Bloomington: Indiana University Press, 1984).
4. E. R. Chamberlin, *The Bad Popes* (New York: Dial Press, 1959; reprinted Barnes & Noble, 1986).

CATALOGUE

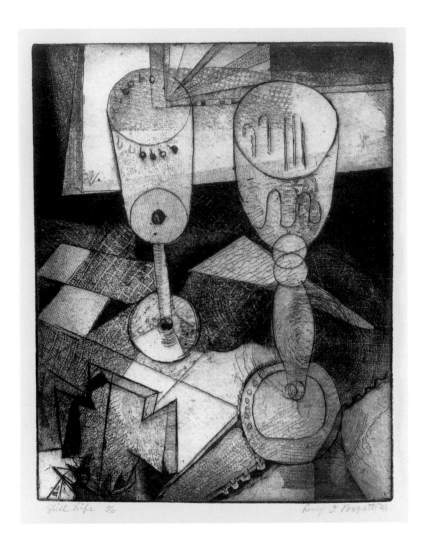

1. Still Life
1948; copper-plate etching, soft-ground etching, and aquatint
on Hammermill Index paper; image: 10 x 7⁷/₈ (25.4 x 20.0),
sheet: 11¹¹/₁₆ x 9⁷/₈ (29.7 x 25.1); edition of 10 (only one copy extant)
(Geske 1)

Made during his senior year at the University of Colorado under the direction of
Wendell Black (1920–1972), this etching was Pozzatti's first foray into printmaking.

NOTE: The catalogue is arranged chronologically. Height precedes width; measurements
are given in inches, then centimeters. All works are from the collection of the artist,
unless otherwise noted. Reference numbers are to Norman A. Geske's catalogue
raisonne, *Rudy Pozzatti: American Printmaker* (University of Kansas Press, 1971).
All works were printed by the artist, unless otherwise indicated.

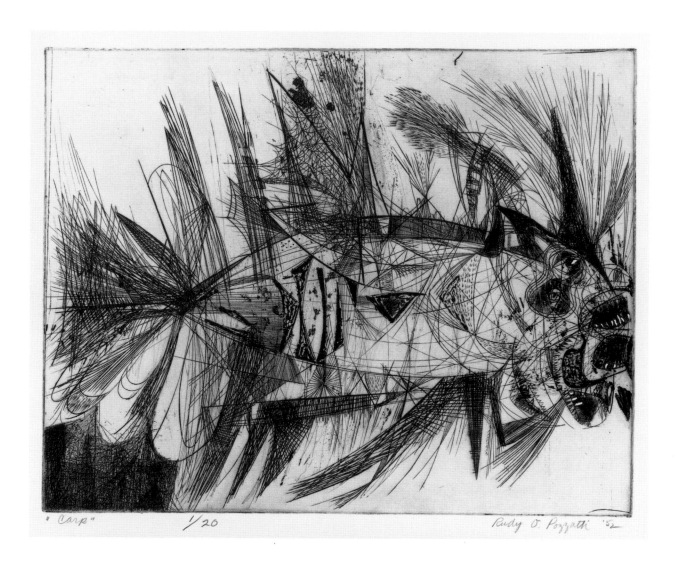

"Carp" 1/20 Rudy O. Pozzatti '52

2. Carp
1952; aluminum-plate engraving with Dremel tool and scraping on
Hammermill Index paper; image: $14^{15}/_{16}$ x 19 (37.9 x 48.3),
sheet: $17^{5}/_{8}$ x $21^{5}/_{8}$ (44.8 x 54.9); edition of 20 (Geske 15)

Because copper was a rare commodity following the war, Pozzatti carved this
image on less expensive, although more difficult, aluminum. Etched with lye, the
process almost caught the print room on fire. This demonic scavenger represents
the artist's first animal print, a theme that would continue to fascinate him
throughout his career. Pozzatti credits his earliest interest in this subject to
studying specimens in natural history museums and to a life-long love of fishing.

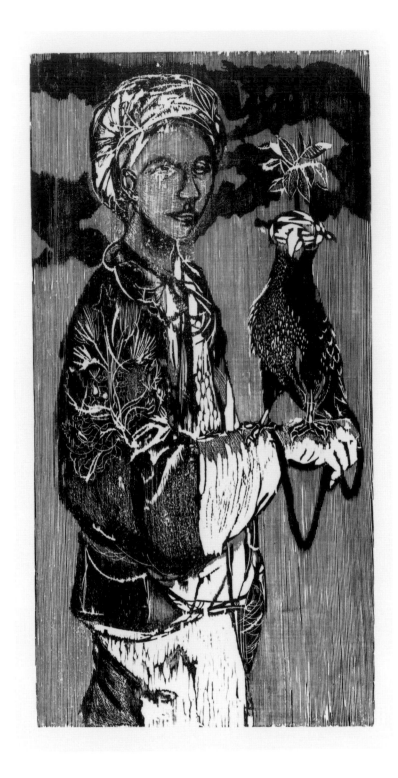

3. *Uomo e Falco* [Man and Falcon]
1952; woodcut on Mulberry paper; image: 26 x 13 (66.0 x 33.0),
sheet: 31⁷/₈ x 18³/₈ (80.9 x 46.7); edition of 20 (Geske 20)

Inspired by the works of the Italian painter, draughtsman, and medallist
Antonio Pisanello (1395–ca. 1455), whom he had studied in an art history
class, this print is Pozzatti's first work in the medium of woodcut.

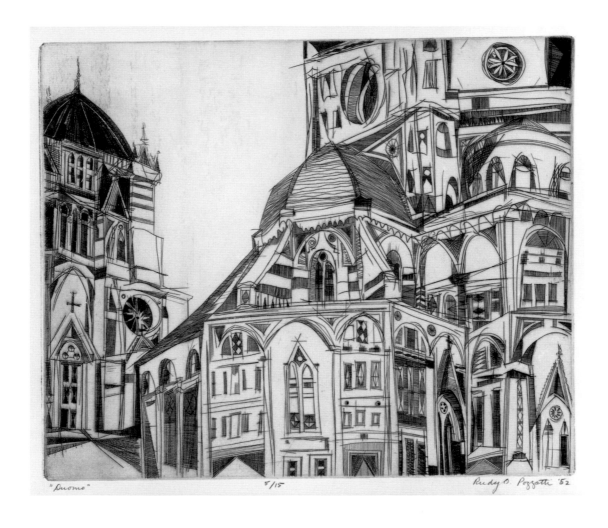

"Duomo" 5/15 Rudy O. Pozzatti '52

4. Duomo
1952; aluminum-plate engraving on Hammermill Index paper;
 image: 15 3/8 x 18 3/4 (39.0 x 47.6), sheet: 16 3/4 x 21 15/16
(45.5 x 55.7); edition of 15 (Geske 19)

Encouraged by Ben Shahn (1898–1969) to explore his Italian heritage, Pozzatti
applied for and received a Fulbright American Scholar stipend. He spent a
year in Italy (1952/53), living and working in Florence, traveling extensively,
and visiting his Italian relatives.

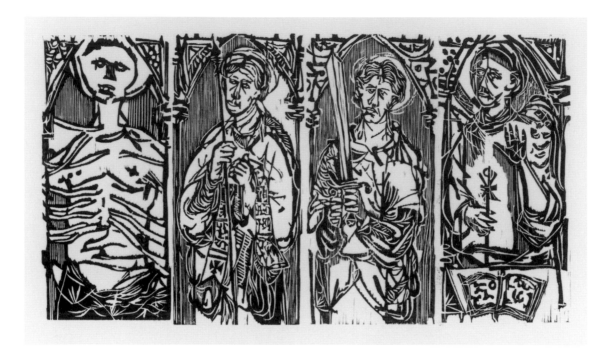

5. Twelve Saints (Section I)
1953; woodcut on Mulberry paper; image: 12 x 21⁷/₈ (30.5 x 55.6),
sheet: 17 x 24⁵/₈ (43.2 x 62.5); edition of 10 (Geske 31)

These saints were based a series of drawings that Pozzatti made after the
relief sculpture on the communion rail in the Duomo, Florence, while he was
in Italy as a Fulbright American Scholar. Each figure was carved on a separate
wood block and then printed in one of three sections comprised of four wood-
cuts each. This section features (from l. to r.) Saints Bartholomew, Thadeus,
Thomas, and Matthew. The wood blocks remain in the artist's collection.

6. The Grasshopper
1954; woodcut on Mulberry paper; image: 16$^1/_2$ x 36 (41.9 x 91.4),
sheet: 23$^1/_4$ x 39$^1/_8$ (59.0 x 99.4); edition of 10 (Geske 37)

This print, which won first prize at the Northwest Printmakers International
Exhibition, brought Pozzatti's work to national attention. Following the exhibition,
Pozzatti was contacted by *Time* magazine about featuring the work in the April 11,
1955, issue—that was, of course, if Picasso didn't die or remarry. Luckily for Pozzatti,
neither event happened. Despite its modest subject matter—inspired by the huge
grasshoppers in Nebraska—one critic suggested that the insect's legs resemble the
spring-loading mechanism of an 8-inch Howitzer, a weapon that Pozzatti was familiar
with from his field artillery battalion during WWII.

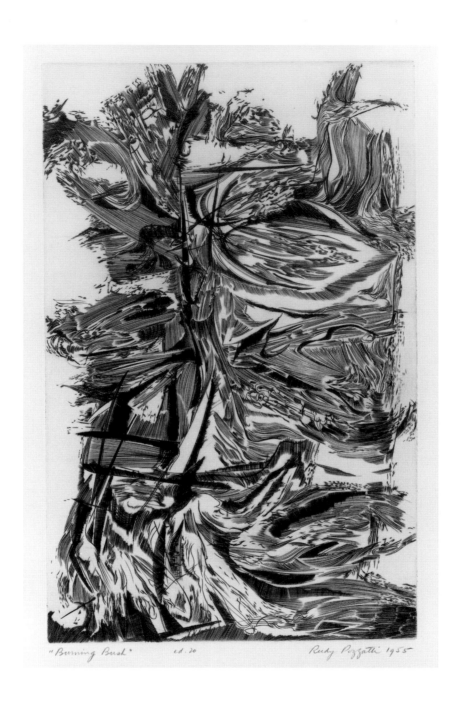

7. Burning Bush
1955; copper-plate engraving on buff BFK Rives paper;
image: $20^{1/2}$ x $13^{1/8}$ (52.1 x 33.3), sheet: $24^{1/2}$ x $18^{13/16}$
(62.2 x 47.8); edition of 20 (Geske 43)

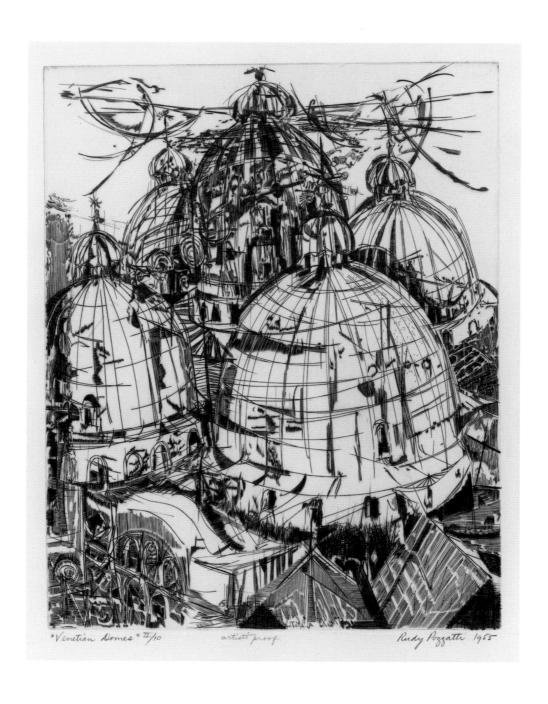

"Venetian Domes" II/10 artist's proof Rudy Pozzatti 1955

8. Venetian Domes
1955; zinc-plate engraving on buff BFK Rives paper;
image: $19^{1/2}$ x $15^{3/4}$ (49.5 x 40.0), sheet: $24^{1/2}$ x $18^{3/16}$
(62.2 x 46.2); artist's proof (Geske 42)

This image derives its inspiration from Pozzatti's memories
and drawings of the domes of San Marco in Venice.

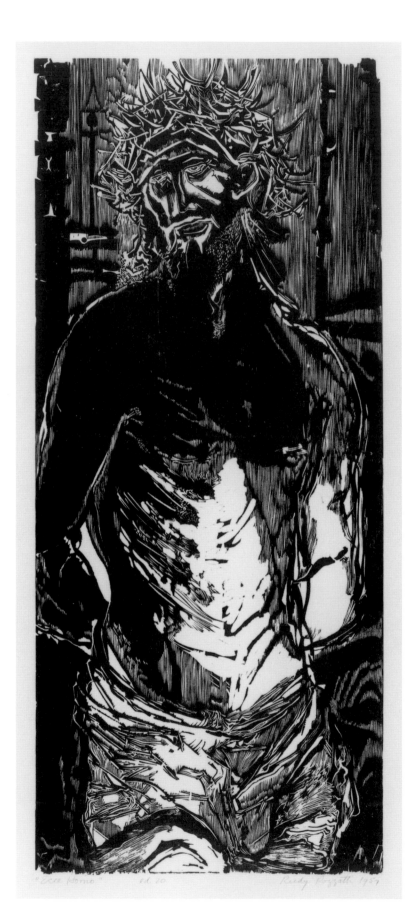

9. Ecce Homo

1957; woodcut on Mulberry paper; image: 35³/₁₆ x 15¹/₈ (89.4 x 38.4), sheet: 38¹/₂ x 19 (97.8 x 48.3); edition of 20 (Geske 62)

The tall, thin, coffin-like format of this print was inspired not only by medieval precedents, but by practicality as well. Pozzatti found the board on which the print was carved in the cellar of his house in Bloomington. He maintained the imperfections of the old shelf in the final piece. The work's human scale and sense of decay add to its haunting power.

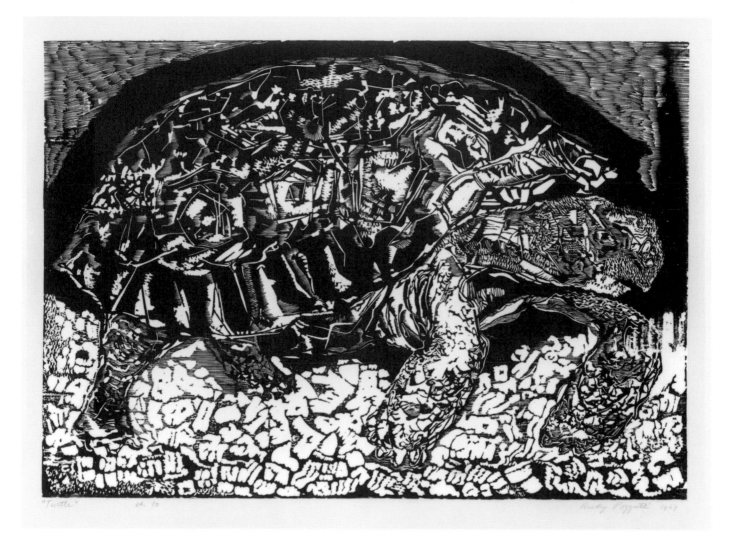

"Turtle" ed. 10 Rudy Pozzatti 1957

10. Turtle

1957; woodcut on Mulberry paper; image: 21^1/$_{16}$ x 29^5/$_8$ (53.5 x 75.2),
sheet: 24^1/$_8$ x 33^{11}/$_{16}$ (61.3 x 85.6); edition of 10 (Geske 63)

A favorite of Pozzatti's, turtles reappear frequently in his work (also see
no. 51). The familiar environment surrounding Pozzatti's Bloomington
home, where turtles proliferated, inspired this print.

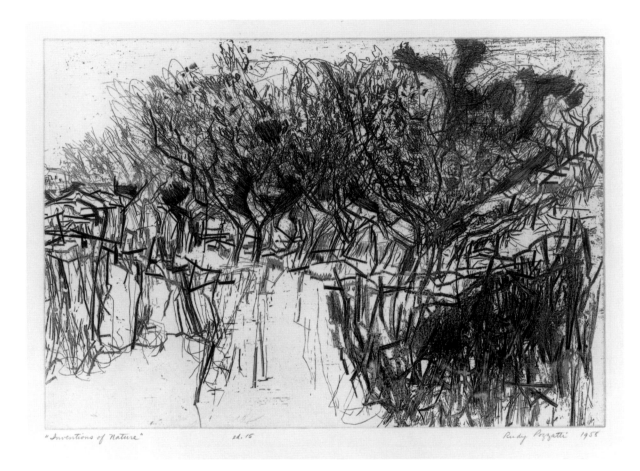

"Inventions of Nature" ed. 15 Rudy Pozzatti 1958

11. Inventions of Nature
1958; aluminum-plate etching and engraving on buff BKF Rives paper
(printed with toned ink); image: $14^7/_8$ x $21^3/_8$ (37.8 x 54.3),
sheet: 20 x $25^{15}/_{16}$ (50.8 x 65.9); edition of 15 (Geske 69)

Among the first intaglio works that Pozzatti did after his move to
Bloomington, the plate's initial design was drawn at one of the area's
famous limestone quarries, with subsequent additions added in the studio.

12. Flagellation

1959; woodcut on Mulberry paper; image: 14^1/$_8$ diameter (35.9), sheet: 22^1/$_2$ x 17^1/$_2$ (57.1 x 44.4); edition of 20 (Geske 78)

Given the limited resources of Indiana University's young print program, Pozzatti often "recycled" material discarded by other units to great advantage. The wood for this print came from the lid of a biology department specimen (frog) container.

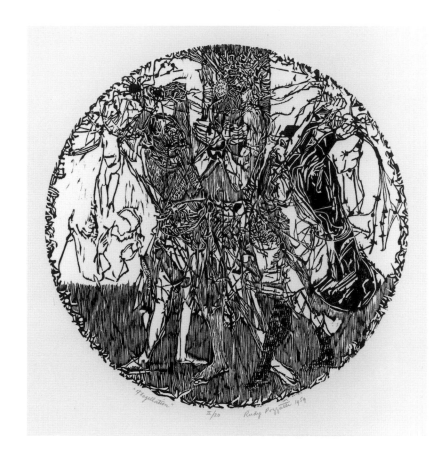

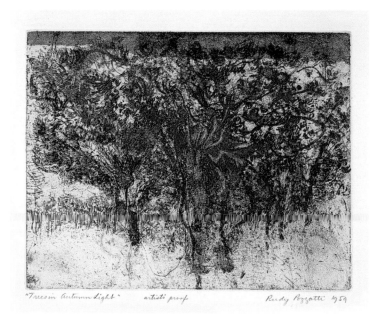

13. Trees in Autumn Light

1959; color copper-plate etching, soft-ground etching, aquatint, and engraving on buff BFK Rives paper; image: 7^7/$_8$ x 9^{15}/$_{16}$ (20.0 x 25.2), sheet: 13^1/$_4$ x 13^1/$_4$ (33.6 x 33.6); artist's proof (Geske 76)

Commissioned by the International Graphics Arts Society (NYC), this print began much closer to home. The imagery was inspired by the so-called "tree center" (now the site of Forest Quad) on the Bloomington campus.

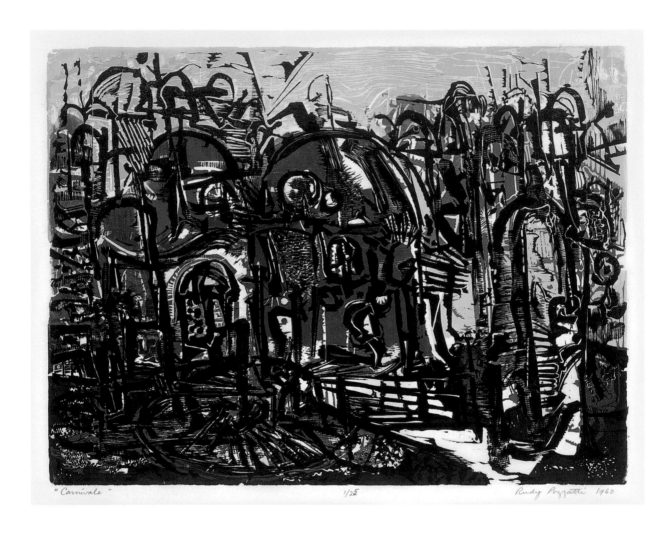

"Carnivale" 1/25 Rudy Pozzatti 1960

14. Carnevale
1960; color woodcut on Mulberry paper; image: 24 x 18$^1/8$ (61.0 x 46.0),
sheet: 24$^{13}/16$ x 30$^3/16$ (63.0 x 76.7); edition of 25 (Geske 86)

This ten-color woodcut is the first of three ambitious color woodcuts that
Pozzatti executed while working in the old print shop at Indiana University's
Mitchell Hall. The other two are *View from the Forum* (1961) and *Sun over
Venice* (1961).

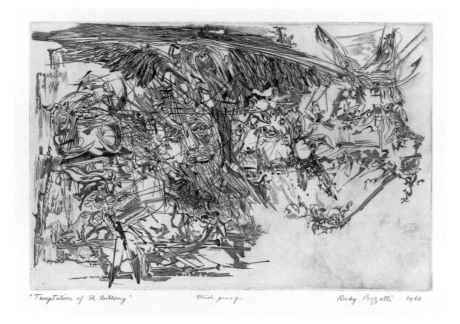

"Temptation of St. Anthony" trial proof Rudy Pozzatti 1960

15. Temptation of St. Anthony
1960; zinc-plate engraving on
German Copperplate paper;
image: 11⁷/₈ x 18 (30.2 x 45.7),
sheet: 16 x 20 (40.6 x 50.8);
trial proof (Geske 82)

Pozzatti frequently returned to
favorite subjects, particularly
when the imagery was wrought
with powerful human emotion.
Inspired by Northern Renaissance
prints, this image depicts the trials
and tribulations of Saint Anthony.
In addition to the standard
demonic beasts and animals, the
saint's tormented state of mind is
reflected in the print's hidden
faces and chaotic composition.
Pozzatti produced a very different
interpretation of this subject in a
1967 lithograph.

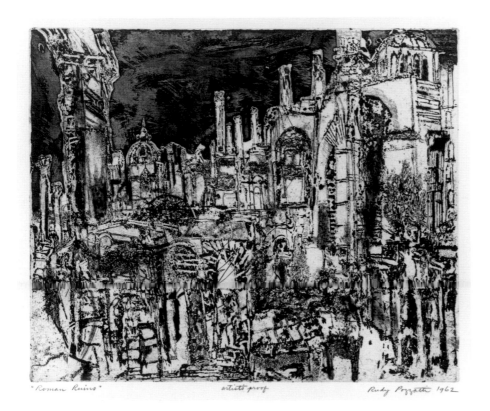

"Roman Ruins" artist's proof Rudy Pozzatti 1962

16. Roman Ruins
1962; zinc-plate etching,
soft-ground etching, lift-ground
etching, aquatint, and drypoint
on German Copperplate paper;
image: 17⁷/₈ x 21⁵/₈ (45.4 x 54.9),
sheet: 23⁵/₈ x 27¹/₁₆ (60 x 68.6);
artist's proof (Geske 95)

Done in contemplation of Pozzatti's
trip to Italy on a Guggenheim
Fellowship, this print proved to
be very successful. It was awarded
a national prize by the Society of
American Graphic Artists and
was named one of the "100 Prints
of the Year."

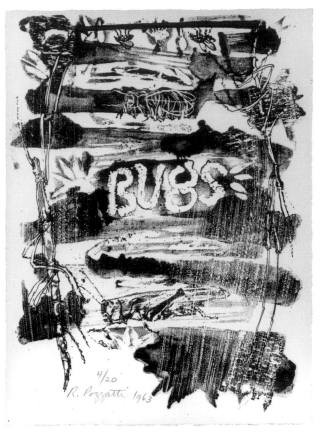

Title Page

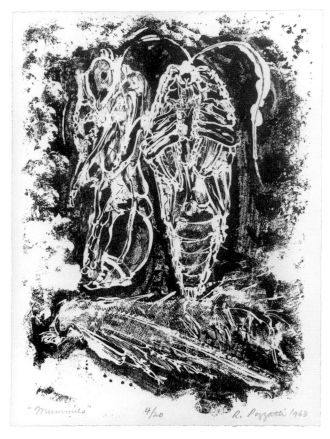

"Mummies"

17. Bugs

1963; portfolio: ten lithographs on buff Arches paper with colophon, title, and dedication pages in cloth-covered slipcase; average sheet size: 10 x 7^1/$_2$ (25.4 x 19.0), box: 10^1/$_2$ x 7^3/$_4$ (26.7 x 19.7); edition of 20; Gift of Henry Hope, Indiana University Art Museum 63.331.1–.10; (Geske 103) (Printed at Tamarind Lithography Workshop in Los Angeles)

This suite is one of two portfolios that Pozzatti completed at the noted fine arts press, along with sixteen individual prints. Dedicated to the artist's children, *Bugs* exhibits the complex techniques that characterized Pozzatti's work at Tamarind. He frequently used gum stop-out and turpentine tusche washes to achieve sharp black-and-white contrasts and, then, "reworked" the stones after they were etched to add the middle grays.

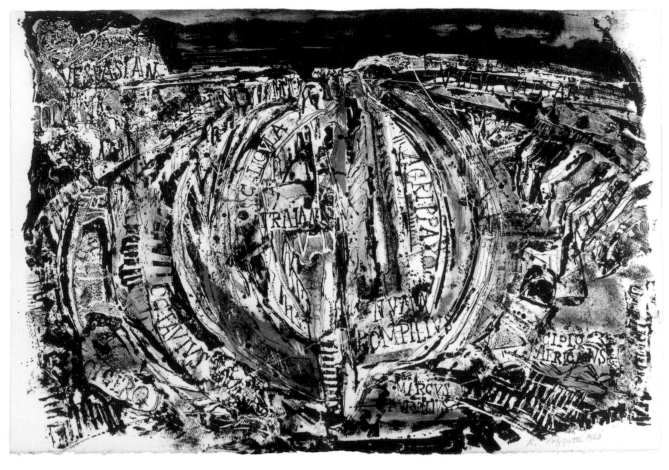

Endsheet

18. XII Romans

1963; portfolio: fourteen lithographs printed in
red-black ink on buff Arches paper and natural
Nacre paper, with titles on interweaving wrappers,
in cloth-covered box; average image/sheet size:
15 x 11$^1/_4$ (38.1 x 28.6), title page: 15$^3/_{16}$ x 23$^3/_8$
(38.6 x 59.4), box: 17$^5/_8$ x 12$^3/_8$ (44.7 x 31.4);
edition of 20 (Geske 103) (Printed at Tamarind
Lithography Workshop)

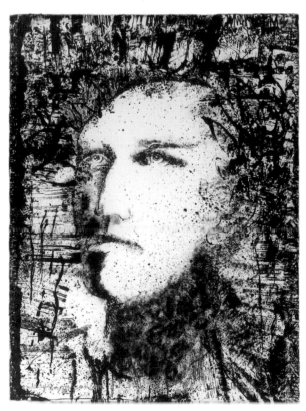

"Vespasian"

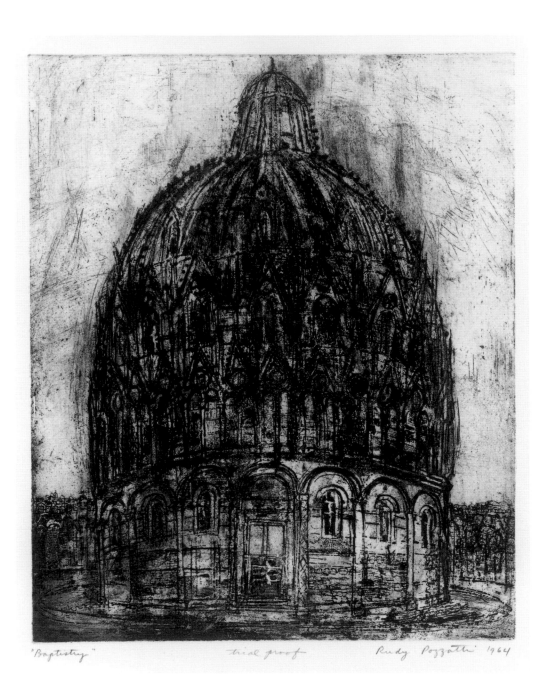

"Baptistry" trial proof Rudy Pozzatti 1964

19. Baptistry
1964; zinc-plate etching, lift-ground etching, and aquatint on
German Etching paper; image: 21^1/$_2$ x 17^7/$_8$ (54.6 x 45.4),
sheet: 29^1/$_{16}$ x 21^1/$_4$ (73.8 x 54.0); trial proof (Geske 138)

While in Italy on a Guggenheim Fellowship, Pozzatti drove
from Florence to Pisa. This print was drawn on site.

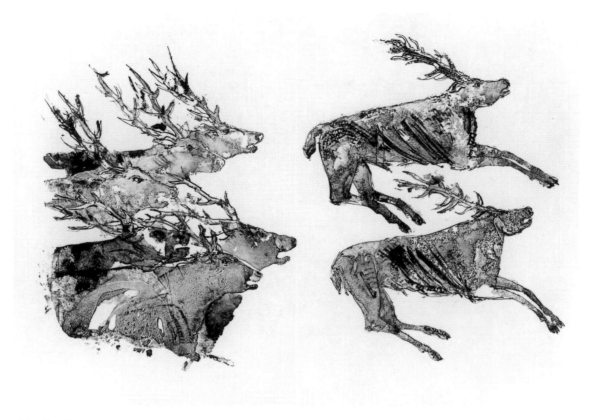

"The Stag"

20. *Physiologus Theobaldis Episcopi de Naturis Duodecim Animalium*
[The Allegorical Bestiary of Bishop Theobaldus]
1964; book: Latin text with English translations
by Willis Barnstone and twelve lithographs and
ten woodcuts on white BFK Rives and Inomachi
Nacre paper in buckram-covered box, published
by Indiana University Press, Bloomington,
designed by George Sadek; average sheet size:
$20^{1}/4$ x $27^{3}/4$ (51.4 x 70.5), box: $21^{3}/4$ x $15^{1}/4$
(55.3 x 38.7); presentation proof; Collection of
Diether Thimme, Indiana University Art Museum,
98.509 (Geske 140)

The lithographs were printed at Il Torcoliere in
Rome under the direction of Virginia Magini,
while the woodcuts were printed by Spiral Press
in New York City.

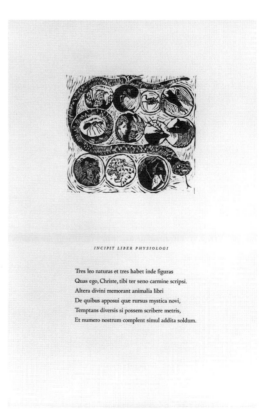

Pictographs

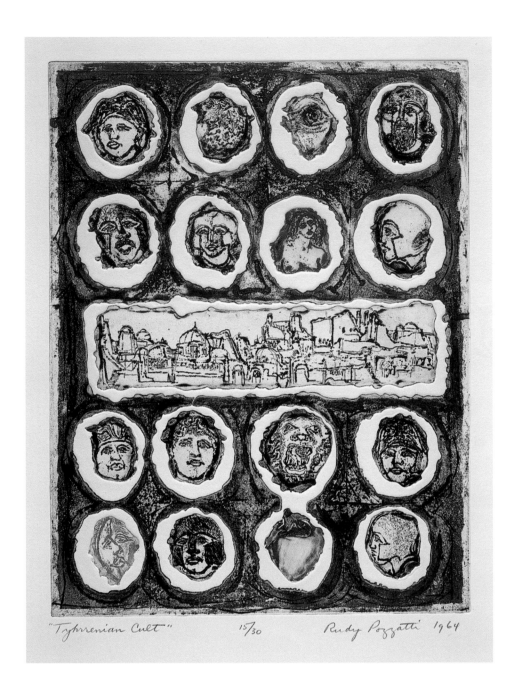

"Tyrrhenian Cult" 15/30 Rudy Pozzatti 1964

21. Tyrrhenian Cult
1964; color zinc-plate etching, lift-ground etching, and aquatint on German
Etching paper; image: 15$\frac{1}{2}$ x 11$\frac{3}{4}$ (39.4 x 29.8), sheet: 20$\frac{3}{4}$ x 15$\frac{1}{2}$
(52.7 x 39.4); edition of 30 (Geske 129)

This print represents the beginning of Pozzatti's use of cut plates in his work.
Interested in the violation of the metal plate, he cut each of the "medallions"
with a torch and fit the parts into a template for printing. This is an excellent
example of Pozzatti challenging himself in order to fully explore the physicality
of the print process and the limits of its possibilities.

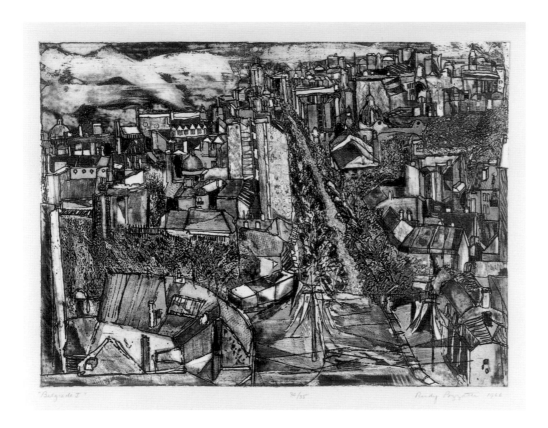

22. Belgrade I
1966; zinc-plate etching, soft-ground etching, and aquatint on German Etching paper; image: 17⅝ x 23¾ (44.8 x 60.3), sheet: 20¾ x 28 (52.7 x 71.1); edition of 35 (Geske 156)

Pozzatti executed the design for this plate while looking out of his hotel window during a U.S. State Department cultural exchange to Yugoslavia. Proofs of the thirteen prints he worked on during his six-week stay in Belgrade were pinned up on large panels at the International Trade Fair, to be viewed by the 435,000 visitors to the Fair.

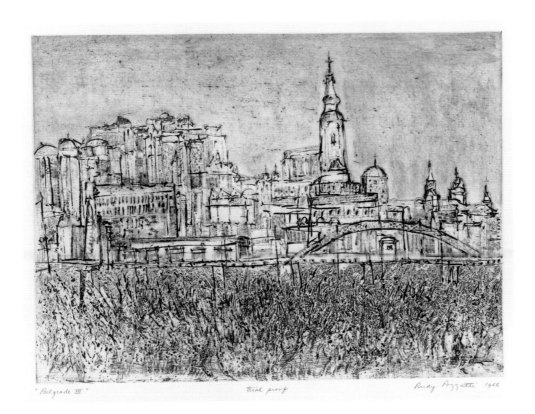

23. Belgrade III
1966; zinc-plate etching, soft-ground etching, lift-ground etching, and drypoint on German Etching paper; image: 17½ x 23½ (44.4 x 56.7), sheet: 20⅝ x 28⅛ (52.4 x 71.4); trial proof (Geske 158)

Pozzatti drew the initial design for this plate while sitting near the railroad tracks in Belgrade.

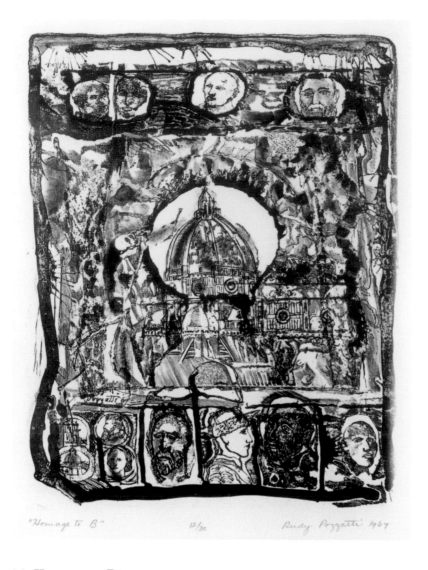

"Homage to B" 12/30 Rudy Pozzatti 1967

24. Homage to B
1967; zinc-plate lithograph on Italia paper; image: 19 x 14³/₄ (48.3 x 37.5), sheet:
25¹¹/₁₆ x 19⁵/₈ (65.2 x 49.8); edition of 30 (Geske 182)

This print was worked on a zinc lithography plate. Zinc, used as a replacement for
stone, was itself supplanted by aluminum litho plates, which were more hydrophilic
(water-loving), allowing for more consistent images. In Italy, however, where this print
was executed, zinc continued to be in use during this period.

25. Homage to Brunelleschi
1968; zinc-plate etching, lift-ground etching, soft-ground etching, and aquatint on
German Etching paper; image: 36 x 25¹/₂ (91.4 x 64.8), sheet: 41³/₄ x 30⁷/₈; edition of
35 (Geske 188)

One of Pozzatti's largest intaglio prints, this piece is not only a technical tour de force
but also is indicative of the artist's sophisticated visual vocabulary. Building on the
compositional format of *Homage to B* (no. 24), the image's central "oculus" contains a
rendering of Filippo Brunelleschi's (1377–1446) famous cathedral dome in Florence.
The wings that sprout from the image are an allusion to Michelangelo's claim that the
dome looked as though it could literally take flight. The surrounding iconography
includes relics of Brunelleschi's life—various architectural projects, theatrical masks,
busts by the architect/sculptor, and a portrait of the man himself (upper center).

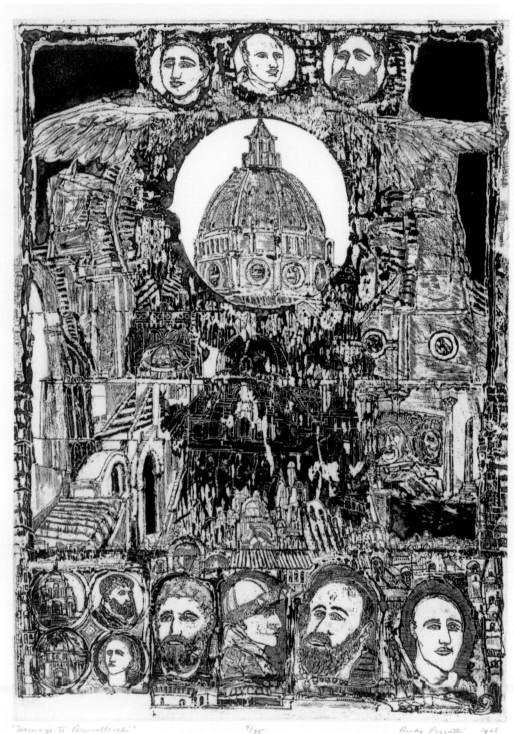

"Homage to Brunelleschi" 9/35 Rudy Pozzatti 1968

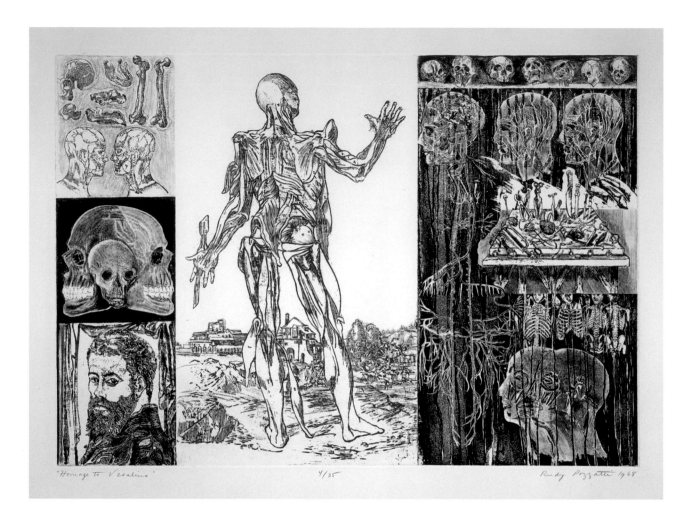

"Homage to Vesalius" 4/35 Rudy Pozzatti 1968

26. Homage to Vesalius
1968; zinc-plate etching, lift-ground etching, engraving,
and aquatint with roulette and sandpaper toning on
German Etching paper (printed with toned ink); image:
25$^{1}/_{2}$ x 36 (64.8 x 91.4), sheet: 30$^{7}/_{8}$ x 41$^{7}/_{8}$ (78.4 x 106.4);
edition of 35 (Geske 187)

The central section of this print was inspired by an
anatomical drawing in a sixteenth-century treatise by
Andreas Vesalius (1514–1564). During his studies as a grad-
uate student, Pozzatti had discovered the scientific writings
of Leonardo da Vinci. He was, likewise, struck by the less-
er-known contributions of the Flemish anatomist Vesalius,
including his seminal work on the human nervous system.
Vesalius's portrait is visible in the lower left-hand corner of
the print.

27. Vietnam
1970; collage with handwork on paper; image/sheet:
12$^{3}/_{8}$ x 10 (31.4 x 25.4); unique

In this collage/drawing, Pozzatti combines patriotic
symbols (an American eagle, the U.S. Capitol, and battle
ribbons) with images of innocence and death (babies,
skeletons, and a skull). Such conflicting imagery suggests
the confusion many Americans, particularly veterans, felt
with regards to the war in Vietnam, which is suggested by
a piece of oriental paper.

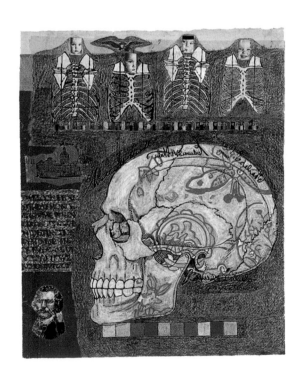

"Summon Out a Spirit" 27/35 Rudy Pozzatti 1968

28. Summon Out a Spirit
1968; color lithograph, zinc-plate etching, and aquatint on German Etching paper; image:
22⅛ x 15⅞ (56.2 x 40.3), sheet: 26⅞ x 20⅝ (68.2 x 52.3); edition of 35 (Geske 195)

The title of this work is derived from John Ciardi's translation of Dante's *Inferno*,
Canto IX, 8th stanza. This complex piece represents one of Pozzatti's earliest uses of
shaped plates and is among his first combination prints, which mix various techniques
(lithography and intaglio).

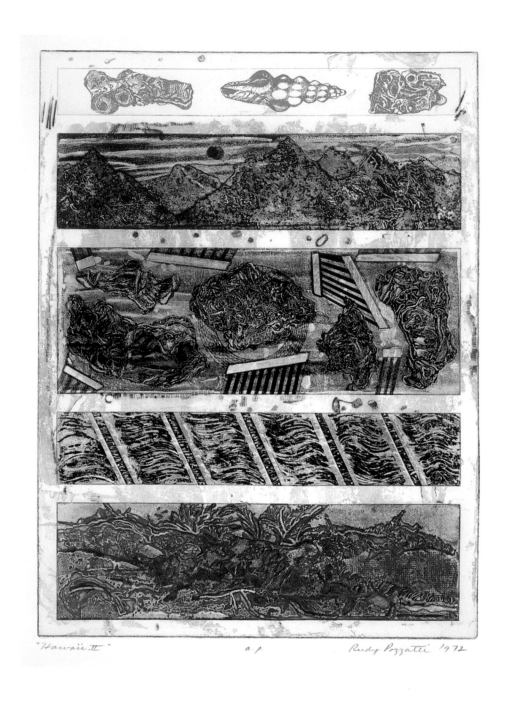

"Hawaii II" a.p. Rudy Pozzatti 1972

29. Hawaii II
1972; color zinc-plate etching, aquatint, lift-ground etching, and soft-ground etching
on German Etching paper; image: 23³/4 x 17³/4 (60.3 x 45.1), sheet: 30¹⁵/16 x 21
(78.6 x 53.3); artist's proof

One of two prints in a series, this piece reflects Pozzatti's response to the exotic environ-
ment (shells, mountains, coral, tidal waves, and volcanic eruptions) that he encountered
as an artist-in-residence for a semester in Honolulu.

40

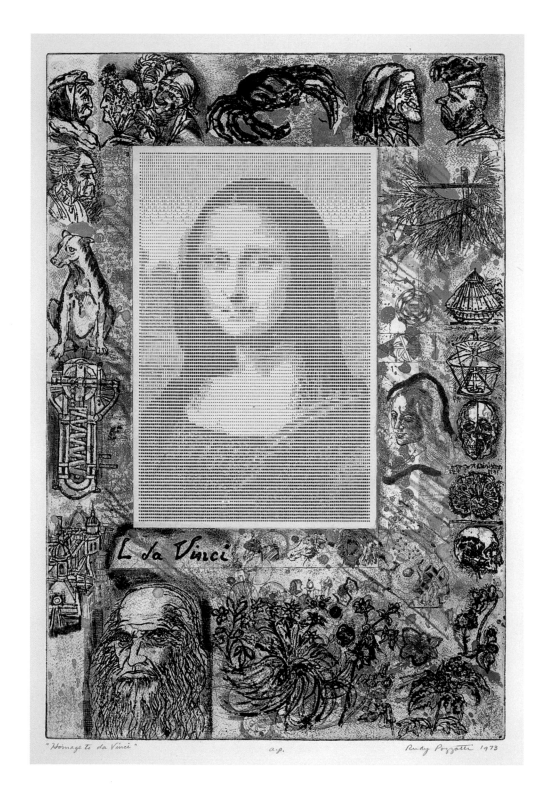

"Homage to da Vinci" a.p. Rudy Pozzatti 1973

30. Homage to da Vinci
1973; color zinc-plate etching, aquatint, and lift-ground etching with computer
printout collage on German Etching paper; image: 35³/₈ x 23³/₄ (89.9 x 60.3),
sheet: 41¹³/₁₆ x 29³/₄ (106.2 x 75.6); artist's proof

Pozzatti had long admired the virtuosity of Leonardo da Vinci (1452–1519), not only as an
artist, but also as a "renaissance" man. He includes "icons" representing da Vinci's many
areas of contribution—botany, anatomy, ballistics, architecture, aviation, marine biology,
physiognomy, among others. In a delightful play on the importance of invention to all ages,
Pozzatti combines a copy of da Vinci's self-portrait in the lower left with a centrally placed
reproduction of da Vinci's great masterpiece, the *Mona Lisa*, as produced in the Indiana
University computer lab by Pozzatti's son, Rudy Jr.

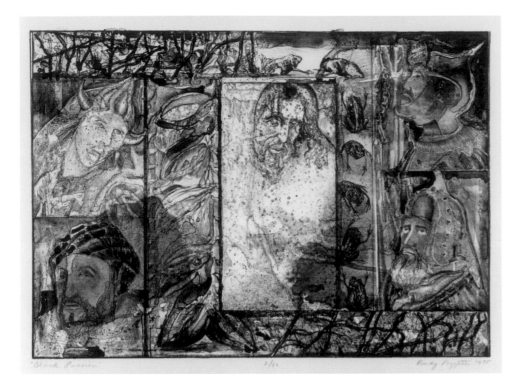

31. Black Passion
1975; aluminum-plate lithograph on white Arches paper; image: 20¹/₁₆ x 28¹/₈ (50.9 x 71.4), sheet: 24¹/₈ x 32¹/₈ (61.3 x 81.6); edition of 50

A favorite image of Pozzatti's, this work started out as a disaster. Produced at Lakeside Studio with Jack Lemon, it was originally intended to be a six-color print. When the results were less than satisfactory, Lemon suggested printing the two plates that had the greatest definition of the image: one in a cool black and the other in a warm black. The proof was "right on!" according to Pozzatti, and the image was printed without another correction. The change not only emphasizes the print's rich tonalities, but it matches the piece's dark narrative as well. The imagery includes references to the seven deadly sins, three Roman soldiers, and Simon of Cyrene, who was forced to help Christ carry the cross.

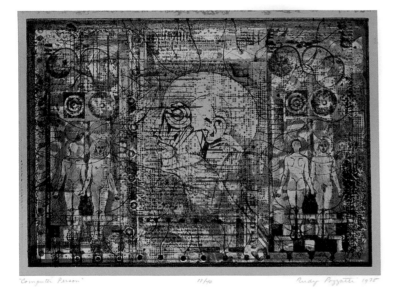

32. Computer Person
1975; color lithograph on aluminum mylar mounted to white Arches paper; image: 12³/₈ x 17 (31.4 x 43.2), sheet: 18 x 22³/₈ (45.7 x 56.8); edition of 40

A trip to International Decorators in Indianapolis with Echo Press's printer, David Keister, led to an interesting new discovery in printing material—mylar. Although it proved difficult use (it is non-absorbent and has a tendency to roll), its unique visual properties meshed perfectly with Pozzatti's developing ideas about the relationship of new technologies to the modern human condition. Pozzatti later printed a second edition on Japan paper using only a blue-black ink.

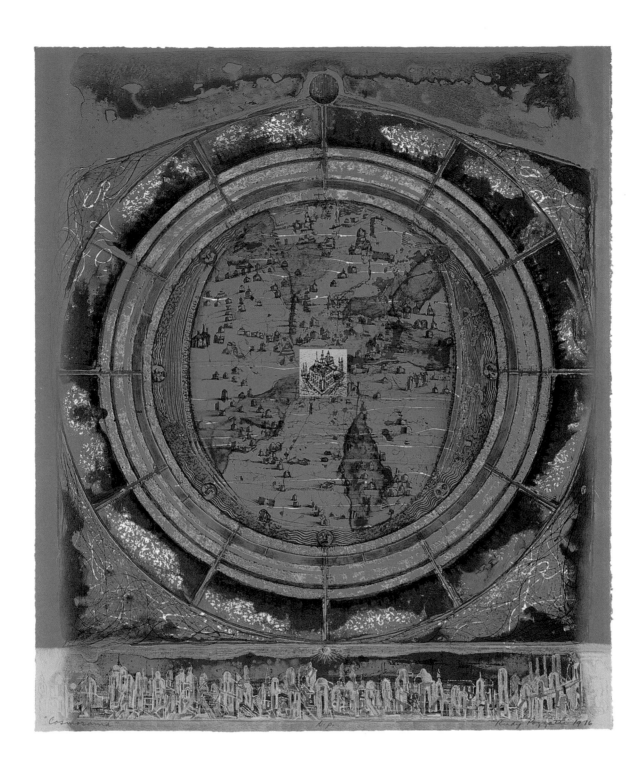

33. Cosmorama
1976; color lithograph and Apex mylar collage on buff BFK Rives paper;
image/sheet: 29⁵/₈ x 25¹/₈ (75.2 x 63.8); artist's proof

This print is a wonderful combination of the old and new worlds. Pozzatti reused an image
of an old "map" found on a lithographic stone from A. Hoen and Company, an important
early American printing company in Baltimore, Maryland. When the business downsized,
Pozzatti and Jack Lemon rescued the stones for Landfall Press and IU's School of Fine Arts.
(Pozzatti and David Keister made a later trip back to Baltimore to acquire additional stones
for Echo Press.) In an interesting twist on technology, Pozzatti reworked the earlier image
and added a distinctly modern twist—self-adhesive mylar—at its center. In Pozzatti's cosmos
there is both a reverence for tradition and a push towards new frontiers.

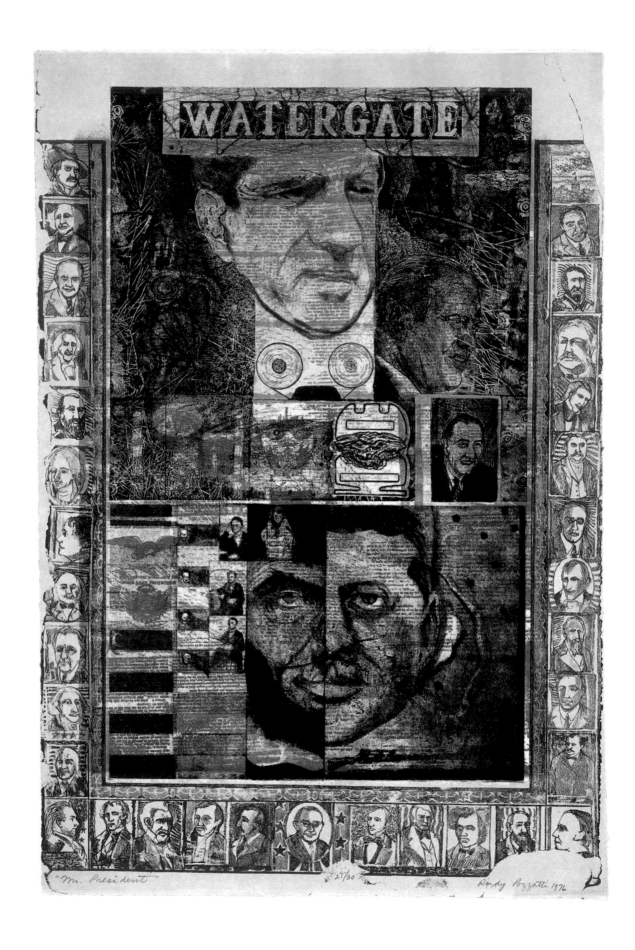

"Mr. President" 27/30 Rudy Pozzatti 1976

44

34. Mr. President
1976; color lithograph, zinc-plate etching, and matboard relief print on German
Etching paper; image/sheet: 36 x 24^{1}/$_{8}$ (91.4 x 61.3); edition of 30

This print started in a totally different direction; however, during its execution
the Watergate scandal broke, prompting a new response. Rather than glorifying
the office of the presidency, Richard Nixon, Spiro Agnew, and the infamous
tapes were shown in stark contrast to the split portrait of Lincoln/Kennedy in
the lower portion. Symbols of money, power, and violence are evident through-
out. The four small skulls with four rifles represent our four fallen presidents,
while portraits of all our national leaders ring the circumference.

35. Papal Bull
1976; color zinc-plate etching with Apex mylar collage on German Etching
paper; image: 19^{7}/$_{8}$ x 29^{5}/$_{8}$ (50.5 x 75.2), sheet: 25 x 33^{7}/$_{8}$ (63.5 x 86.4);
edition of 15

Printed while Pozzatti was a National Endowment for the Arts artist-in-
residence at David Driesbach's Northern Illinois State workshop, this etching
was inspired by E. R. Chamberlin's *The Bad Popes*. The print combines
symbols of the Church and Rome, such as Bernini's columns in St. Peter's
Basilica, a rising sun, and a cityscape, with suggestions of the great personal
wealth of the popes—lush purple fabric and jeweled mitres.

36. "Station 4: Christ Meets His Mother," from the *Stations of the Cross*
1977; transfer lithograph on Twinrocker handmade paper; image: 21¹/₈ x 15⁵/₈ (53.6 x 39.6), sheet: 24¹/₈ x 18¹/₈ (61.3 x 46); edition of 50

Printed at Landfall Press with Jack Lemon, this series of twelve "Stations" played an important role in Pozzatti's oeuvre. Unlike most contemporary art, which was rarely religious in content, these prints served a true liturgical function. When installed in a church (as they have been), the Stations possess a devotional significance not unlike the great religious art of the past. The series also holds a special significance as a memorial to the artist's mother.

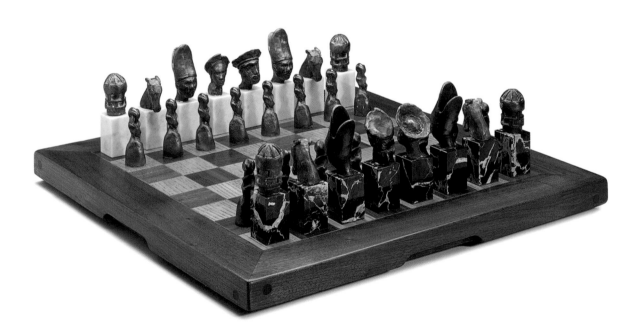

37. Chess Set
1978; chess pieces: cast bronze and Carrara marble; chessboard: black walnut, cherry, white ash, and brass; tallest piece: 5⁷/₈ (14.8), board: 23¹/₁₆ x 23¹/₁₆ x 1⁷/₁₆ thick (58.6 x 58.6 x 3.6); edition of 15

Pozzatti first considered making sculptures in Italy between 1963 and 1964 while he was on a Guggenheim Fellowship. There he met a young Italian sculptor who gave him some wax to model. This piece, his most ambitious in three dimensions, was cast in Kalamazoo, Michigan. Pozzatti acquired the marble for the chess piece bases during a summer teaching stint at the Art Institute in Massa-Carrara, Italy. They not only had wonderful facilities for marble carving, but easy access to the local quarries, as well.

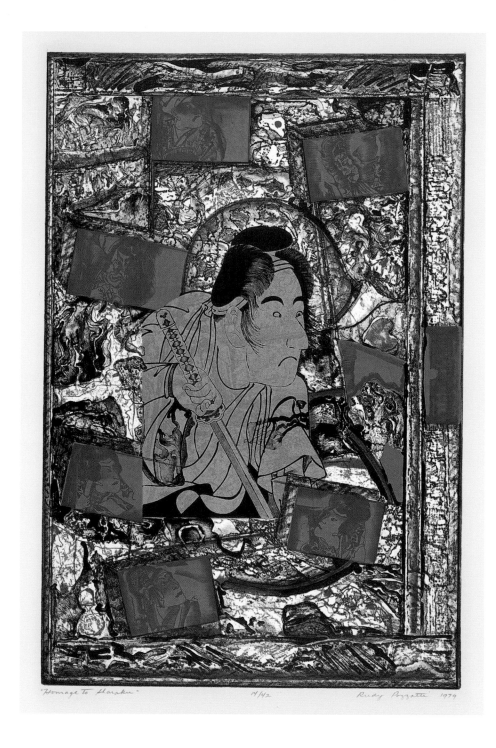

"Homage to Sharaku" 14/42 Rudy Pozzatti 1979

38. Homage to Sharaku
1979; color aluminum-plate lithograph with gold Japanese tissue collage on Goya Copperplate
paper; image: 30$^{1/2}$ x 20$^{3/16}$ (77.5 x 51.3), sheet: 35$^{5/16}$ x 24$^{7/8}$ (89.7 x 63.2); edition of 40
(Printed with the assistance of David Keister)

With the aid of several granting agencies, including the Ford Foundation, Pozzatti traveled to
the Adachi Institute in Japan to learn the techniques of *ukiyo-e* printmaking. Among the earlier
Japanese printmakers that he most admired was Toshusai Sharaku (active 1794–1795).
Ironically, when he returned home, he discovered that the Indiana University Art Museum
owned a collection of cherry wood blocks for one of that artist's works. Pozzatti received
permission to print from the blocks, and the resulting work became the focus of this print.
The surrounding designs were taken by Pozzatti from other Sharaku images and recall the
Japanese artist's dual career as an actor in the Kabuki theatre. Pozzatti chose the gold tissue
and vibrant colors after those he had admired in oriental prints.

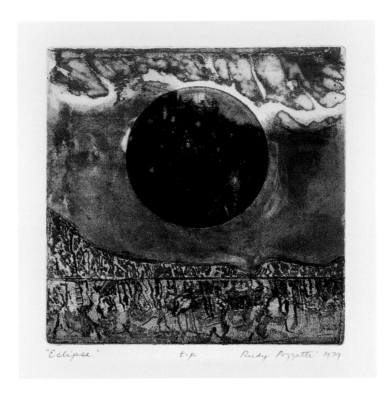

39. Eclipse
1979; color zinc-plate etching, aquatint, and relief print on buff Arches paper; image: 8⁷/₈ x 8¹⁵/₁₆ (22.5 x 22.7), sheet: 16⁹/₁₆ x 12¹⁵/₁₆ (42.1 x 32.9); trial proof

Using a single plate, Pozzatti worked with six colors above and below the surface of the plate in a combination of intaglio and relief printing.

40. Blue Totem
1980; color zinc-plate relief print with color woodcut collage on buff Arches paper; image: 24 x 18 (61 x 45.7), paper: 29¹¹/₁₆ x 20⁷/₈ (75.4 x 53); edition of 18

Although inspired by the natural landscape of the southwest and the surface of a wooden plank, this print suggests a more supernatural realm. The totemic composition directly reflects Pozzatti's continuing fascination with the monolith in Stanley Kubrick's 1968 film, *2001: A Space Odyssey.*

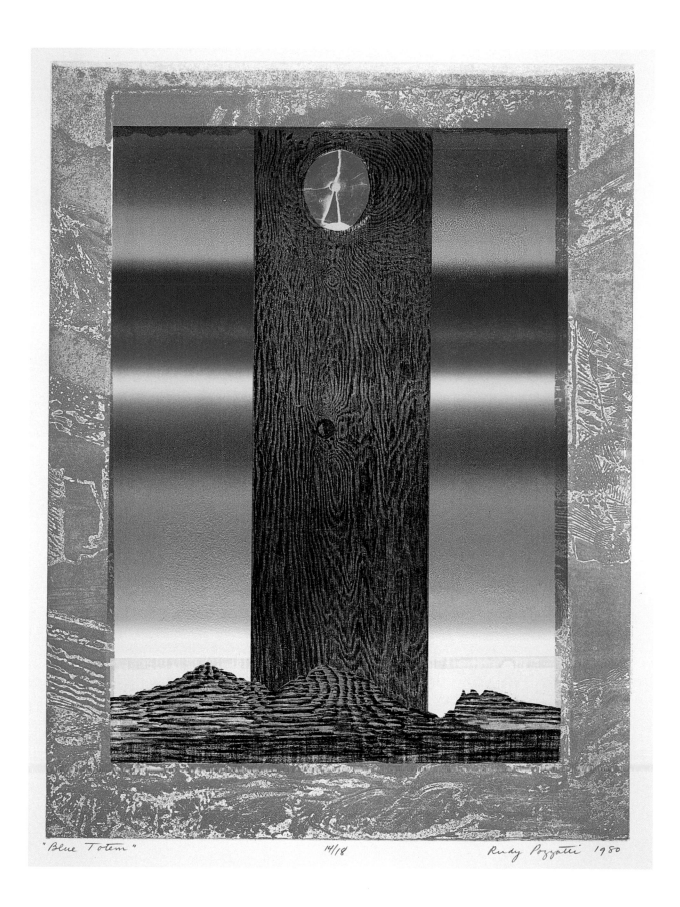

"Blue Totem" 14/18 Rudy Pozzatti 1980

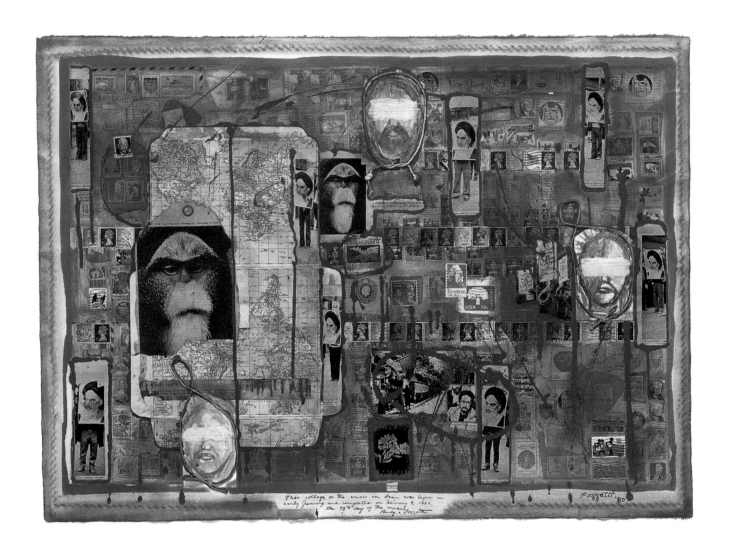

41. Crisis in Iran
1980; watercolor, tempera, and collage on buff Arches paper;
image/sheet: 22¼ x 29⅞ (56.5 x 75.9); unique

An angry personal reaction to the taking of the U.S. Embassy in Iran, this
collage combines mass media imagery with regional maps and stamps. The
piece was completed on the 98th day that the hostages were held captive.

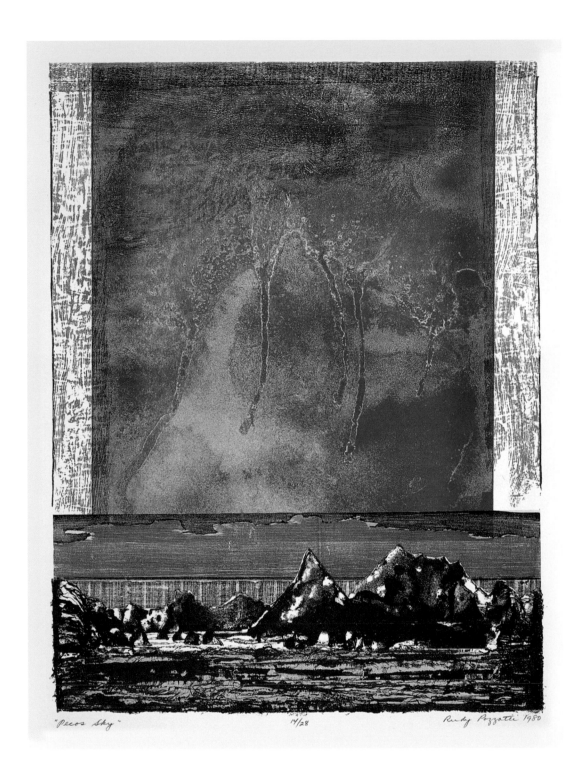

"Pecos Sky" 14/28 Rudy Pozzatti 1980

42. Pecos Sky
1980; color lithograph and matboard relief print with color woodcut collage on
German Etching paper; image: 27^{1}/$_{2}$ x 20^{7}/$_{8}$ (69.8 x 53), sheet: 32^{1}/$_{8}$ x 24
(81.6 x 61); edition of 28

While living for a year in Roswell, New Mexico, on a "Gift of Time" grant that
provided his accommodations, living expenses, and unlimited art supplies, Pozzatti
enjoyed the leisure to carefully observe the region's unique environment. This print
recalls the "finger rain" phenomena that he saw in the Pecos Valley.

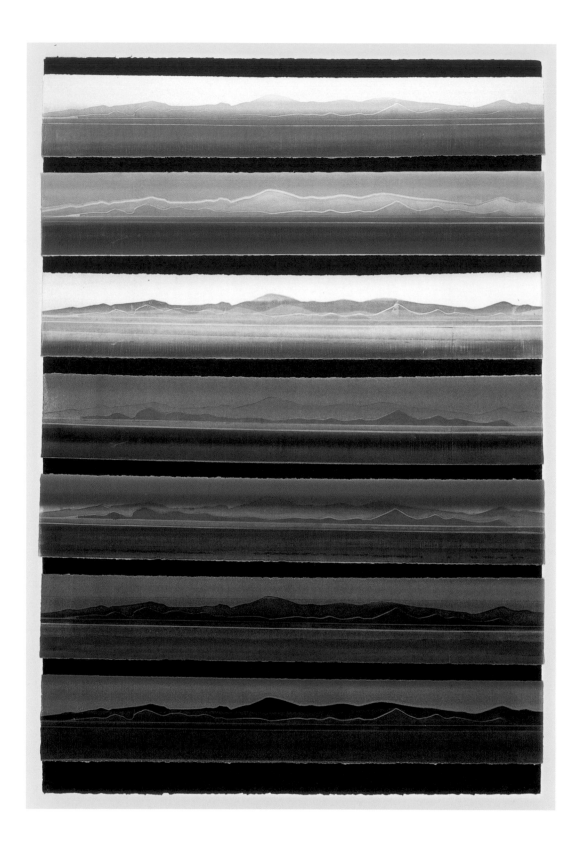

43. New Mexico Landscape/Seven Phases I
1980; color aluminum-plate relief print on white Arches paper mounted on black Arches paper;
image (irregular): 44⅛ x 30¼ (112.1 x 76.8), sheet: 44 x 30 (111.8 x 76.2); unique; lent by Mr. and
Mrs. Richard Yoakam

The first of a series of progressive landscapes (ten in all), this image uses a single plate printed in
different colors to capture the times of day from morning to night. Printed with the lightest tones
first, this process achieved its subtle atmospheric changes through "innumerable" passes through
the press.

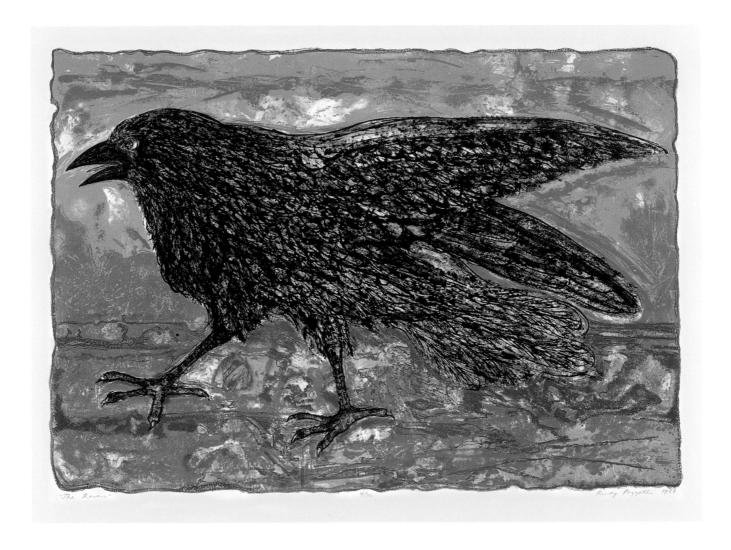

44. The Raven
1981; color transfer lithograph on unsized white BFK Rives paper; image: 28 x 40
(71.1 x 101.6), sheet: 31 x 43 (78.7 x 109.2); edition of 30

Printed at Echo Press, the subject of the raven holds a special meaning for Pozzatti. Not only
were these large black birds prevalent on his trips to New Mexico, but during his visit to Japan,
he discovered that they were regarded by the Japanese as important omens of good fortune.
Pozzatti printed a second state of this image using only blue-black ink on gray Arches paper.

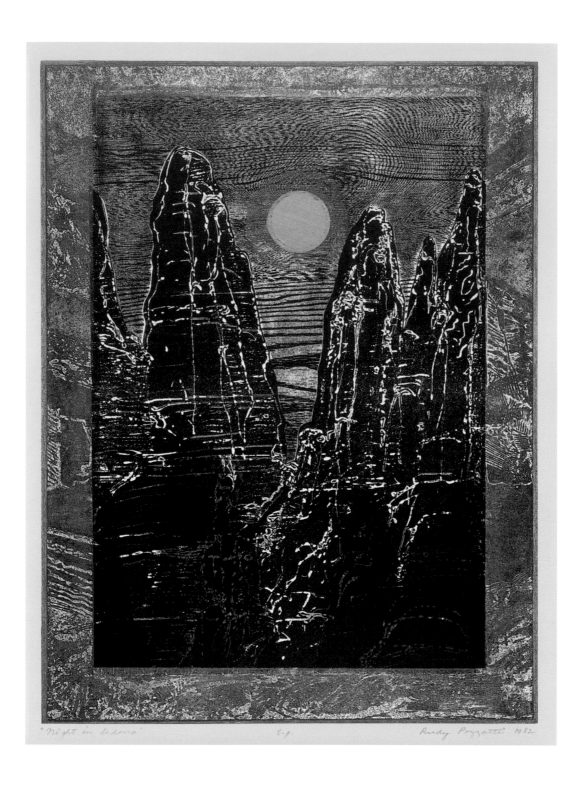

45. Night in Sedona
1982; color aluminum-plate lithograph and woodcut with silver paper collage on white BFK Rives paper; image: 24^1/$_2$ x 18^3/$_8$ (62.2 x 46.7), sheet: 30 x 22^1/$_8$ (76.2 x 51.2); trial proof

Printed at Augustana College in Sioux Falls, South Dakota, this print serves as both a remembrance of the artist's first visit to Sedona, a magical place when seen at nightfall, and as a tribute to his friend Jimmy Ernst, whose father, Max, had a house in the area. Although Pozzatti never visited him there, the surrealism of the scene suggests an allusion to the older surrealist master. The wood grain effect was created as a transfer-paper rubbing of an actual board. The pattern was then transferred to an aluminum lithography plate for printing.

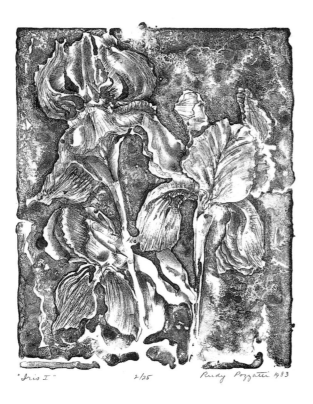

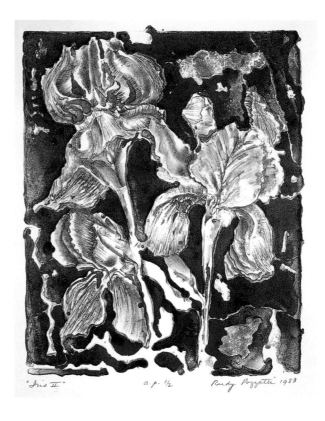

46. Iris I
1983; color lithograph on Nacre paper;
image: 15$^{1}/_{4}$ x 12$^{3}/_{16}$ (38.7 x 31.1), sheet:
22$^{5}/_{8}$ x 16$^{1}/_{2}$ (57.5 x 42); edition of 25

While staying in the "poet's house" in New
Harmony, Indiana, Pozzatti discovered, after
a hard day in the printshop, that Jane Owen,
the city's patroness, had left these beautiful
flowers in his room. Inspired, he asked a former
graduate student, John Begley, to bring him a
stone on the spot. Drawn in one night, the print
captures the freshness and spontaneity of that
fleeting moment. Begley later assisted him with
the printing of three editions.

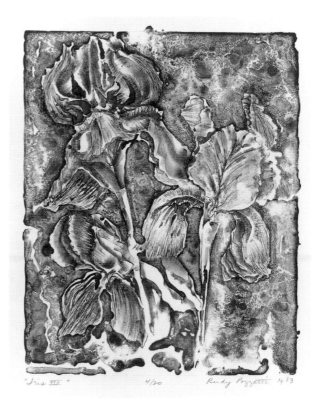

47. Iris II
1983; color lithograph on white Arches 88 paper;
image: 15$^{1}/_{4}$ x 12$^{3}/_{16}$ (38.7 x 31.1), sheet: 20$^{1}/_{2}$ x
16$^{1}/_{4}$ (52.1 x 41.3); artist's proof (one of two)

48. Iris III
1983; lithograph on buff Arches paper,
image: 15$^{1}/_{4}$ x 12$^{3}/_{16}$ (38.7 x 31.1),
sheet: 20$^{1}/_{8}$ x 16 (51.1 x 40.6); edition of 20

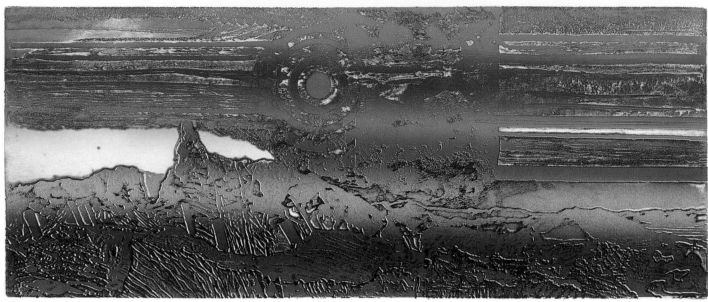

"Moon Landscape" *color trial proof (unique)* *Rudy Pozzatti 1983*

49. Moon Landscape
1983; color zinc-plate etching and relief print
on German Etching paper; image: 9³/4 x 23⁵/8
(24.8 x 60), sheet: 14¹/8 x 31 (35.9 x 78.7);
color trial proof

Although printed at the University of West
Virginia, this image evokes Pozzatti's memories
of the southwest, particularly of Roswell, New
Mexico. Printed in a series of approximately
twenty-five color variations, this unearthly image
links the New Mexico landscape with moon craters
in a haunting, unnatural light.

50. Enchanted Land/Seven Views
1984; color aluminum-plate and transfer
lithograph on Mulberry paper; image: 32¹/4 x
21 (81.9 x 53.3) (irregular), sheet: 37¹/4 x 24³/4
(94.6 x 62.9); color trial proof

In order to achieve the full range of natural
lighting effects Pozzatti desired in this print,
thirty-eight colors were used. Printed at Echo
Press, the process involved six runs (the pro-
gressive proofs are in the Echo Press Archive,
Indiana University Art Museum) on six
aluminum plates using extensive blend rolls.
The edges of the image were left intentionally
ragged to soften the otherwise rigid geometry.

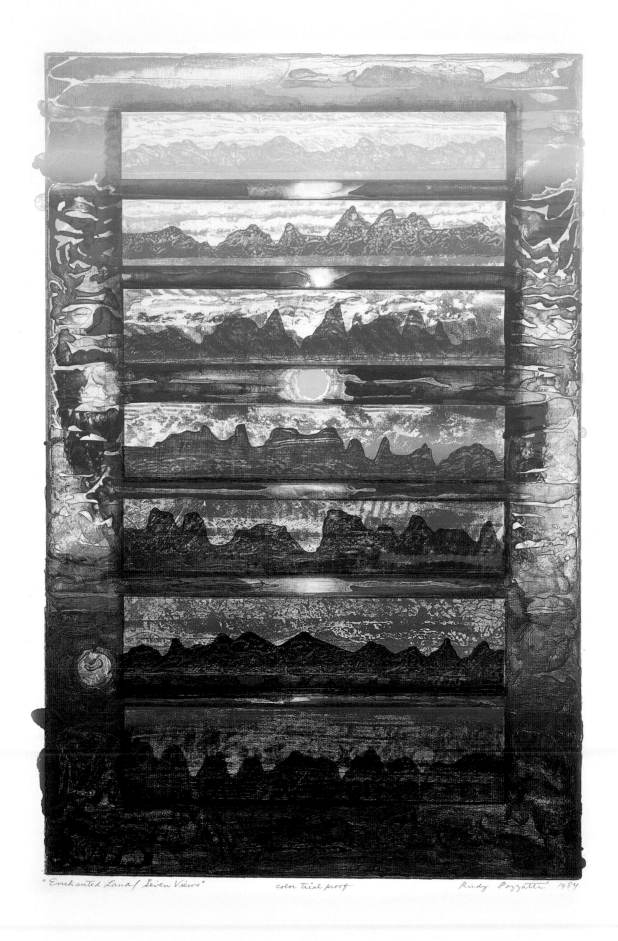

"Enchanted Land / Seven Views" color trial proof Rudy Pozzatti 1984

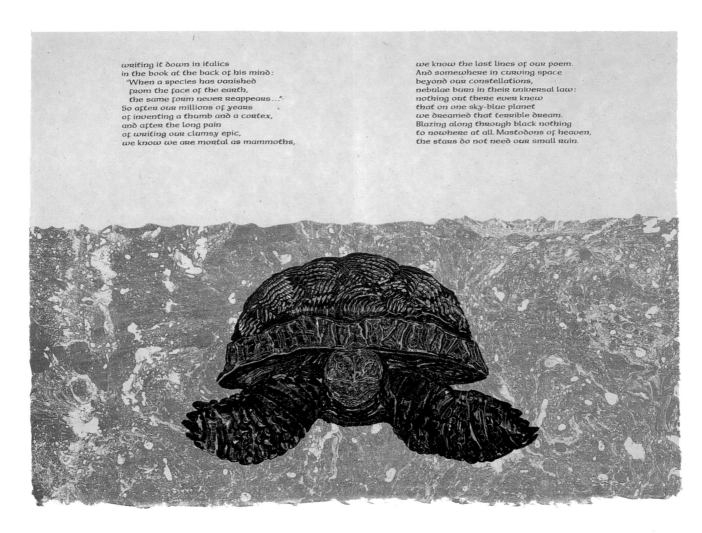

writing it down in italics
in the book at the back of his mind:
 "When a species has vanished
 from the face of the earth,
 the same form never reappears..."
So after our millions of years
of inventing a thumb and a cortex,
and after the long pain
of writing our clumsy epic,
we know we are mortal as mammoths,

we know the last lines of our poem.
And somewhere in curving space
beyond our constellations,
nebulae burn in their universal law:
nothing out there ever knew
that on one sky-blue planet
we dreamed that terrible dream.
Blazing along through black nothing
to nowhere at all. Mastodons of heaven,
the stars do not need our small ruin.

"Tortoise for *The Skeletons of Dreams*"

51. Darwin's Bestiary
1986; book: poems by Philip Appleman with
six woodcuts and 11 aluminum-plate and stone
lithographs on white Kitikata paper mounted to
white BFK Rives paper, with half-title page, title
page, and colophon, in cloth-covered box (most
images printed in toned ink); average sheet size:
18 x 25³/4 (45.7 x 65.4), box: 18⁷/8 x 14 x 1¹/2 (47.9
x 35.6 x 3.8); archive impression; Echo Press
Archive, Indiana University Art Museum
88.41.1a-l (printed at Echo Press; letter type
set by Frederic Brewer; calligraphy by Darlene;
box by Jim Canary)

"The Gossamer"

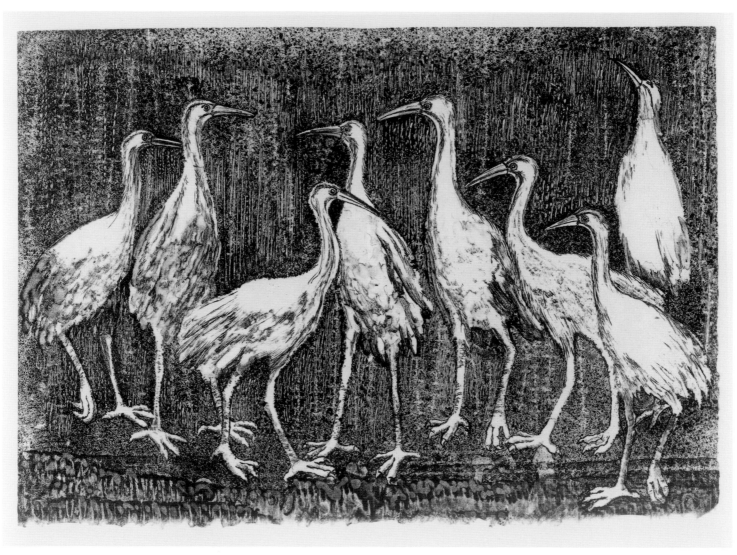

"Cranes for *Mr. Extinction, Meet Ms. Survival*"

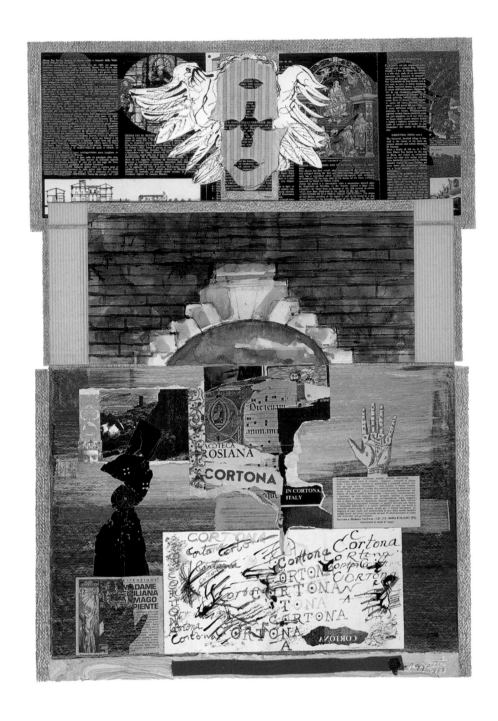

52. Remembrances of Cortona
1988; mixed media collage on Fabriano paper; image/sheet (irregular):
30³/₈ x 21⁵/₁₆ (76.5 x 54.1); unique

Combining references to the old city (an ink wash drawing of a Romanesque
archway, simulated fluted pilasters, and a winged mask) with modern-day
entertainments (tinfoil from a champagne bottle, Italian newspaper clippings,
travel brochures and a fortuneteller's advertisement), Pozzatti recaptures the
experiences of his 1987 residency in Cortona, Italy, as part of the University of
Georgia's summer program.

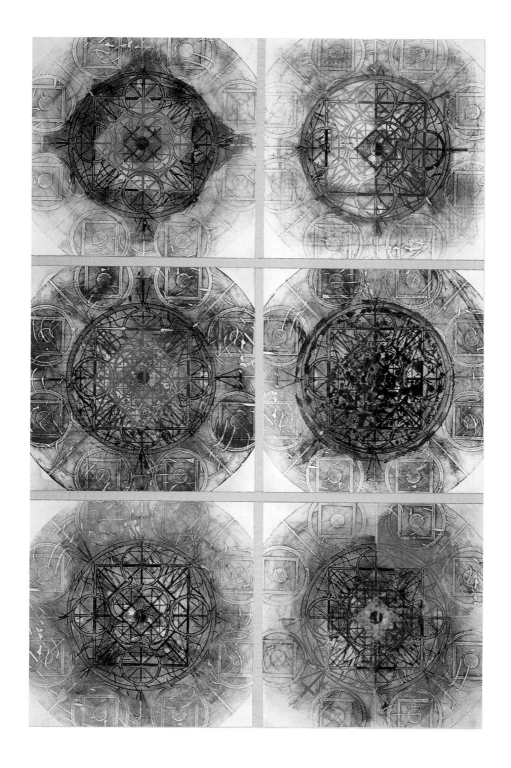

53. Window 17
1989; color zinc-plate etching and watercolor on German Etching paper with inkless embossing on gray Arches paper; image/sheet: 45¹/₄ x 30 (114.9 x 76.2); unique

Memories of the great stained glass windows in Germany, France, and Italy seen during his many travels abroad inspired Pozzatti and offered him a spiritual and transformative symbol free of excessive narrative and full of color and life. The window motif, found in innumerable combinations, continued to fuel his imagination for the majority of the 1990s. Working in series, the "windows" provided Pozzatti with a rich opportunity to explore color variations. In this work, one etching plate is used for each image, but re-inked in different color combinations, with each pane separated by paper "molding."

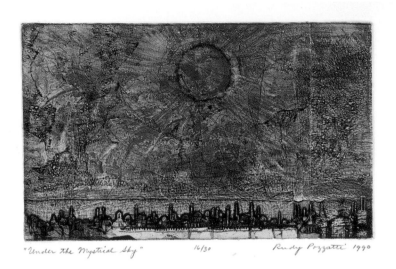

"Under the Mystical Sky"

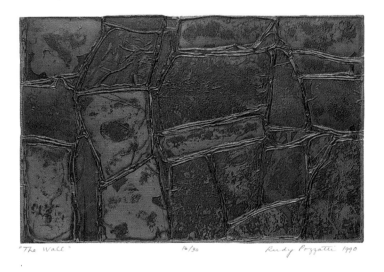

"The Wall"

54. Israel: Words and Images
1990; portfolio: nine color zinc-plate etching and relief prints and one lead relief on buff Arches paper with title page and colophon in a cloth-covered box; average sheet size: 15 x 11 (38.1 x 27.9), box: 16 5/8 x 11 7/8 (42.2 x 30.0); edition of 30

Published at the University of South Dakota, each of the images in this boxed portfolio accompanies a poem by one of Pozzatti's younger daughters, Mia and Illica. The poems of these two young women, written at age fifteen and thirteen respectively, recall their experiences with their father during his artist-in-residency in Israel. Arriving during a period of war, the images and words of parent and children reflect both the region's beauty and its hardships, which Pozzatti expressed in the metaphor "a passion flower among thorns."

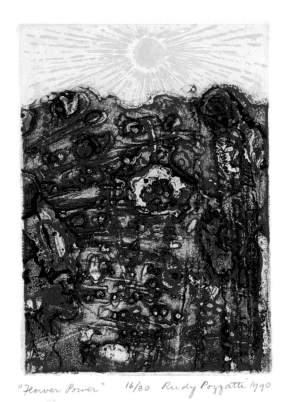

"Flower Power" 16/30 Rudy Pozzatti 1990

"Flower Power"

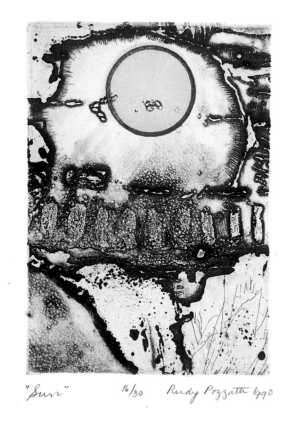

"Sun" 16/30 Rudy Pozzatti 1990

"Sun"

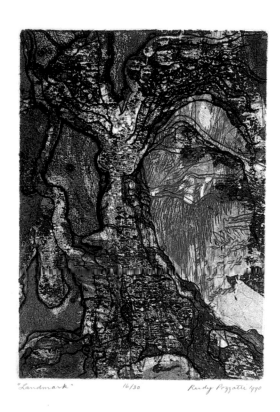

"Landmark" 16/30 Rudy Pozzatti 1990

"Landmark"

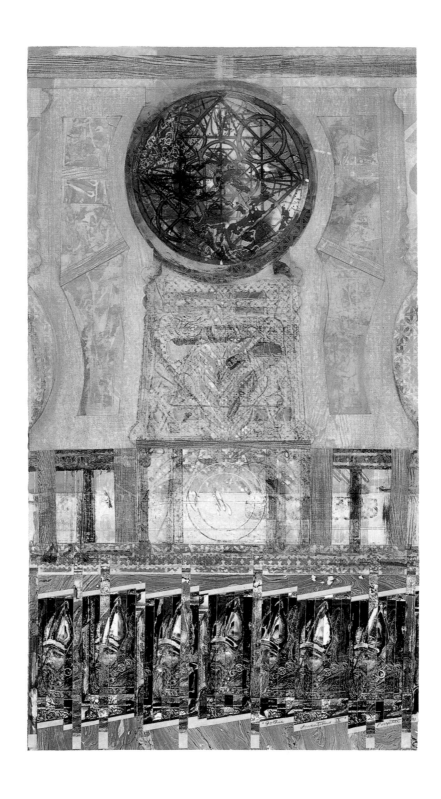

55. Gothic Inventions IX

1991; color zinc-plate etching and wood and matboard relief print with collage (marbleized paper and print remnants) on Mulberry paper, gray Arches paper, and white BFK Rives paper; image/sheet: 39³/4 x 22 (100.9 x 55.9); unique

Pozzatti worked on "Gothic Inventions," a series of ten large mixed-media print/collages, over a long period of time. Utilizing a standardized architectural template, he combined his window motif in the upper register with a playful nod to the religious and political figures of the past in the lower band.

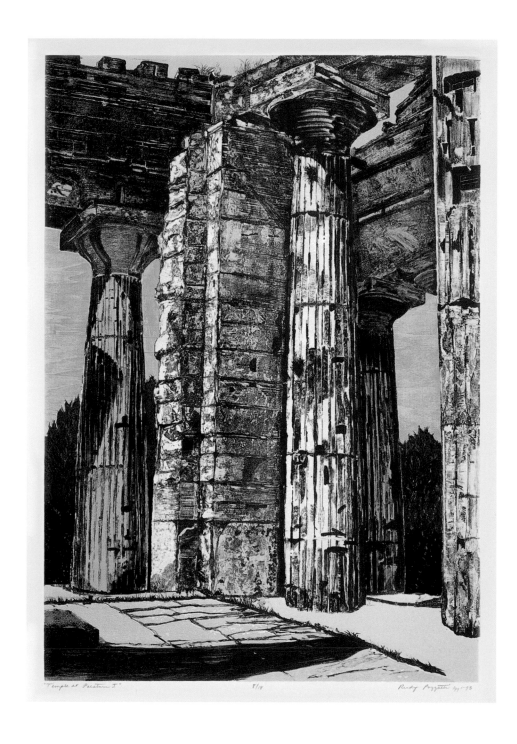

56. Temple at Paestum I
1991, color matboard relief print and transfer lithograph on white BFK Rives
paper; image: 36 x 25 (91.4 x 63.5), sheet: 41^1/$_2$ x 49^3/$_4$ (105.4 x 126.4);
edition of 18

Pozzatti returned to his favorite spot in Italy for a series of four prints on the
subject of the ruins at Paestum. Like the great prints of Giovanni Battista
Piranesi (1720–1778), this image mixes the grandeur of the past with a more
intimate moment in the present.

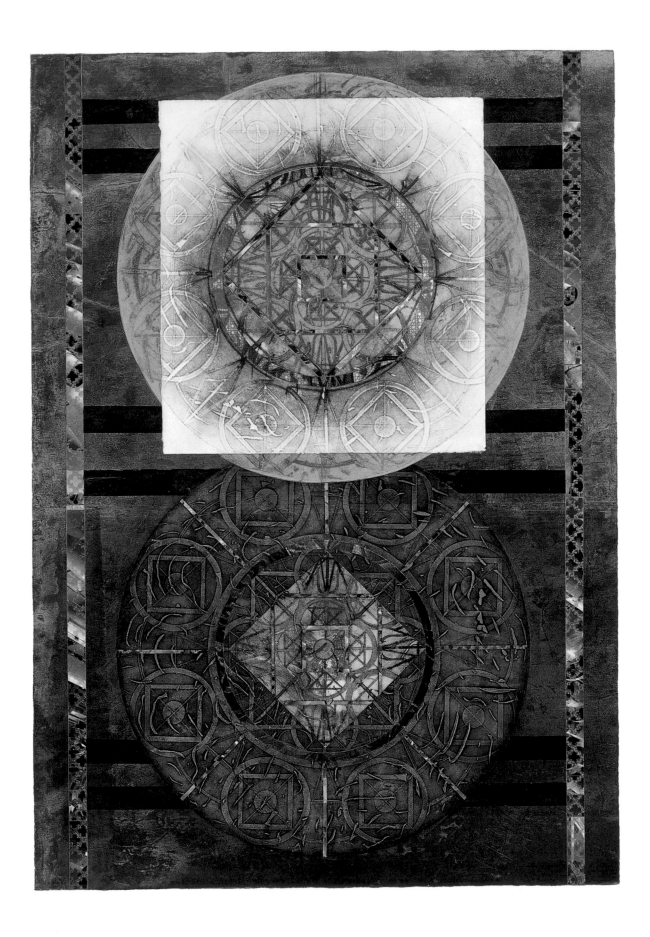

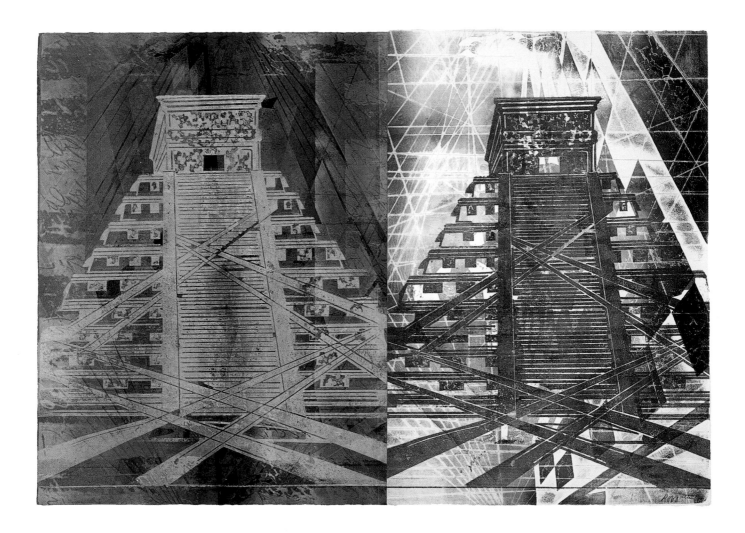

57. Double Circle I
1992; color zinc-plate relief print with handwork, collage, and embossed lead sheet
mounted on matboard; image/sheet: 36 x 25^3/$_{16}$ (91.4 x 64); unique

In an interesting reversal on the use of metal in printing, Pozzatti began experimenting
with thin lead sheets as part of the image itself. After a visiting artist brought a carton
of the material with him to Echo Press, Pozzatti discovered that it was not only easy to
cut into various shapes, but it also took embossing beautifully.

58. Mayan Reality and Fantasy II
1993; color zinc-plate and matboard relief print with blend roll on black Arches (left)
and white Arches (right) paper; image/sheet: 20^1/$_8$ x 28^5/$_8$ (51.1 x 72.7); unique

After a working vacation to the Yucatan Peninsula, including a climb to the top of a
Maya pyramid, Pozzatti began a series of images exploring the myth and majesty of
these ancient peoples through their architecture.

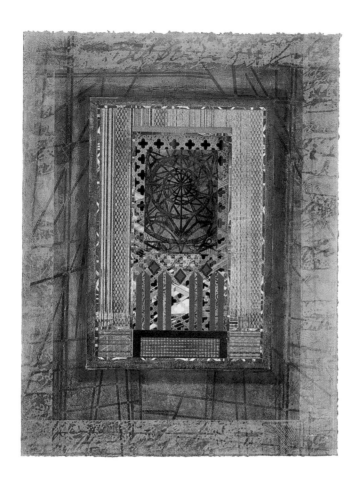

59. Chapel Window XIII
1996; color matboard relief print and collage with handwork on white Arches paper; image/sheet: 20³/₈ x 15¹/₄ (51.8 x 38.7); unique

A trip to Portugal, Spain, and Morocco in 1995 resulted in an ambitious series of fifteen small, jewel-like "chapel" windows. Layered like Persian miniatures, they invite careful examination and calm reflection.

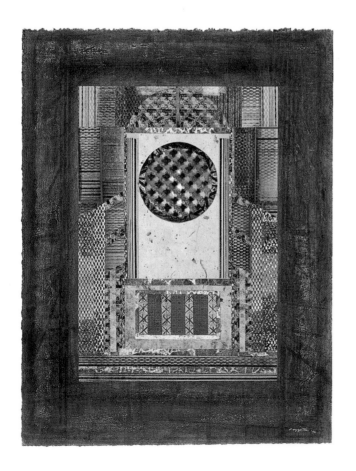

60. Chapel Window XIV
1996; color matboard relief print and collage on white Arches paper; image/sheet: 20³/₈ x 15¹/₈ (51.7 x 38.4); unique

61. Chapel Window XV
1996; color matboard relief print and collage on white Arches paper; image/sheet: 19³/₄ x 15³/₈ (50.2 x 39.4); unique

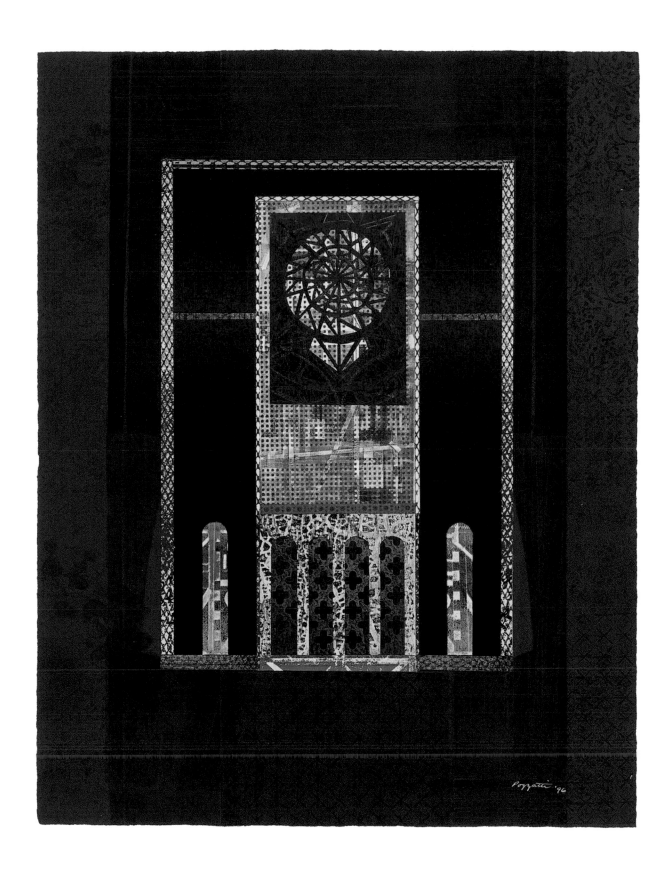

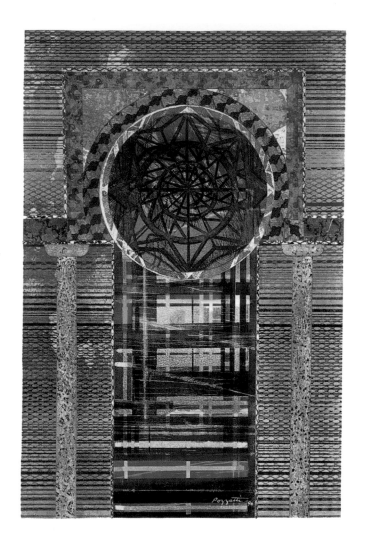

62. Moroccan Inventions X
1996; color matboard relief print and collage on white Arches paper;
image/sheet: 14$^{1}/_2$ x 9$^{9}/_{16}$ (36.8 x 23.5); unique

An intensified interest in pattern and texture emerged following
Pozzatti's visit to Morocco in 1995.

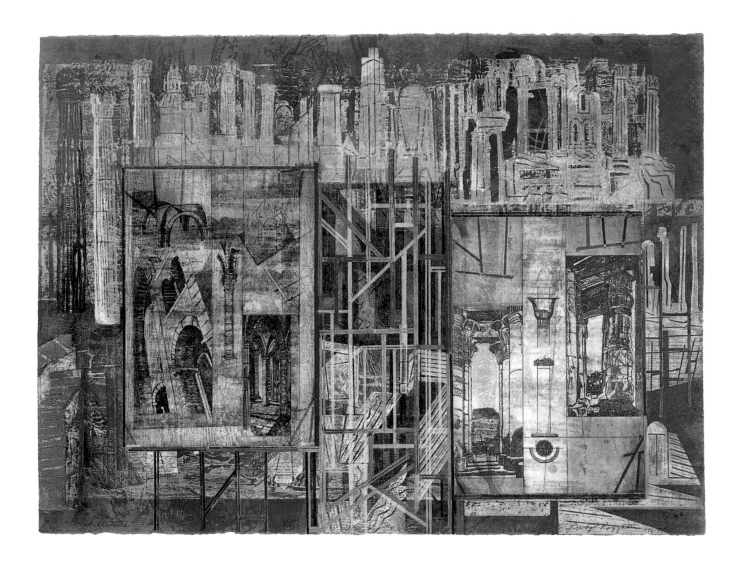

63. Architecture
1996–97; color matboard relief print and woodcut on white Arches paper
with color zinc-plate etching collage on German Etching paper;
image/sheet: 22½ x 30⅛ (67.1 x 76.5); variant edition of 5

Utilizing imagery collaged from earlier prints, this studio assemblage serves
as a summation of Pozzatti's persistent love and admiration for architectural
forms, dating back to his earliest travels to Italy.

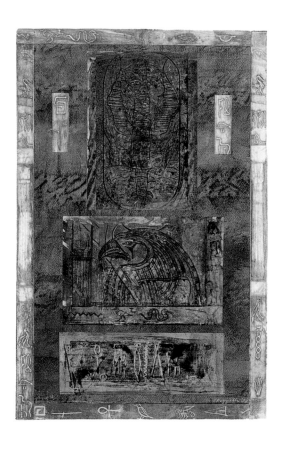

64. Ramses and Falcon
1999; color zinc-plate etching
print collage on German Etching
paper; image/sheet: 19 x 12¹/4
(68.3 x 31.1); unique

This print derives its three
central images, two side panels,
and borders from an earlier
print, *Enigma* (1998), which
was commissioned by the
Rochester Print Club. Pozzatti
frequently recycles his previous
work to create new variations
on a theme. His interest in
Egyptian iconography was
fostered by his fiftieth wedding
anniversary trip.

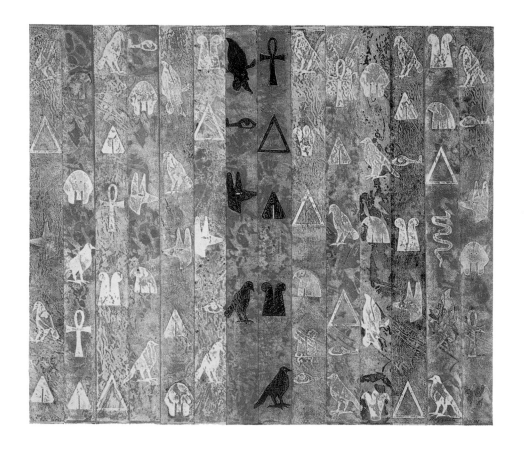

65. Egyptian Scrabble I
2001; color aluminum-plate
relief print with inkless
embossing and aluminum-plate
collage on strips of German
Etching paper; image/sheet:
24 x 28¹/16 (61 x 71.3); unique

From a series of two prints, this
image began to take shape when
Pozzatti looked at the small
metal symbols he was printing
on the press and opted to
include them directly on the
print itself. The title recalls
Pozzatti's lifelong love of word
games, especially crosswords.

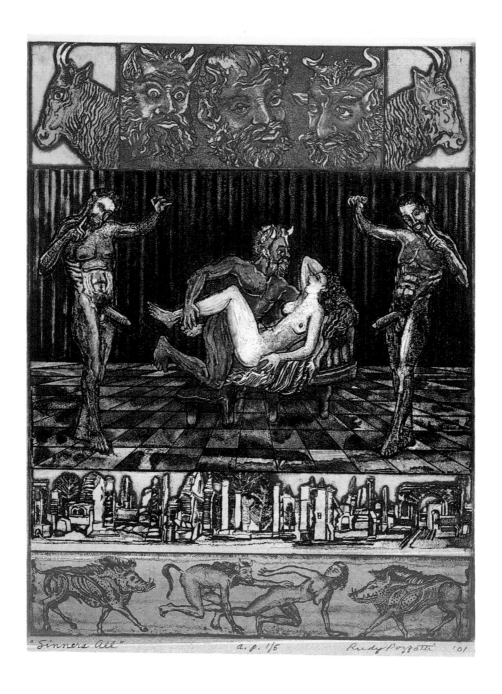

"Sinners All" a.p. 1/5 Rudy Pozzatti '01

66. "Sinners All" from *Saints and Sinners*
2001; color zinc-plate engraving, etching, and aquatint on German Etching paper;
image/sheet: 15 x 10³/₈ (38.1 x 26.3); artist's proof (one of five)

This print is part of an international print symposium, exhibition, and portfolio
sponsored by the Corcoran College of Art and Design. Twenty-five printmakers from
around the world were asked to select a subject relating to the theme of saints and
sinners. Pozzatti, who had long been interested in the struggle of good and evil in
religious subjects, decided to turn instead to the erotic world of Roman mythology—
boars, centaurs, nymphs. He jokingly noted later that, "I'd been a saint for too long."

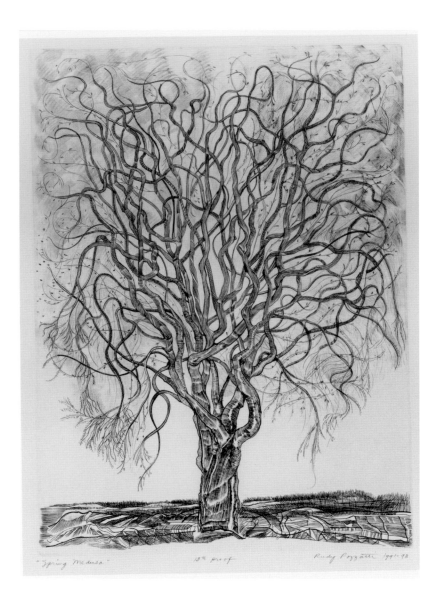

"Spring Medusa" 13th proof Rudy Pozzatti 1991-93

67. Spring Medusa (13th proof)
1991–93; copper-plate engraving with Dremel tool and scraping on German Etching
paper; image: 23¹¹/₁₆ x 17¹¹/₁₆ (60.2 x 44.9), sheet: 30³/₄ x 20⁷/₈
(78.1 x 52.9); unique

68. Spring Medusa
2001; copper-plate engraving with Dremel tool and scraping on German Etching
paper (printed with toned ink); image: 23¹¹/₁₆ x 17¹¹/₁₆ (60.2 x 44.9), sheet: 30¹³/₁₆
x 21 (78.3 x 53.3); not yet editioned

Observed during a walk through his neighborhood with his wife, the contorted limbs
of this magnificent tree inspired Pozzatti to rush back to his studio and grab a
plate. Further "refinements" off and on over the next ten years resulted in more
than thirteen different states (or proofs) before this final version. As Pozzatti noted,
"In between these proofs, I scraped out most of the engraved area under the tree. I
left only the far edge, which meets the horizon. In studying the work, I felt the over-
active area under the tree detracted from the tree itself. It was a big decision after
having cut all the lines, but to me the end result justified the move."

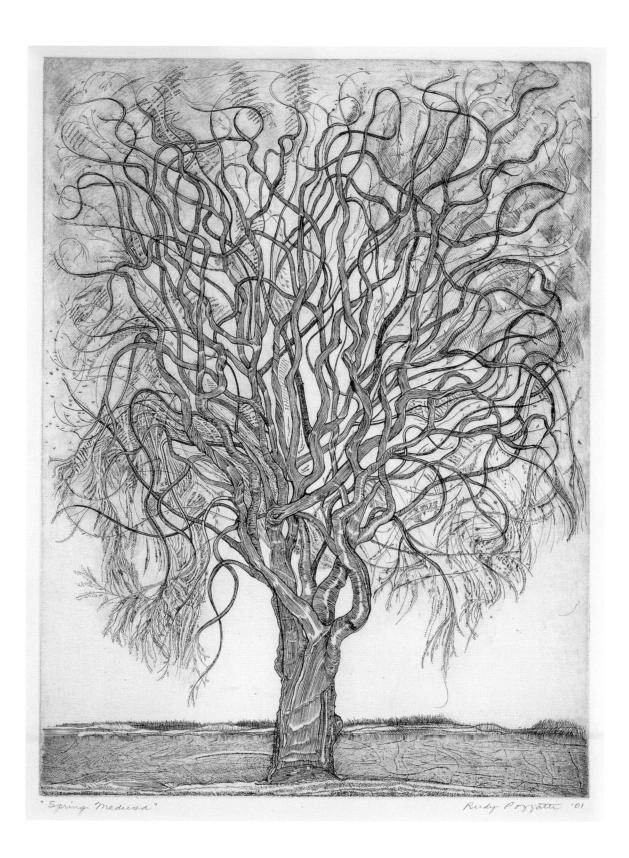

"Spring Medusa" Rudy Pozzatti '01

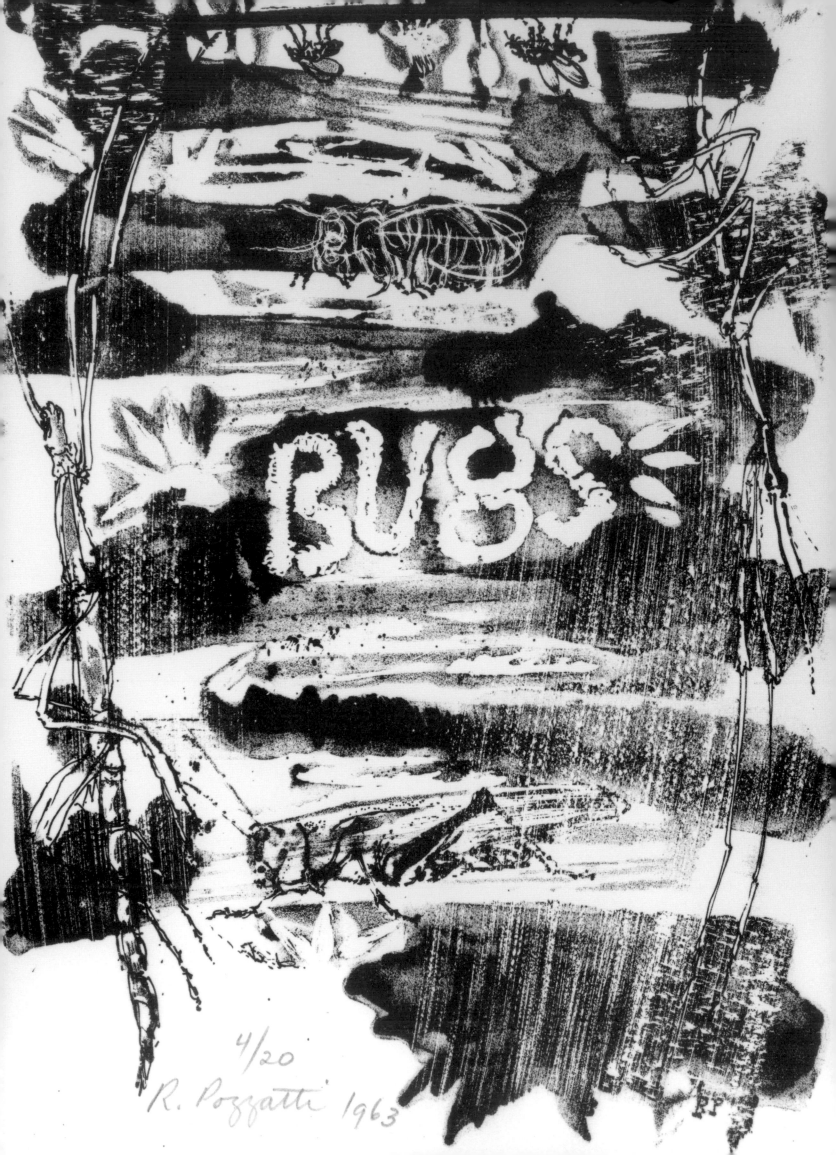

BUGS

4/20
R. Pozzatti 1963

Chronology and Résumé

Born January 14, 1925, Telluride, Colo.
Only son of Italian immigrants, Innocente and
 Mary Mimiolla Pozzatti
Military service, 1943–1946; spent sixteen months overseas
 with the 659th Field Artillery, 7th Army, and fought in
 the Battle of the Bulge
Married his high school sweetheart, Dorothy Bassetti, in
 1946. Five children: Valri Marie, Rudolph Otto, Jr., Gina
 Maria, Mia Ines, and Illica Lara.

Education

1942 Graduated as valedictorian from Silverton High School,
 Silverton, Colo.
1948 B.F.A, University of Colorado, Boulder (began as a
 painting student before the war and discovered print-
 making when he returned to school)
1950 M.F.A, University of Colorado, Boulder
 (studied with Wendell Black, Emilio Amero, Max
 Beckmann, and Ben Shahn)
1973 Doctor of Humane Letters, Honoris Causa, University
 of Colorado, Boulder

Teaching

Graduate Assistant, University of Colorado, Boulder,
 1948–50
Instructor, University of Nebraska, Lincoln, 1950–52
Visiting Professor, University of Colorado, Boulder,
 summer 1951
Instructor, University of Nebraska, Lincoln, 1953–54
Visiting Professor, University of Colorado, Boulder,
 summer 1954
Assistant Professor, University of Nebraska, Lincoln,
 1954–56
Assistant Professor, Indiana University, Bloomington,
 1956–59
Visiting Professor, Yale Summer Art School, Norfolk, Conn.,
 summer 1957
Visiting Professor, Ohio University, Athens, summer 1958
Associate Professor, Indiana University, Bloomington,
 1959–64
Professor, Indiana University, Bloomington, 1964–72
Visiting Professor, Bottega d'Arte Graffica, Florence, Italy,
 summer 1967 (sponsored by the University of Arizona)
Acting Chairman, Fine Arts Department, Indiana University,
 Bloomington, 1968
Visiting Professor, East Texas State University, Commerce,
 summer 1972
Distinguished Professor, Indiana University, Bloomington,
 1972–91
Visiting Professor, Institute of Art, Massa, Italy, summer 1974
 (sponsored by Manhattanville College, Purchase, N.Y.)
Director, Echo Press, Bloomington, Ind., 1979–94 (after
 1979, Pozzatti split his time between his teaching and
 directing Echo Press, a fine arts printmaking workshop,
 which he co-founded with David Keister)
Visiting Professor, UGA Studies Abroad, Cortona, Italy,
 summer 1987 (sponsored by the University of
 Georgia, Athens)
Distinguished Professor Emeritus, Indiana University,
 Bloomington, 1991–

Artist-in-Residence

Honolulu Academy of Arts, Jan.–June 1971
University of Louisville, Jan.–June 1973 (Barry Bingham
 Professor of Humanities)
Fort Wayne Art Institute, Fort Wayne, Ind., March 1974
Northern Illinois University, DeKalb, Nov.–Dec. 1976
Ox-Bow Summer School of Art, Sagatuck, Mich.,
 summer 1977 and Aug. 1982
Reynolda House of American Art, Winston-Salem, N.C.,
 May 1978 and Feb. 1979
Roswell Museum and Art Center, Roswell, N. Mex.,
 Aug. 1979–Aug. 1980
Mishkenot Sha Ananim, Jerusalem, Israel, June 1982

Visiting Artist

University of Manitoba, Winnipeg, Canada, 1972
Skidmore College, Saratoga Springs, N.Y., 1972
S.U.N.Y. at Plattsburg, Plattsburg, N.Y., 1972
East Texas State University, Commerce, 1973 and 1977
Southern Illinois University, Edwardsville, 1973 and 1976
North Texas State University, Denton, 1974
University of South Dakota, Vermillion, 1976 and 1978
University of Nebraska at Omaha, 1976 and 1978
Tulane University, Newcomb College Art Department,
 New Orleans, 1976
Louisiana State University, Baton Rouge, 1977
Eastern Kentucky University, Richmond, 1977
Texas Tech University, Lubbock, 1977 and 1980
Creative Arts Center, University of West Virginia,
 Morgantown, Jan. 1983
University of Houston at Clear Lake City, Tex., March 1983
University of New Mexico, Albuquerque, March 1984
McNeese State University Art Department, Lake Charles, La.,
 Oct. 1984
Wake Forest University Art Department, Winston-Salem,
 N.C., Feb. 1985
Memphis College of Art, May 1986
Ohio Wesleyan University, Delaware, Jan. 1988
College of Santa Fe, summer 1988
University of South Dakota, Vermillion, Feb. 1990
Baylor University, Waco, Tex., Feb. 1994

Grants

Fulbright Grant, Italy, 1952–53 and a travel grant, Italy,
 1963–64
Yale University, Summer School Fellowship, 1955
Indiana University Graduate School Fellowship, Mexico,
 summer 1956
U.S. State Department, Cultural Exchange visit to Soviet
 Union, April–June 1961 (with Jimmy Ernst)
Ford Foundation, Tamarind Lithography Workshop,
 Los Angeles, Feb.–April, 1963
Guggenheim Fellowship, Creative Printmaking, Italy,
 1963–64
U.S. State Department, Cultural Exchange visit to Yugoslavia,
 Sept.–Oct., 1965
Improvement of Teaching Grant, Indiana University,
 summer 1968
Faculty Fellowship for Creative Research, Indiana University,
 summer 1970

S.T.A.G., United States Information Agency, Washington,
 D.C., series of printmaking workshops in Rio de Janeiro,
 San Paolo, and Salvador, Brazil, summer 1974
N.E.A. Grant (Visiting Artists Program), University of
 Missouri, Columbia, with Philip Pearlstein, Frank Gallo,
 and Rudolph de Harak, June 1974
Ford Grant, and Faculty Research and Graduate
 Development Grant, Indiana University, to study tradi-
 tional manner of producing Japanese color woodblock
 prints, Adachi Institute, Tokyo, Japan, May 1981
International Cultural Exchange, Budapest, Hungary,
 Oct. 1985
Rockefeller Grant, Rockefeller Study and Conference Center,
 Bellagio, Italy, Aug. 1995

Honors (Exhibition awards and purchase prizes are listed
under exhibitions.)
Academy of Arts and Letters, New York, 1960
George Norlin Silver Medal for Outstanding Achievement,
 University of Colorado, Boulder, 1974
Indiana Arts Award given by the State of Indiana,
 Governor of Indiana and Indiana Arts Commission,
 Indianapolis, 1981
Elected to National Academy of Design, New York, Oct. 1981
$1,000 Purchase Award, Allen County Library, Ft. Wayne,
 Ind. Work to hang in Allen County Library in honor of
 Robert H.Vegeler, Director Emeritus, 1981
Commencement speaker, at Memphis College of Art, 1985

Memberships
Member of Board of Directors, College Art Association of
 America, New York, 1974–78
Member of Pennell Selection Committee, Library of Congress,
 Division of Prints and Photographs, Washington, D.C.,
 1960s (served for six years)
Member of College Entrance Examination Board for Music
 and Art (Advanced Placement) Educational Testing
 Service, Princeton University, Princeton, N.J., 1976–82

One-man Exhibitions
In addition to the list below, in the1950s, 1960s, and 1970s,
Pozzatti had a number of one-man shows in New York with E.
Weyhe, Inc. (prints and drawings), Martha Jackson Gallery
(paintings and drawings), and Jacques Seligmann (paintings).
Since 1968, Pozzatti has shown regularly in one-man and
group exhibitions at The Gallery in Bloomington, Indiana
(prints, drawings, mixed media, and sculpture).

Exhibitions accompanied by a catalogue or brochure are
indicated with an asterisk; for complete citations, see the
artist's bibliography, pp. 93–105.

1954
Prints and Drawings: Rudy Pozzatti, Art Institute of Chicago,
 Chicago, Feb. 1954

1955
Work of Rudy Pozzatti, Print Club of Cleveland, Cleveland
 Museum of Art, Nov. 2–Dec. 31, 1955 (126 pieces) (A
 selection from the exhibition was circulated by the
 Smithsonian Institution, Washington, D.C., 1956–57)*

1956
The Graphic Arts of Rudy Pozzatti, University of Maine Art
 Gallery, Orono, Nov. 1–30, 1956
Painting and Graphics by Pozzatti, Gump's Gallery, San
 Francisco, Sept. 1–Oct. 1, 1956*

1957
Rudy Pozzatti, Blanden Gallery, Fort Dodge, Iowa,
 June 1–30, 1957
Work by Rudy Pozzatti, Art Center Gallery, Indiana
 University, Bloomington, Feb. 25–March, 1957
 (61 pieces)*

1958
Paintings, Prints & Drawings by Rudy Pozzatti, University
 Gallery, Northrop Memorial Auditorium, Minneapolis,
 Sept. 29–Oct. 31, 1958

1959
Rudy Pozzatti—An Exhibition of Drawings and Prints,
 Moreau Gallery, St. Mary's College, Notre Dame, Ind.,
 April 12–30, 1959

1960
Pozzatti, Walker Art Center, Minneapolis, March 6–April 17,
 1960 (68 pieces)*

1961
Pozzatti, Fine Arts Gallery, Jewish Community Center of
 Greater Washington, Washington, D.C., Jan. 7–21, 1961
 (12+ pieces)*

1962
Paintings, Drawings and Graphics by Rudy Pozzatti, Robert
 Schuenke Fine Arts, Milwaukee, Oct. 1962*
Pozzatti, Allen R. Hite Art Institute, University of Louisville
 Library, Nov. 20, 1962–Jan. 4, 1963 (39 pieces)*

1963
Pozzatti: Prints and Drawings, University Art Gallery,
 Michigan State University–Oakland, Rochester,
 Jan. 16–Feb. 28, 1963 (35 pieces)*

1964
*Italy 1964: Prints, Drawings, Sculpture, and Paintings by
 Rudy Pozzatti*, Indiana University Art Museum,
 Bloomington, Oct. 18–Nov. 15, 1964
Recent Prints by Rudy Pozzatti, Philadelphia Print Club,
 Nov. 6–27, 1964 and Weyhe Gallery, New York,
 Nov. 1964
Rudy Pozzatti: Incisioni, litografie, Galleria Mazzuchelli,
 Florance, Italy 1964*

1965
Rudy Pozzatti Graphics, Everson Museum, Syracuse, N.Y.,
 April–May 6, 1965
Rudy Pozzatti: Paintings and Prints, Forsythe Gallery, Ann
 Arbor, June 14–July 8, 1965*

1966

An Exhibition of Recent Paintings by Rudy Pozzatti, J. B.
Speed Art Museum, Louisville, May 17–June 19, 1966
(39 pieces)*

New Prints and Drawings by Rudy Pozzatti, Weyhe Gallery,
New York, 1966*

Paintings and Graphic Art by Pozzatti/66,
Nelson-Atkins Gallery, Kansas City, Mo., Oct. 9–Nov. 6,
1966 (67 pieces)

1967

Bronzes, Painting and Graphic Art by Pozzatti/67,
Jane Haslem Gallery, Madison, Wis.,
Nov. 7–Dec. 4, 1967 (48 pieces)*

Pozzatti, Merida Gallery, Louisville, 1967*

Pozzatti: A One-Man Show of Recent Prints, Capper's Gallery,
San Francisco, Dec. 6, 1967–Jan. 6, 1968

Rudy Pozzatti: Drawings and Graphics,
Kalamazoo Institute of Arts, Jan. 3–Feb. 12, 1967
(81 pieces)*

1968

The Graphic Art of Rudy Pozzatti, Fine Arts Festival,
Southwest Texas State College, San Marcos,
March 1–6, 1968*

[Rudy Pozzatti], Galerie Daberkov, Frankfort, Germany, 1968

Rudy Pozzatti, Southwestern Michigan College Art Gallery,
Dowagiac, March 19–April 15, 1968*

1969

Graphic Art of Rudy Pozzatti, Nebraska Art
Association/Sheldon Memorial Art Museum, University of
Nebraska, Lincoln, Oct.–Nov. 1969 (125 pieces/ twenty
year retrospective)*

1970

Prints by Rudy Pozzatti, Art Museum, University
of Manitoba, Winnipeg, Canada, Nov.–Dec. 1970
(40 pieces)

Recent Prints and Collages: Rudy Pozzatti, Weyhe Gallery,
New York, 1970 (exhibition catalogue, illus.)

1971

Prints by Rudy Pozzatti, Honolulu Academy of Arts,
Feb. 4–March 7, 1971 (48 pieces)*

1972

Rudy Pozzatti, Gloria Luria Gallery, Miami, Fl., 1972*

1973

Prints and Other Media, J. B. Speed Art Museum, Louisville,
March, 1973

1974

Rudy Pozzatti, Festival of the Arts, Franklin College,
Franklin, Ind., March 21–29, 1974*

Rudy Pozzatti, Galeria do Instituto Brasil Estados Unidos,
1974

Rudy Pozzatti: Gravador americano, The Museum of Modern
Art, Rio de Janeiro, Brazil, May–June 1974*

1975

Pozzatti, Goshen College Art Gallery, Goshen, Ind.,
Nov. 2–23, 1975

Rudy Pozzatti: Mid-States Tour, organized by Iowa State
University, Ames, Sept. 1975–March 1977 (30 pieces)*

Works on Paper: Rudy Pozzatti, Jane Haslem Gallery,
Washington, D.C., 1975*

1976

Rudy Pozzatti, Johnson-Whitty Gallery, New Orleans, 1976*

1977

Prints and Bronzes, Cushing Galleries, Dallas, spring 1977

Rudy Pozzatti: Watercolor—Collages—Prints, Commons
Galleries, Columbus, Ind., Feb. 1977

1979

Prints, Watercolors, and Sculpture by Rudy Pozzatti, Sheldon
Swope Art Gallery, Terre Haute, Ind., Jan. 12–Feb. 11,
1979 (50 pieces)*

1980

*New Work by Rudy Pozzatti: Prints, Mixed Media, and
Sculpture*, Sheldon Swope Art Gallery, Terre Haute, Ind.,
Dec. 5, 1980–Jan. 4, 1981 (42 pieces)*

Rudy Pozzatti, Tower Park Gallery, Peoria Heights, Ill.,
Oct. 5–31, 1980*

*Rudy Pozzatti: Prints, Mixed Media, Drawings, and
Sculpture*, Roswell Museum and Art Center, Roswell,
N. Mex., July 6–Aug. 3, 1980 (52 pieces)*

1982

[Pozzatti], Hunter Museum & University of Tennessee,
Chattanooga, Jan.–Feb. 1982

[Pozzatti], Western Illinois University, Macomb, Feb. 1982

Pozzatti, Shircliff Gallery, Vincennes University, Vincennes,
Ind., March 22–April 16, 1982

[Pozzatti], University of West Virginia, Fine Arts Museum,
Morgantown, Nov. 1982

[Pozzatti], Merida Galleries, Louisville, Nov. 14–Dec. 2,
1982

[Prints by Pozzatti], New American Center Modern Art
Gallery, Belgrade, Yugoslavia, spring 1982 (30 pieces)

Rudy Pozzatti: A Retrospective Exhibit, Southern Illinois
University, Carbondale, Jan. 18–Feb. 18, 1982*

1983

Prints, B. K. Smith Gallery, Lake Erie College, Painesville,
Ohio, Nov. 11–Dec. 10, 1983

Prints and Mixed Media, Evansville Museum of Art,
Evansville, Ind., June 26–Sept. 6, 1983 (40 pieces)

1984

New Works by Rudy Pozzatti, Griffin Gallery, Cincinnati,
Jan.–Feb. 1984

[Pozzatti], New Cultural Art Center, American Embassy,
Belgrade, Yugoslavia, Jan. 5–Feb. 5, 1984 (20 pieces)

[Pozzatti], McNeese State University, Art Gallery, Lake
Charles, La., Oct.–Nov. 1984

[Pozzatti], J. B. Speed Art Museum, Louisville,
Dec. 1984–Jan. 1985

1985

An Exhibition of the Works of Rudy Pozzatti, Printmaker, Fort Wayne Museum of Art, Fort Wayne, Ind., May 11–June 9, 1985*

Partial Retrospective, Norton Center, Center College, Danville, Ky., Jan.–Feb. 1985

[*Pozzatti*], Adair Margo Gallery, El Paso, Tex., Dec. 1985

Prints and Mixed Media, University of Evansville, Art Gallery, Evansville, Ind., Jan. 1985

Recent Works–Rudy Pozzatti, Mankato State University, Mankato, Minn., March 19–April 18, 1985*

Rudy Pozzatti, New Works: Collages, Alice Simsar Gallery, Ann Arbor, Jan. 12–Feb. 13, 1985*

Stations of the Cross, St. Meinrad Abbey, St. Meinrad, Ind., Lenten Season and Easter, 1985

1986

Pozzatti, Sioux City Art Center, Sioux City, Iowa, Feb. 16–March 23, 1986*

Prints, Memphis College of Art, Fine Arts Museum, April 1986

Prints, Watercolors, Drawings, Hayden Gallery, Lincoln, Nebr., Oct. 1986

1987

Rudy Pozzatti: One-Man Exhibit, Art Association of Richmond, Richmond, Ind., Oct. 11–Nov. 1, 1987

Vignettes of Cortona, Indiana University School of Fine Arts Gallery, Bloomington, Nov. 5–9, 1987

1988

Prints and Mixed Media, Neville-Sargent Gallery, Chicago, May 20–June 11, 1988

Recent Works by Rudy Pozzatti, Tarble Arts Center, Charleston, Ill., Sept. 23–Oct. 22, 1988

1989

[*Pozzatti*], Southeastern Graphic Arts Association, Austin, Tex., March 1989 (Printmaker Emeritus Award, $2,000)

Recent Works by Rudy Pozzatti, Snite Museum of Art, Notre Dame, Ind., Jan. 22–March 5, 1989

Rudy O. Pozzatti: A Retrospective Exhibition, Southwestern University, Georgetown, Tex., Feb. 8–28, 1989, and St. Edwards University, Austin, Tex., March 8–26, 1989*

1992

Rudy Pozzatti: Four Decades of Printmaking, Mitchell Museum, Mt. Vernon, Ill., April 26–June 28, 1992 (Exhibition traveled to five other sites in Illinois, Indiana, Kentucky, and Texas) (82 pieces)*

Undated One-Man Exhibitions

Drawings by Rudy Pozzatti, The Elsie Allen Art Gallery, Baker University, Baldwin, Kan., Dec. 1–15

Pozzatti, Clayton Junior College Libraty, Morrow, Ga.

Rudy Pozzatti Prints, Sioux City Art Center, Sioux City, Iowa, May 7–25

Group Exhibitions
1951

One Hundred and Forty-Sixth Annual Exhibition of Painting and Sculpture, Pennsylvania Academy of Fine Arts, Philadelphia, Jan. 23–Feb. 25, 1951*

Third Biennial Exhibition of Paintings and Prints from the Upper Midwest, Walker Art Center, Minneapolis, Oct. 28–Dec. 30, 1951 (Purchase Award)*

1952

All Nebraska Exhibition, Joslyn Art Museum, Omaha, Oct. 7–Nov. 2, 1952 and University Art Galleries–Morrill Hall, Lincoln, Nebr., Nov. 21–Dec. 29, 1952 (Honorable Mention)*

Contemporary Drawings from 12 Countries (1945–1952), Art Institute of Chicago, 1952*

Fiftieth Annual Exhibition—Watercolors—Prints—Drawings, Pennsylvania Academy of the Fine Arts and the Philadelphia Water Color Club, Philadelphia, Oct.19–Nov. 23, 1952*

Fifty-Eighth Western Annual Exhibition, Denver Art Museum, Denver, June 2–31, 1952*

Nineteen-fifty-two Annual Exhibition of Contemporary American Painting, Whitney Museum of American Art, New York, Nov. 6–Jan. 4, 1952–53*

Regional Paintings: Friends of Art Second Biennial, Kansas State College, Manhattan, March 30–April 20, 1952*

Seventeenth Annual New Years Show, Butler Art Gallery, Youngstown, Ohio, Jan. 1–27, 1952 (Purchase Prize)*

Sixteenth Annual Drawing and Print Exhibition of the San Francisco Art Association, San Francisco Museum of Art, May 8–June 1, 1952*

Sixth National Print Annual Exhibition, Brooklyn Museum, New York, March 19–May 18, 1952*

Tenth National Exhibition of Prints Made during the Current Year, Library of Congress, Washington, D.C., May 1–Aug. 1, 1952*

Twenty-Second Annual Exhibition, Springfield Art Museum, Springfield, Mo., March 31–April 26, 1952*

1953

Fifth-First Annual Exhibition: Watercolors, Prints, Drawings, Pennsylvania Academy of the Fine Arts and the Philadelphia Water Color Club, Philadelphia, Oct. 18–Nov. 22, 1953*

Fourteen American Artists, American Library Exhibition Hall, Via Veneto, Rome, Italy, March 1953

Fourteenth Artists West of the Mississippi, Colorado Springs Fine Arts Center, March 8–April 28, 1953*

Nineteen-Fifty-Three Baltimore National Water Color Exhibition, Baltimore Art Museum, Feb. 3–March 8, 1953*

Seventh Annual Exhibition of Oil Painting by Artists of the Missouri Valley, Mulvane Art Museum, University of Topeka, Nov. 11–Dec. 18, 1953*

Young American Printmakers, Museum of Modern Art, New York, Nov. 25, 1953–Jan. 24, 1954*

1954

American Drawing Annual XII, Norfolk Museum, Norfolk, Va., Feb. 5–28, 1954*

American Painting 1954, Virginia Museum of Fine Arts, Richmond, Feb. 26–March 21, 1954 and Des Moines Art Center, April 4–May 2, 1954*

College Prints 1954, Butler Art Institute, Youngstown, Ohio, May 2–24, 1954*

Exhibition of Western Art, Schleier Gallery, Denver Art Museum, June 14–Aug. 1, 1954*

Fourth Biennial Exhibition of Paintings and Prints, Walker Art Center, Minneapolis, Jan. 17–March 7, 1954*

Friends of Art: Third Biennial Regional Exhibition, Kansas State College, Manhattan, April 11–May 1, 1954*

Graphic Arts USA, University of Illinois, Champaign, Feb. 7–March 7, 1954*

Midwestern Painters, Department of Art Education Gallery, University of Wisconsin, Madison, March 24–30, 1954*

National Prize Print Exhibition, Dallas Print Society, Dallas Museum of Fine Arts, July 4–Sept. 12, 1954*

Nineteenth Annual Midyear Show, Butler Institute of American Art, Youngstown, Ohio, July 1–Sept. 1, 1954*

One Hundred and Forty-Ninth Annual Exhibition of Painting and Sculpture, Pennsylvania Academy of the Fine Arts, Philadelphia, Jan. 24–28, 1954*

Paintings for Young Collections, Dallas Museum of Fine Arts, Dec. 20, 1954 –Jan. 1, 1955*

Second Invitational Print Exhibition, University Gallery, Department of Art, University of Minnesota, Minneapolis, 1954*

Thirteenth Annual Missouri Exhibition, City Art Museum, St. Louis, Feb. 15–March 15, 1954*

Twelfth National Exhibition of Prints Made during the Current Year, Library of Congress, Washington, D.C., May 1–August 1, 1954*

Twenty-Sixth International Exhibit, Northwest Printmakers, Seattle Art Museum, March 10–April 4, 1954*

Twenty-Third Annual Graphic Arts and Drawing Exhibition, Wichita Art Association, Jan. 10–Jan. 31, 1954*

Younger American and European Painters, Martha Jackson Gallery, New York, May 18–June 12, 1954

1955

Annual Exhibition, Paintings, Sculpture, Watercolors, Drawings, Whitney Museum of Art, New York, Jan. 12–Feb. 20, 1955*

El Arte moderno en los Estadoc Unidos: III Bienal hispanoamericana de arte, Museo de Arte Moderno, Barcelona, Spain, Sept. 24–Oct. 24, 1955*

Brooklyn Museum Ninth National Print Annual, Brooklyn Museum, New York, April 27–June 26, 1955*

Exhibition of Contemporary Liturgical and Religious Art, Denver Art Museum, 1955*

Fifteenth Artists West of the Mississippi, Colorado Springs Fine Arts Center, 1955*

First Graphics Exhibition, Texas Western College, El Paso, Nov. 1–20, 1955*

First National Exhibition of Prints, Bay Printmakers Society, Oakland Art Museum, Nov. 12–Dec. 4, 1955*

Fortieth Anniversary Exhibition, Print Club, Philadelphia, 1955 (Mildred Boericke Award)*

Fourteenth Annual Missouri Exhibition, City Art Museum, St. Louis, March 7–April 14, 1955*

International Invitational Print Exhibition, Washington University, St. Louis, Nov. 2–23, 1955*

Nineteenth Annual All Nebraska Show of Nineteen-Fifty-Five, Joslyn Memorial Art Museum, Omaha, Nov. 3–27, 1955 (Honorable Mention)*

Ninth Annual Exhibition of Oil Painting by Artists of the Missouri Valley, Mulvane Art Museum, Washburn University, Topeka, Nov. 19–Dec. 16, 1955*

Northwest Printmakers Twenty-Seventh International Exhibition, Seattle Art Museum, March 10–April 3, 1955*

Siouxland Watercolor Show, Sioux City Art Center, Oct. 17–Nov. 4, 1955*

Sixty-First Western Annual, Denver Art Museum, June 13–Aug. 3, 1955**Twentieth Annual Midyear Show,* Butler Institute of American Art, Youngstown Ohio, July 1–Sept. 1, 1955*

Twenty-Fourth Annual American Graphic Arts and Drawing Exhibition, Wichita Art Association, Jan. 9–31, 1955*

Twenty-Seventh International Exhibition, Northwest Printmakers, Seattle Art Museum, March 10–April 3, 1955 (First Prize)

1956

Brooklyn Museum Tenth National Print Annual, Brooklyn Museum, New York, 1956*

Contemporary Arts of United States: A National Exhibition, Los Angeles County Fair, Pomona, Calif., Sept. 14–30, 1956*

Contemporary Painting, Fine Arts Gallery, University of Colorado, Boulder, June 27–Aug. 19, 1956*

Festival of Religious Art Exhibit, Ohio Union, Ohio State University, Columbus, Jan. 8–29, 1956*

Fifteenth Annual Missouri Exhibition, City Art Museum, St. Louis, Feb. 13–March 12, 1956*

Fifty Contemporary Printmakers, Second Biennial Exhibition, University of Illinois, Champaign/Urbana, March 4–25, 1956

Forty-Seven Midwestern Printmakers, 1020 Art Center, Chicago, Feb. 28–April 1, 1956*

IV Mostra internazionale di bianco e nero, Lugano, Italy, March 29–June 10, 1956*

Fourteenth National Exhibition of Prints Made during the Current Year, Library of Congress, Washington, D.C., May 1–Sept. 1, 1956*

Fourth Midwest Biennial, Joslyn Art Museum, Omaha, 1956 (Honorable Mention)*

Fourth Regional Friends of Art Biennial, Kansas State College, Manhattan, Feb. 19–March 10, 1956 (Recommended for Purchase)*

International Invitational Print Exhibition, University of Minnesota, Minneapolis, Jan. 6–27, 1956*

Leroy Burket/Rudy Pozzatti, Museum of Art, University of Oklahoma, Norman, Nov. 4–28, 1956 (included 27 pieces by Pozzatti)*

Nineteen-Fifty-Six Annual Exhibition of Contemporary American Sculpture, Watercolors and Drawings, Whitney Museum of American Art, New York, April 18–June 10, 1956*

Nineteen-Fifty-Six Biennial of Paintings, Prints and Sculpture from the Upper Midwest, Walker Art Center, Minneapolis, May 13–summer 1956*

Northwest Printmakers Twenty-Eighth International Exhibition, Seattle Art Museum, March 28–April 22, 1956*

Recent Drawings USA, Museum of Modern Art, New York, April 25–Aug. 5, 1956*

Rudy Pozzatti/M.J. Kitzman, Sioux City Art Center, May 7–25, 1956

Sixth Mid-America Annual Exhibition, Nelson Gallery-Atkins Museum, Kansas City, Mo., May 10–June 10, 1956*

Sixty-Second Annual for Western Artists, Denver Art Museum, June 11–July 30, 1956*

University of Nebraska Art Facility Exhibition, Miller and Paine Auditorium, Lincoln, Feb. 13–18, 1956

1957

American Drawing Annual XVI, Norfolk Museum, Norfolk, Va., Dec. 1–31, 1957*

Ball State College Drawing and Small Sculpture Show, Ball State Galleries, Muncie, Ind., March 1957 (Purchase Prize, Honorable Mention)

Bay Printmakers Society Third National Exhibition of Prints, Oakland Art Museum, Oct. 5–27, 1957*

Church Art Today: An Exhibition of Contemporary Ecclesiastical Arts, Grace Cathedral, San Francisco, Dec. 1–22, 1957*

Eighth Annual Michiana Regional Art Exhibition, South Bend Art Association, South Bend, Ind., March 10–31, 1957* (Purchase Prize)

Festival of Religious Art Exhibit, Ohio Union, Ohio State University, Columbus, Jan. 20–Feb. 9, 1957*

First National Print Exhibition, Hunterton County Art Center, Clinton, N.J., Jan. 20–Feb. 28, 1957*

IV Biennale di pittura americana, Citta' di Bordighera Palazzo del Parco, May 25–June 23, 1957*

One-Hundred-Fifty-Second Annual Exhibition (Water Colors, Prints and Drawings), Pennsylvania Academy of the Fine Arts, Philadelphia, Feb 1957

Society of Washington Printmakers Twenty-First Exhibition, United States National Museum, Washington, D.C., Jan. 4–27, 1957*

Third Annual Drawings and Small Sculpture Show, Ball State Teachers College, Muncie, Ind., March 1957*

1958

Bay Printmakers Society Fourth National Exhibition, Oakland Art Museum, Nov. 1958*

Boston Printmakers Eleventh Annual Exhibition, Museum of Fine Arts, Boston, Oct. 7–Nov 4. 1958 (Paul Sachs Award)*

Exhibition of Recent Paintings and Prints by Leon Golub, Harry Engel and Rudy Pozzatti, Art Center Gallery, Louisville, Oct. 1–21, 1958

Festival of the Arts Nineteen-Fifty-Eight, Milliken University, Decatur, Ill., April 21–May 14, 1958*

Fifth Friends of Art Biennial Regional Exhibition, Kansas State College, Manhattan, March 2–17, 1958*

First Provincetown Arts Festival: American Art of Our Time, July 15–Aug. 17, 1958*

Fourth Annual Drawing and Small Sculpture Show, Ball State Teachers College Art Gallery, Muncie, Ind., March 1958*

Fourth Biennial Exhibition: 50 Indiana Artists, John Herron Art Museum, Indianapolis, May 11–June 8, 1958*

Fourth Biennial Indiana Printmakers Exhibition, John Herron Art Museum, Indianapolis, May 11–June 8, 1958

Midwestern University Print-Makers, University of Kansas Museum of Art, Lawrence, March 7–April 15, 1958*

Music and Art, University of Minnesota Art Gallery, Minneapolis, April 4–May 18, 1958, and Grand Rapids Art Gallery, Grand Rapids, Mich., June 15–July 29, 1958*

Nineteen-Fifty-Eight Louisville Art Center Annual Exhibition of Art, J. B. Speed Museum, Louisville, 1958*

Ninth Michiana Regional Art Exhibition, Paintings—Prints—Drawings, Art Center, South Bend, Ind., March 16–April 16, 1958*

Original Prints in Limited Editions, Milton Okrent Co., Cincinnati, Oct. 20–Nov. 1, 1958

Prima bienal interamericana de pintura y grabado, Instituto Nacional de Bellas Artes, Mexico, June 6–Aug. 20, 1958*

Second Interior Valley Competition, Contemporary Arts Center, Cincinnati Art Museum, May 18–Aug. 20, 1958 (Honorable Mention)*

Second National Print Exhibition, Hunterton County Art Center, Clinton, N.J., Jan. 26–Feb. 28, 1958*

Sixteenth National Exhibition of Prints Made during the Current Year, Library of Congress, Washington, D.C., May 1–Sept. 1, 1958

Tenth Anniversary Exhibition: Current Painting Styles and Their Sources, Des Moines Art Center, June 1–July 20, 1958*

Third Biennial Invitational Exhibition, Recent American Prints, University of Illinois, Champaign, Feb. 16–March 16, 1958*

Twenty-Second Exhibition, Society of Washington Printmakers, U.S. National Museum, Washington, D.C., Jan. 26–Feb. 16, 1958

What Makes a Print? An Exhibition of Etchings, Woodcuts, Engravings, Lithographs, Silk Screen Prints, Junior Art Gallery, Louisville, Nov. 18–Dec. 13, 1958*

1959

American Drawing Annual XVII, Norfolk Museum, Norfolk, Va., Feb. 1–March 1, 1959*

College Artist-Teachers' Print Exhibition, Philadelphia Art Alliance, Feb. 26–March 29, 1959

Contemporary Graphics, Memorial Union Building, University of Maine, Orono, March 9–April 6, 1959

Eleven American Printmakers, Pennsylvania State University, University Park, Nov. 21–Dec. 10, 1959*

Exhibition of Original Signed Prints by American Award Winning Artists, Jack Soles Gallery, Olympia, Wash., April 6–19, 1959

Graphics '59, University of Kentucky Art Gallery, Lexington, Nov. 22–Dec. 19, 1959, and Jan. 6–20, 1960*

La Gravure américaine d'aujourd'hui/American Prints Today, Print Council of America, Centre Culturel Américain, ca. 1959*

Italian American Painters, Harry Salpeter Gallery, New York, Nov. 3–30, 1959*

Nineteen-Fifty-Nine Louisville Art Center Annual Exhibition of Art, Art Center Association of Louisville, J. B. Speed Museum, Louisville, April 1–30, 1959*

Oklahoma Printmakers Society First National Exhibition of Contemporary American Graphic Art, Oklahoma City University, Feb. 15–April 1, 1959*

One-Hundred-and-Fifty-Fourth Annual Exhibition: Watercolors, Prints and Drawings, Pennsylvania Academy of the Fine Arts, Philadelphia, Jan. 25–March 1, 1959*

Prints and Printmakers, University of Michigan, Ann Arbor, 1959 (Symposium and Exhibition)

Prints by College Artist-Teachers, Philadelphia Art Alliance, Feb. 26–March 29, 1959*

Seventeenth National Exhibition of Prints Made during the Current Year, Library of Congress, Washington, D.C., May 1–Sept. 1, 1959*

Xylon: 3rd Internationale Ausstellung von Holzschnitten, Museum zu Allerheiligen, Schafhausen, Switzerland, Nov. 21, 1959–Jan. 10, 1960*

1960

Bay Printmakers Society Fifth National Exhibition, Oakland Art Museum, 1960*

Drawing: I. A. E. A. Directions, Illinois Art Education Association, Chicago, 1960*

An Exhibition of Prints by Invitation, Brooks Memorial Art Gallery, Memphis, April 3–25, 1960*

Fifty Indiana Prints, John Herron Art Museum, Indianapolis, May 15–June 15, 1960*

Print Festival: Contemporary American Etchings, Lithographs, Serigraphs, Woodcuts, Lawrence Drake Gallery, Carmel, Calif., Nov. 28–Dec. 30, 1960

Twenty-Ninth Annual American Graphic Arts and Drawing Exhibition, Wichita Art Association, Jan. 8–Feb. 1, 1960

Young America 1960, Whitney Museum of American Art, New York, Sept. 14–Oct. 30, 1960 (Exhibition traveled to Baltimore, Cincinnati, St. Louis, and Columbus, Nov. 16, 1960–June 5, 1961)*

1961

Boston Printmakers Fourteenth Annual Print Exhibition, Museum of Fine Arts, Boston, Oct. 31–Dec. 3, 1961 (Paul J. Sach Award)*

Centennial Exhibition American Association of Land Grant Colleges and Universities, Nelson Gallery and Atkins Museum, Kansas City, Mo., Nov. 12–Dec. 3, 1961*

Drawings/USA: First Biennial Exhibition, St. Paul Gallery and School of Art, St. Paul, Minn., Nov. 1961–Jan. 1962 (Exhibition also traveled to Pensacola, Fla., Madison, Wis., and Nashville, Tenn.)*

Fifth American Printmakers, DeCordova and Dana Museum, Lincoln, Mass., April 3–June 11, 1961*

IV Exposition internationale de gravure, Museum of Ljubljana, Yugoslavia, 1961

Grabados Originales, Coleccion Pennell, Biblioteca del Congreso de los EE, UU, Centre El Salvador, Estados Unidos, San Salvador, Central America, Oct. 2–14, 1961*

Graphics 61, University of Kentucky Art Gallery, Lexington, 1961*

Third Annual Contemporary American Printmakers, DePauw University, Greencastle, Ind., March 5–April 5, 1961*

Third Interior Valley Competition: Painting, Sculpture, Drawing, Contemporary Arts Center, Cincinnati Art Museum, May 27–Aug. 10, 1961*

Third National Exhibition, Oklahoma Printmakers Society, Oklahoma Art Center, Oklahoma City, April 16–May 14, 1961*

Ultimate Concerns, Second National Exhibit, Ohio University Gallery, Athens, 1961*

1962

American Printmakers 1962, Syracuse University, Jan. 21–Feb. 21, 1962*

Fifty Indiana Prints: Sixth Biennial Exhibition, Herron Museum of Art, Indianapolis, May 13–June 10, 1962*

Fifty-Fifth Annual Indiana Artists Exhibition, Herron Museum of Art, Indianapolis, April 29–May 27, 1962*

First National Invitational Print Exhibition, Otis Art Institute of Los Angeles County, Los Angeles, Jan. 11–Feb. 25, 1962*

Fourth Annual Contemporary American Printmakers Exhibition, Art Center, DePauw University, Greencastle, Ind., 1962 (Purchase Award)

Graphics 'Sixty-Two, University of Kentucky Art Gallery, Lexington, Part I: Dec. 2–20, 1962, and Part II: Jan. 6–20, 1963*

Third Invitational Print Annual, Brooks Memorial Art Gallery, Memphis, Nov. 4–29, 1962*

Twenty-Fourth Exhibition, Society of Washington Printmakers, U.S. National Museum, Washington, D.C., Jan. 13–Feb. 4, 1962 (Berryman Award)

Ultimate Concerns, Third National Exhibit, Ohio University Gallery, Athens, March 18–31, 1962 (Purchase Prize Winner)*

1963

Contemporary Masters—Drawings and Prints: Kane Memorial Exhibition, Providence Art Club, Providence, R.I., March 17–April 5, 1963*

Drawing Invitational, Louisiana State University, Baton Rouge, March 17–April 8, 1963*

Mother and Child in Modern Art, New York World's Fair, New York, 1963*

Nineteenth National Exhibition of Prints, Library of Congress, Prints and Photographs Division, Washington, D.C., May 1–Sept. 1, 1963*

One Hundred Prints of the Year, 1962, Society of American Graphic Artists, Inc., New York, March 1963 (First Prize of $3,000)*

Prints on a Synthetic Fabric, Tweed Gallery, University of Minnesota, Duluth, 1963*

Prize Winning Graphics, Fort Lauderdale, Fla., 1963*

Second National Invitational Print Exhibition, Otis Art Institute of Los Angeles County, Los Angeles, Jan. 10–Feb. 4, 1963*

Suggested Additions, Milwaukee Art Center, May 8–June 9, 1963

1964

Collectors' Choice III: A Special Christmas Season Exhibition, Sheldon Swope Art Gallery, Terre Haute, Ind., Nov. 15, 1964–Jan. 10, 1965*

An Exhibition of Contemporary Art from the Collection of Mr. and Mrs. Leslie L. Johnson, Studio San Giuseppe, College of Mount St. Joseph, Cincinnati, Feb. 16–March 13, 1964*

The Fabulous Decade: A Collection of Prints of the 1950s,
Free Library of Philadelphia Print and Picture
Department, May 15–June 6, 1964*

Fifteen American Printmakers, Ball State University Art
Gallery, Muncie, Ind., Dec. 1964*

Four American Artists: Denzer, Hunter, Pransky and Pozzatti,
Palazzo Strozzi, Florence, Italy, March–April 1964*

*Fourth Christocentric Arts Festival: An Invitational Exhibition
of Contemporary Christian Liturgical Art*, Lewis Gallery,
University of Illinois, Champaign-Urbana, March 8–22,
1964*

[*Fulbright Scholars*], Art Gallery, Villa Schifanoia, Via
Boccaccio, Florence, Italy, 1964

Kansas National Invitational Print Exhibition, University of
Kansas Museum of Art, Lawrence, Oct. 19–Nov. 14,
1964*

Living Prints, Free Library of Philadelphia, Sept. 24–Nov. 30,
1964*

One Borsisti Fulbright, Saletta USIS, Borgo San Sepolcro,
Italy, March 1964*

*Paintings, Drawings, Prints from the Collection of Mr. and
Mrs. Leslie L. Johnson*, Lilly Library, Earlam College,
Richmond, Ind., Oct. 4–31, 1964*

Thirty Contemporary American Prints, IBM Gallery, New
York, Feb. 17–March 13, 1964

1965

American Illustrated Books: 1945–1965, Grolier Club, New
York, Dec. 21, 1965–Feb. 4, 1966*

*Art and Liturgy 1965: Seventh Annual Ecclesiastical Arts
Exhibit of the National Conference on Church Architecture*,
Pick Congress Hotel, Chicago, April 27–29, 1965
(Juror)*

Black and White Exhibition, Print Club, Philadelphia,
Feb. 5–26, 1965*

Boston Printmakers Seventeenth Annual Print Exhibition,
Museum of Fine Arts, Jan. 5–Feb. 7, 1965*

Come Up and See Our Etchings, C. Troup Gallery, Dallas,
Feb. 1965

Distinguished University Artists, Ackland Art Center,
Chapel Hill, N.C., April 2–May 2, 1965*

Drawings from Seventeen States, Museum of Fine Arts,
Houston, Feb. 11–March 14, 1965*

Eleventh Annual Drawing and Small Sculpture Show, Ball
State University Art Gallery, Muncie, Ind., March 1965*

Fifth National Print and Drawing Exhibition, Olivet College
Festival of Fine Arts, Olivet, Mich., Feb. 27–March 18,
1965 (Exhibition traveled to three other Michigan venues,
March 21–May 19, 1965) (Sculpture Association of Flint
Purchase Award)*

*Forty-Sixth Annual Exhibition of the Society of American
Graphic Artists*, Associated American Artists Gallery, New
York, March 2–27, 1965*

Nebraska Art Association LXXIIII Annual Exhibition, Sheldon
Memorial Art Gallery, University of Nebraska Art
Galleries, Lincoln, April 4–May 2, 1965*

Northwest Printmakers Thirty-Sixth International Exhibition,
Seattle Art Museum, March 3–April 4, 1965, and
Portland Art Museum, April 15–May 15, 1965*

One Hundred: An Exhibition of Contemporary Art, University
of Dayton, Sept. 23–Oct. 15, 1965*

One-Hundred-and-Sixtieth Annual Exhibition,
The Pennsylvania Academy of the Fine Arts,
Philadelphia, Jan. 22–March 7, 1965*

*Ray French, Dean Meeker, Rudy Pozzatti, Bruce Spruance:
Group Print Show*, Art Gallery, Durham, N.C.,
Dec. 1965*

Sales and Rental Gallery Exhibition, Laguna Gloria Art
Museum, Austin, Tex., Nov. 14, 1965–Jan. 10, 1966*

Second Annual Exhibition of Lithography, Florida State
University, Tallahassee, Feb. 24–March 16, 1965*

Seventh National Exhibition of Contemporary Art, Oklahoma
Printmakers Society, Oklahoma Art Center, Oklahoma
City, April 4–25, 1965 (Special Recognition)*

Third Annual Tippecanoe Regional Exhibition, Lafayette Art
Center, Lafayette, Ind., April 4–25, 1965
(Honorable Mention)*

Twenty-First American Drawing Biennial, Norfolk Museum of
Arts and Sciences, Norfolk, Va., Jan. 4–31, 1965*

Tyrrhenian Portraits by Rudy Pozzatti, Sheldon Memorial Art
Gallery, Lincoln, Nebr., Feb. 2–28, 1965

*Ultimate Concerns, Sixth National Exhibition of Prints and
Drawings*, Ohio University, Athens, March 9–28, 1965*

1966

Boston Printmakers Eighteenth Annual Print Exhibition,
Museum of Fine Arts, Jan. 11–Feb. 13, 1966*

Carleton Centennial Print Invitational, Carleton College,
Northfield, Minn., Oct. 5–23, 1966*

*Collection of Paintings, Drawings, and Sculpture of Mr. and
Mrs. Leslie L. Johnson*, University Club, Cincinnati,
March 1966

*Eighth Annual Contemporary American Printmakers
Exhibition*, Art Center, DePauw University, Greencastle,
Ind., March 6–April 6, 1966*

Eighth National Exhibition of Prints and Drawings,
Oklahoma Art Center, Oklahoma City, April 23–May 15,
1966*

Fifty Indiana Prints 1966: Eighth Biennial Exhibition, John
Herron Museum of Art, Indianapolis, May 15–June 12,
1966 (Anonymous Prize, $25)*

First Annual Exhibition of the '500' Festival of the Arts,
Indianapolis, May 16–21, 1966 (Professional Award
Winner, $100)*

*Forty-Seventh Annual Exhibition of the Society of American
Graphic Artists*, Pepsi Cola Gallery, New York,
Jan. 6–28, 1966*

Howard S. Wilson Memorial Collection, Sheldon Memorial Art
Gallery, Lincoln, Nebr., Oct. 11–Nov. 13, 1966*

*Northwest Printmakers Thirty-Seventh International
Exhibition*, Seattle Art Museum Pavilion, Feb. 15–
April 3, 1966, and Portland Art Museum, April 10–
March 10, 1966*

Pacific Print II, Orange Coast College, Costa Mesa, Calif.,
Nov. 16–Dec. 16, 1966*

*Perspectives in Color: A National Invitational Color Print
Exhibition*, Madison Art Center, Madison, Wis.,
Jan. 5–20, 1966 (A selection was circulated through the
University of Wisconsin Center System,
Sept. 1966–Nov. 1967)*

Printmaking USA, Fine Arts Gallery, Purdue University,
Lafayette, Ind., Oct. 3–28, 1966*

Return Engagement: Philadelphia Art Alliance Fiftieth

Anniversary Exhibition, Print Club, Philadelphia,
 Feb. 21–March 20, 1966*
Second Dulin National Print and Drawing Competition, Dulin
 Gallery of Art, Knoxville, April 14–May 8, 1966*
Sixth National Print and Drawing Exhibition, Collegiate
 Center, Olivet College, Olivet, Mich., Feb. 28–March 18,
 1966*
Sixth National Print Exhibition, Silvermine Guild of Artists,
 Inc., New Canaan, Conn., March 6–31, 1966*
Twentieth National Exhibition of Prints, Library of Congress,
 Prints and Photographs Division, Washington, D.C.,
 May 1–Sept. 18, 1966 (Juror)*
*Twenty-Five: A Tribute to Henry Radford Hope in Celebration
 of His 25th Year as Chairman of Indiana University's
 Department of Fine Arts*, Indiana University Art Museum,
 Bloomington, May 22–Oct. 1, 1966
*Ultimate Concerns, Seventh National Prints and Drawings
 Exhibition*, Ohio University, Athens, March 8–28, 1966
 (Recommended for Purchase)*

1967
Cincinnati Biennial I, Cincinnati Art Museum, Dec. 1,
 1967–Jan. 7, 1968*
Collectors' Opportunities 1967, High Museum of Art, Atlanta,
 Nov. 12–26, 1967*
Contemporary American Drawings II, Smithsonian Institute,
 Washington, D.C., 1967
*Exhibition of Contemporary Art from the Collection of Mr. and
 Mrs. Leslie L. Johnson*, Studio San Giuseppe Art Gallery,
 College of Mount St. Joseph, Cincinnati,
 Sept. 10–Oct. 11, 1967*
[Group Exhibition], Hume Gallery, Hershey, Pa.,
 Dec. 1–21, 1967
Lowe/Pozzatti, American Embassy Gallery, Belgrade,
 Yugoslavia, 1967
Nebraska Art Today: A Centennial Invitational Exhibition,
 Joslyn Art Museum, Omaha, March 1967*
*Ninth Annual Contemporary American Printmakers
 Exhibition*, DePauw University, Greencastle, Ind.,
 Feb. 5–March 8, 1967*
Nineteenth Annual Boston Printmakers Exhibition,
 Museum of Fine Arts, Boston, Feb. 28–April 2, 1967
 (Presentation Artist)*
*Paintings, Drawings, Sculpture, Graphics from the Collection
 of Mr. and Mrs. Leslie L. Johnson*, Fort Wayne Museum of
 Art, Fort Wayne, Ind., May 2–28, 1967*
Potsdam Prints 1967, State University College, Potsdam,
 N.Y., 1967*
Recent Indiana Art, Anderson Fine Arts Center, Anderson,
 Ind., Jan. 15–Feb. 12, 1967*
Seventh National Print and Drawing Exhibition, Olivet
 College Festival of Fine Arts, Olivet, Mich.,
 Oct. 23–Nov.11, 1967*
'67 Wisconsin Printmakers, Stout State University,
 Menomonie, Wis., April 11–May 11, 1967 (Juror)*
*Stampe di due mondi/Prints of Two Worlds: An Exhibition of
 American and Italian Printmaking*, Tyler School of Art in
 Rome, April 13–May 27, 1967, and Philadelphia
 Museum of Art, May 15–June 25, 1967*
Third National Invitational Print Exhibition, Otis Art
 Institute of Los Angeles County, Los Angeles,
 Jan. 12–Feb. 19, 1967*

1968
Albion College National Print and Drawing Exhibition 68,
 Albion College, Albion, Mich., April 3–27, 1968
 (Purchase Prize)*
American Graphic Workshops: 1968, Cincinnati Art Museum,
 Jan. 8–March 3, 1968*
Artists-Teachers Today, U.S.A., State University of New York,
 Oswego, (Purchase Prize)
Big Prints, Art Gallery, State University of New York, Albany,
 Feb. 16–March 24, 1968*
Exhibition of Annual Exhibitions, St. Lawrence University,
 E. J. Noble Center Gallery and Griffiths Art Center
 Gallery, Canton N.Y., May–June 1968*
Festival of Contemporary Art, Springfield Art Center,
 Springfield, Ohio, July 4–31, 1968*
First Wisconsin Print Show International, Madison Art Center
 and the Ellison Bay Festival of the Arts, Madison,
 July 1968–Feb. 1969 (Exhibition traveled to four venues
 in Wisconsin)*
500 Festival of the Arts, various venues, Indianapolis, May
 12–25, 1968 (Best of Show, $1,000 Prize)*
Fourth Dulin National Print & Drawing Exhibition, Dulin
 Gallery, Knoxville, Tenn., May 8–June 23, 1968
 (Purchase Prize)*
National Print and Drawing Exhibition, Northern Illinois
 University, Dekalb, 1968*
*Ninth Annual Contemporary American Printmakers
 Exhibition*, DePauw University, Greencastle, Ind.,
 Feb. 5–March 8, 1967*
Potsdam Prints 1968, State University College, Potsdam,
 N.Y., May 1968*(Purchase Prize)
*Potsdam Prints, 1968 National Print Exhibition, New
 Directions in Printmaking*, Emily Lowe Gallery, Hofstra
 University, Hempstead, N.Y., Jan. 10–Feb. 2, 1968
Tenth Annual National Exhibition of Prints and Drawings,
 Oklahoma Art Center, Oklahoma City, April 20–May 19,
 1968*
Third International Miniature Print Exhibition, Pratt
 Graphics Center Gallery, New York, Oct. 2–Nov. 23,
 1968*
Twelfth Bradley National Print Show, Bradley University and
 Art Guild of Lakeview Center, Peoria, Nov. 8–Dec. 8,
 1968*
*Twentieth-Century Prints from the Miami University
 Collection*, Heistand Gallery, Miami University, Oxford,
 Ohio, Sept. 22–29, 1968*
*Twenty-Ninth Annual Exhibition of the American Color Print
 Society*, American Color Print Society, Philadelphia,
 1968 (Florence Tonner Award)*
Ultimate Concerns: Graphics 1968, Ohio University, Athens,
 April 3–28, 1968*

1969
Black and White Exhibition, Print Club, Philadelphia,
 Feb. 5–26, 1969 (International Graphic Arts Society Cash
 Award for Outstanding Print)*
Boston Printmakers Twenty-First Annual Print Exhibition,
 Museum of Fine Arts, Boston, March 4–30, 1969*
Four Printmakers, Arkansas State University Art Gallery,
 Jonesboro, March 5–27, 1969*
National Invitational Drawing Exhibition, University of

Wisconsin, Green Bay, July 20–Aug. 31, 1969*
Northwest Printmakers Fortieth International Exhibition,
Seattle Art Museum, Feb. 6–March 9, 1969, and
Portland Art Museum, April 11–27, 1969*
One-Hundred-and-Sixty-Fourth Annual Exhibition,
Pennsylvania Academy of the Fine Arts, Philadelphia,
Jan. 17–March 7, 1969*
Second Annual Print and Drawing Competition, University of
Illinois, Dekalb, May 1969 (Prize Winner)*
Twenty-First National Exhibition of Prints, Library of
Congress, Washington, D.C., May 1–Sept. 2, 1969*

1970
Boston Printmakers Twenty-Second Annual Print Exhibition,
Copley Society, Boston, April 19–May 6, 1970, and
Brandeis University, Waltham, Mass., May 10–31, 1970*
*Color Prints of the Americas: Thirty-First Annual Exhibition
of the American Color Print Society,* American Color Print
Society, Philadelphia, 1970*
Contemporary American Prints, Krannert Art Museum,
University of Illinois, Champaign/Urbana,
Feb. 8–March 1, 1970*
Fifth Invitational Print Exhibition, Lindenwood College, St.
Charles, Mo., Nov. 8–Dec. 1, 1970*
Four Midwest Printmakers, Northern Illinois University,
Dekalb, March 1–21, 1970*
*Graphics from the Collection of Mr. and Mrs. William A.
Combs,* Kalamazoo Institute of Arts, June 17–July 18,
1970*
Multiples U.S.A., Western Michigan University, Kalamazoo,
March 1–28, 1970
National Invitational Prints, Anchorage Historical and Fine
Arts Museum, 1970*
National Print Exhibition, Georgia State University, High
Museum, Atlanta, March 1970 (Purchase Award)
Preview '71, Studio San Giuseppe Art Gallery, College of
Mount St. Joseph, Cincinnati, Oct. 18–Nov. 8, 1970*
Print National Invitational, University of Nevada Arts
Festival, Reno, 1970*
Selected Works from the Collection of Mrs. A. B. Sheldon,
Sheldon Memorial Art Gallery, Lincoln, Nebr.,
Jan. 20–Feb. 15, 1970*
Selections from the Charles R. Penney Collection, Lake View
Gallery, Moline, Ill. March 6–31, 1970*
Twelfth National Exhibition of Prints and Drawings,
Oklahoma Art Center, Oklahoma City, May 10–31, 1970*

1971
Colorprint U.S.A., Texas Tech University, Lubbock, 1971*
First Hawaii Print Exhibition, Honolulu Academy of Arts,
May 3–28, 1971*
*Seventh Annual All-California Print Exhibition and First
National Print Invitational,* California Museum of Science
and Industry, Los Angeles, Jan. 16–Feb. 28, 1971
(Guest Artist)
Thirteenth Annual Bradley National Print Show, Bradley
University and the Peoria Art Guild, Peoria,
April 2–30, 1971*

1972
American Prints: 72, Iowa State University, April 1–30, 1972,
and Davenport Municipal Art Gallery, Davenport, Iowa,
May 22–June 22, 1972*
*Artists in Indiana, Then and Now: Works on Paper by Indiana
Artists,* Ball State University Art Gallery,
Muncie, Ind., 1972*
Eighty Prints, Fine Arts Gallery, Purdue University,
Lafayette, Ind., Feb. 1–29, 1972*
500 Festival of the Arts, Convention Center, Indianapolis,
1972 (Two Purchase Awards and Best Print of Show)
Fourteenth National Exhibition of Prints and Drawings,
Oklahoma Art Center, Oklahoma City, May 2–28, 1972*
Graphics from the Collection of Mr. & Mrs. Leslie L. Johnson,
Fine Arts Gallery of San Diego, San Diego,
Jan. 22–March 5, 1972*
Indiana Printmakers Exhibition, Indianapolis Art League,
1972 (Second Prize)
Judith Brown/Rudy Pozzatti, John P. Myers Fine Art Gallery,
State University College of Arts and Science, Plattsburg,
N.Y., Nov. 5–30, 1972 (43 pieces by Pozzatti)*
National Invitational Prints, Anchorage Historical and Fine
Arts Museum, Dec. 6–31, 1972*
Potsdam Prints 1972, State University College, Potsdam,
N.Y., 1972*
Tennessee Printmakers 1972, Dulin Gallery of Art, Knoxville,
April 9–May 7, 1972*
Third Annual Colorprint, U.S.A., Texas Tech University,
Lubbock, 1972 (Purchase Prize)*

1973
Artist and Medicine, National Library of Medicine, Bethesda,
Oct. 15, 1973–Feb. 25, 1974*
The Bardstown Invitational Art Exhibition, Bardstown, Ky.,
Oct. 13–14, 1973*
Eighth Annual Thirty Miles of Art, Junior League of Kansas
City, Kansas City, Mo., Feb. 19–March 3, 1973 (Juror)*
'500' Arts Exhibit, Indiana Convention-Exposition Center,
Indianapolis, May 6–31, 1973*
Fourth Annual Colorprint U.S.A., Texas Tech University,
Lubbock, 1973* (Prize Winner)
Fourth National Invitational Drawing Exhibition, University
of Wisconsin, Green Bay, March 17–April 15, 1973*
Indiana University Faculty and Student Print Show,
Washington Gallery, Indianapolis, April 1–29, 1973*
The Innovators: Renaissance in American Printmaking, Jane
Haslem Gallery, Washington, D.C., 1973*
Oversized Print Show, Studio San Giuseppe Art Gallery,
College of Mount St. Joseph, Cincinnati,
March 4–26, 1973
Six Printmakers Revisited, Kalamazoo Institute of Arts,
Jan. 3–28, 1973*
*Society of American Graphic Artists Fifty-second National
Print Exhibition,* Associated American Artists Gallery,
New York, March 12–April 7, 1973*

1974
Boston Printmakers, Art Complex, Duxbury, Mass.,
Nov. 3–Dec. 31, 1974*
Engraving America 1974, Albrecht Art Museum, St. Joseph,
Mich., March 1974*

Inaugural Fine Arts Exhibition, Indiana State Museum, Indianapolis, May 23–Sept. 15, 1974*

Indiana Printmakers, Indiana Arts Commission, 1974–75 (A traveling exhibition organized by the Ball State University Art Gallery, Muncie, Ind.)*

National Invitational Prints 2, Anchorage Historical and Fine Arts Museum, Oct. 4–29, 1974*

Potsdam Prints 1974, State University College, Potsdam, N.Y., 1974*

1975

Contemporary American Master Printmakers, ADI Gallery, San Francisco, July 10–Sept. 7, 1975

Emden Invitational, Emden Gallery, St. Louis, Sept. 16–Oct. 12, 1975

Faculty and Staff Collects, Iowa State University, Ames, Jan. 13–Feb. 14, 1975*

Fifteenth National Bradley Print Show, Bradley University, Peoria, Jan. 18–Feb. 23, 1975*

Fifth International Miniature Print Exhibition, Pratt Graphics Center Gallery, New York, March 15–April 19, 1975*

Fifty-Third Annual Exhibition of the Society of American Graphic Artists, Azuma Galleries, New York, April 1–19, 1975, and Wood Art Gallery, Montpelier, Vt., May 1975*

Graphics Biennial, Metropolitan Museum and Art Center, Miami, Fla., April 26–May 25, 1975*

Kentuckiana Painters Invitational Exhibition, Phelps Dodge Communication, Elizabethtown, Ky., Nov. 17–Dec. 15, 1975*

Mid-States Art Exhibition: Twenty-Eighth Annual Competition, Evansville Museum of Arts and Science, Evansville, Ind., Nov. 9–Dec. 7, 1975*

Preview Exhibition of Gallery Artists, Johnson-Whitty Gallery, New Orleans, Oct. 11–Nov. 29, 1975*

Third Hawaii Print Exhibition, Honolulu Academy of Arts, Oct. 10–Nov. 9, 1975*

Works on Twinrocker Handmade Paper, Indianapolis Museum of Art, April 15–May 25, 1975*

1976

All Out for Christmas, Johnson-Whitty Gallery, New Orleans, 1976

Art 500, Churchman-Fehsenfeld Galleries, Indianapolis, June 12–26, 1976 (Jury Prize for Best Drawing, Print, or Photograph, $100)*

Artists in Indiana—Then and Now: Works on Paper by Indiana Artists, Art Gallery, Ball State University, Muncie, Ind., Oct. 10–Nov. 28, 1976*

Beyond Illustration: The Livre d'Artiste in the Twentieth Century, Lilly Library, Bloomington, Ind., 1976*

Book as Art, Fendrick Gallery, Washington, D.C., Jan. 12–Feb. 14, 1976*

Contemporary Art Show, Indiana State Museum, Indianapolis, May 23–Sept. 22, 1976*

Illinois/Indiana Bicentennial Exhibition, Hammond, Ind., March 2–April 30, 1976 ($1,000 Purchase Prize for Painting)*

Lowe/Pozzatti, New Harmony Gallery of Contemporary Art, New Harmony, Ind., Feb. 15–March 7, 1976*

Second National Print Invitational Exhibition, State Historical and Fine Arts Museum, Anchorage, 1976 (Purchase Prize)

Seventh Annual Colorprint U.S.A., Texas Tech University, Lubbock, 1976 (Cash Award Winner)*

Thirty-Fifth National Exhibition of the American Color Print Society, Philadelphia Art Alliance, Sept. 26–Oct. 24, 1976*

Twentieth Brooklyn National Print Exhibition, Brooklyn Museum, New York, Nov. 20, 1976–Jan. 30, 1977*

1977

Eight Printmakers, Studio San Giuseppe Art Gallery, College of Mount St. Joseph, Cincinnati, Sept. 25–Oct. 9, 1977

Eleven in Seventy-Seven (Invitational Exhibition), Northern Illinois University, Dekalb, March 1–23, 1977*

Invitational American Drawing Exhibition, Fine Arts Gallery, San Diego, Sept. 17–Oct. 30, 1977*

Rudy Pozzatti/Brian Baker, Byck Gallery, Louisville, Nov. 18, 1977–Jan. 5, 1978*

Sixth International Miniature Print Exhibition, Pratt Graphics Center Gallery, New York, March 5–April 11, 1977*

Society of American Graphic Artists Fifty-Fifth National Print Exhibition, Associated American Artists Gallery, New York, April 4–30, 1977 (Special Honorable Mention)*

Society of American Graphic Artists Fifty-Fifth National Traveling Exhibition, Oct. 1977–Dec. 1979 (Exhibition traveled to seventeen venues in New York, New Jersey, Illinois, Alaska, Oklahoma, Kansas, Missouri, South Dakota, Indiana, North Dakota, and Arizona)*

1978

Christchurch Arts Festival Invitational of Drawings, Robert McDougall Art Gallery, Christchurch, New Zealand, March 4–April 3, 1978*

Fifth Annual Southeastern Graphics Council Conference, University of Alabama, Birmingham, Feb. 24–26, 1978*

Indianapolis Open-Air Gallery, Indianapolis Art League, Jan. 15–Feb. 15, 1978*

Instructors and Their Students: An Exhibition of Works on Paper, Texas Tech University, Lubbock, 1978*

Thirty-Sixth National Exhibition of the American Color Print Society, Philadelphia Art Alliance, Sept. 11–Oct. 15, 1978

USD/ART: National Invitational Printmaking Exhibition, University Art Gallery, Warren M. Lee Center for the Fine Arts, University of South Dakota, Vermillion, Feb. 5–24, 1978*

1979

Fifty-Eighth Annual Society of American Graphic Artists, New York, 1979 (Gladys Mock Memorial Cash Award)

Recent Paintings and Prints by Rudy Pozzatti and Robert Postma, Washington Gallery, Indianapolis, May 11–June 1, 1979

Third Biennial Printmaking Symposium Guest Artists' Exhibition, Drake University, Des Moines, April 8–27, 1979*

Thirty-Seventh Annual American Color Print Society, Philadelphia, 1979 (Carl Zigrosser Memorial Cash Award)

Treasure of Island Creek: Mixed Media from Corporate Headquarters, Actors Theatre, Louisville, July 15–20, 1979*

Twenty-Second North Dakota Drawing Annual, University of North Dakota, Grand Forks, April 10–27, 1979*

1980

Fifty-Eighth National Print Exhibition of the Society of American Graphic Artists, Fashion Institute of Technology, New York, Sept. 16–Oct. 18, 1980 (Gladys Mock Memorial Award, $100)*

Inaugural Exhibit, North Salem Gallery, Salem, N.Y., 1980

In Celebration of Prints, Print Club of Philadelphia and Philadelphia Art Alliance, ca. 1980*

Ninth Annual Colorprint U.S.A., Texas Tech University, Lubbock, 1980*

1981

Contemporary Printmaking: Intaglio, Allen R. Hite Art Institute, University of Louisville, Feb. 16–March 13, 1981*

IV American Biennial of Graphic Arts, Museo d'Arte Moderno, La Tertula, Cali, Colombia, S.A., 1981*

The Indiana Five, Dayton Art Institute, Jan. 1981

Indiana 5 + 1, Indianapolis Art League, April 24–May 13, 1981*

1982

Cast in Carbondale, Laumeier International Sculpture Park, St. Louis, July 18–Sept. 12, 1982, and Alexandria Museum Visual Art Center, Alexandria, La., October 9–Jan. 8, 1983*

Fifty-Ninth National Print Exhibition of the Society of American Graphic Artists, Cooper Union, New York, Nov. 16–Dec. 2, 1982*

Thirty American Printmakers, University Gallery of Fine Arts, Ohio State University, Columbus, Jan. 1982 (Exhibition traveled for two years)

1983

Print 1/500: International Printmaking Invitational, California State College, San Bernardino, April 20–May 27, 1983*

Sixtieth Society of American Graphic Artists National Print Exhibition, Hutchins Gallery, C.W. Post College, Greenvale, N.Y., Oct. 1–28, 1983, and Galleries at F.I.T. Shirley Goodman Resource Center, New York, Dec. 19–Jan. 14, 1984*

Tenth Annual Colorprint U.S.A., Texas Tech University, Lubbock, March 6–April 3, 1983*

Works on Paper Partnership International, Rio Grande do Sul, Brazil, 1983*

1984

Artists in the Trenches Invitational Print Show, Katherine E. Nash Gallery, Willey Hall, University of Minnesota, West Bank Campus, Minneapolis, Nov. 12–Dec. 7, 1984*

First Minneapolis College of Art and Design Print Invitational, College of Art and Design, Minneapolis, April–May 1984

Fortieth American Color Print Society Exhibition, Abington Art Center, Jenkintown, Pa., Oct. 13–Nov. 10, 1984*

Indiana Printmakers: An Exhibition of Selected Printmakers Who Work and Teach in Indiana, Moreau Gallery, St. Mary's College, Notre Dame, Ind., Jan. 20–Feb. 17, 1984

Miami Collects, Miami University Art Museum, Oxford, Ohio, Oct. 27–Dec. 17, 1984*

National Printmaking IUP Invitational, Kipp Gallery, Indiana University of Pennsylvania, Indiana, Pa., April 1–19, 1984*

School of Fine Arts Faculty Exhibition, Indiana University Art Museum, Bloomington, Oct. 3–Dec. 16, 1984*

Sixtieth S.A.G.A. National Print Exhibition, Society of American Graphic Artists, New York, Dec.–Jan. 1984

1985

Annual Fall Exhibition, Indianapolis Museum of Art, Oct. 1985

Fifteen Artists Revisited, Kalamazoo Institute of Art, Nov. 1985

Original Christmas Card Exhibition, Water Tower Art Association, Louisville, Dec. 1985

Print Invitational, Wake Forest University Fine Arts Gallery, Winston-Salem, N.C., Sept. 6–Oct. 4, 1985

Sixty-First National Print Exhibition of the Society of American Graphic Artists, Firehouse Gallery, Nassau Community College, Garden City, N.Y., Sept. 3–27, 1985*

1986

Collection '87, Fort Wayne Museum of Art, Fort Wayne, Ind., Oct.–Nov. 1986

Faculty Exhibition, Indiana University Art Museum, Bloomington, Oct.–Nov. 1986

Illinois Regional Print Show: Seventh Midwest Print Exhibition, Dittmar Gallery, Norris Center, Northwestern University, Evanston, Apr. 4–28, 1986 (Juror)*

The Printmaker's Art, Neville-Sargent Gallery, Chicago, July 1986

Selections from the Sioux City Art Center Permanent Collection, Sioux City Art Center, June–Aug. 1986*

Sixty Square Inches Maximum: Small Print Exhibition, Stewart Center Gallery, Purdue University, Lafayette, Ind., April 7–May 3, 1986 (Jurors' Invitational)*

Works on Paper: IU and Purdue University Faculty Exhibition, summer 1986 (Exhibition toured Germany)*

1987

Getting Away: Art Inspired by Artists' Travels, Louisville Art Gallery, Dec. 8–Jan. 31, 1987

A Gift of Time: 20^th Anniversary, The Artist-In-Residence Program, Roswell Museum and Art Center, Roswell, N. Mex., March 8–Aug. 16, 1987*

1988

Colorprint U.S.A., Texas Tech University, Lubbock, March 6–May 22, 1988*

Willa Shalit: Lifecasts/Rudy Pozzatti: Prints, College of Santa Fe Gallery of Fine Arts, July 14–25, 1988

1989

Arkansas Arts 89, Arkansas Art, Arkadelphia, Feb. 12–Marh 8, 1989 (Juror)*

City on a Hill: Twenty Years of Artists at Cortona, Georgia Museum of Art, Athens, March 25–May 7, 1989*

Faculty of the Indiana University Printmaking Program,

Stockton State College Art Gallery, Pomona, N.J.,
Oct. 10–27, 1989*

*The Printmaker's Choice: Works of Eight Premier American
Printmakers*, Leeds Gallery, Earlham College, Richmond,
Ind., Oct. 5–28, 1989

Printmaking Invitational, Studio San Giuseppe Art Gallery,
College of Mount St. Joseph, Cincinnati,
Feb. 19–March 19, 1989

U.S.A. Printmakers, Kipp Gallery, Indiana University of
Pennsylvania, Indiana, Pa., April 30–May 20, 1989*

1990

Contemporary Trends in Printmaking, Northern Kentucky
University, Highland Heights, Nov. 2–17, 1990*

Echo Press: A Decade of Printmaking, Indiana University Art
Museum, Bloomington, Oct. 23, 1990–Jan. 6, 1991 (A
selection of works from the exhibition traveled to the Fort
Wayne Art Museum in Jan. 18–March 29, 1992)*

1991

*Henry Radford Hope School of Fine Arts: 1991 Faculty
Exhibition*, Indiana University Art Museum, Bloomington,
Jan. 29–March 17, 1991*

Indiana Printmakers, Emison Art Center, DePauw University,
Greencastle, Ind., Sept. 1–30, 1991

*National Academy of Design: One-Hundred-Sixty-Sixth
Annual Exhibition*, National Academy of Design, New
York, April 2–May 12, 1991*

*Nineteenth and Twentieth-Century American and European
Portraits and Heads from the Dadée and George Burk
Collection*, Evansville Museum of Arts and Science,
Evansville, Ind., July 21–Sept. 8, 1991*

1992

The Breverman Collection, Trisolini Gallery of Ohio
University, Athens, May 6–June 13, 1992*

1993

*Celebrating SOFA: Hope School of Fine Arts Biennial Faculty
Show*, March 31–May 16, 1993

Echo Press Prints, Goshen College Art Gallery, Goshen, Ind.,
Feb. 14–March 21, 1993

1994

*Twenty Years of Collecting: The Wabash College Permanent
Collection of Contemporary Art, 1974–1994*, Wabash
College, Crawfordsville, Ind., Jan. 17–Feb. 11, 1994*

1995

*Directions: The First All-Campus Fine Arts Faculty Exhibition
from Indiana University*, Indiana University Art Museum,
Bloomington, Feb. 3–March 12, 1995 (Exhibition also
traveled to Kokomo and Indianapolis campuses)*

Echo Press: A Tribute, Turman Art Gallery, Indiana State
University, Terre Haute, Oct. 22–Nov. 10, 1995

Fifteenth Annual Statewide Print Competition, Alma College,
Alma, Mich., Nov. 6–Dec. 8, 1995 (exhibition traveled to
six other Michigan venues, Jan. 15–Sept. 30, 1995)
(Juror)*

McNeese National Printmaking Invitational, McNeese State
University, Abercrombie Gallery, Lake Charles, La.,
Oct.–Nov. 1995*

*The Plain Brown Wrapper Hard Times National Print
Exhibition*, Georgia State University Gallery, Art & Music
Building, Atlanta, April 24–May 12, 1995*

1996

*A Century of Art: 100th Anniversary of the Henry Radford
Hope School of Fine Arts, Faculty Artists Past and Present*,
Indiana University Art Museum, Bloomington, Nov.
1–Dec. 22, 1996

Echo Press: A Tribute, Indiana University Art Museum,
Bloomington, Jan. 19–Feb. 25, 1996

1997

International Print Exhibition, Portland Art Museum,
Portland, Oreg. Feb. 15–May 11, 1997 (Purchase Prize)*

*Pressed and Pulled VI: National Juried Printmaking
Exhibition*, Georgia College & State University,
Blackbridge Hall Gallery, Milledgeville, Sept. 29–
Oct. 31, 1997 (Juror) *

1998

Colorprint U.S.A.: Spanning the States in '98, Texas Tech
University, Lubbock, Nov 1998

Touchstone: 200 Years of Artists' Lithographs, Harvard
University Art Museums, Cambridge, Aug. 15–Nov. 1,
1998 (Traveled to University of Michigan, Ann Arbor;
Queens College, Ontario, Canada; and Ackland Art
Museum, University of North Carolina, Chapel Hill)*

1999

*An Artistic Community: The Henry Radford Hope School of
Fine Arts Biennial Faculty Show*, Indiana University Art
Museum, Bloomington, Jan. 22–March 14, 1999

2000

Seventh Eiteljorg Museum Biennial Exhibition, Eiteljorg
Museum, Indianapolis, May 6–August 7, 2000*

2001

*A Bloomington Biennial: Faculty Artists from IU's Hope
School of Fine Arts*, IU Art Museum, Bloomington, March
23–May 6, 2001

Saints and Sinners: Observations on the Sacred and Profane,
Cortona, Italy, and Corcoran College of Art and Design,
Washington, D.C., 2001

Undated Group Exhibitions

American Graphic Arts 1, American Graphic Arts, Encino

Artists Abroad, Institute of International Education

Art Smart: New Vistas Two, Greater Lafayette Museum of Art,
Lafayette, Ind.

Contemporary American Prints, Williamsburg Restoration,
Inc., Williamsburg, Va.

Eighth Annual Colorprint U.S.A., Texas Tech University,
Lubbock

Exhibition of Recent Prints by Six Contemporary Artists,
Milwaukee Dower College

Four Brothers Press, 1980-87, University of Illinois
at Chicago

Important Prints, Jane Halsem Gallery, Washington, D.C.

Modern Masters of Intaglio, Queens College, The City
 University of New York
National Invitational Print Show, California State College at
 Long Beach Art Gallery
New Direction in American Printmaking, Hofstra University,
 Emily Lowe Gallery, Hempstead, N.Y.
Printmakers of Indiana, Art Education Association of
 Indiana, Fort Wayne, Ind.
Prints, Gallery 288, St. Louis, Mo.
Second International Invitational Print Show, Eastern
 Michigan University, Ypsilanti
Tenth Annual Christocentric Arts Festival, Newman
 Foundation Galleries, Champaign, Ill.
Third Annual Invitational Exhibition, American Drawings
 and Prints, University of Utah, Salt Lake City
U. S. Drawings, Texas Tech University, Lubbock
Works of Twelve Artists of the Hour, Gump's Gallery,
 San Francisco

Print Commissions

Cleveland Print Club, Cleveland Museum of Art, 1954
International Graphic Arts Society, New York, 1958, 1961,
 and 1963
Conrad Hilton Hotel, New York, 1961
Clairol, Inc. for New York World's Fair, 1963
Ferdinand Roten Galleries, Inc., Baltimore, 1967 and 1968
International Print Society, New Hope, Pa., 1968
Philadelphia Print Club, 1969
Nasson College, Springvale, Maine, 1970
John Deere and Co., Moline, Ill., 1973
University of Nebraska at Omaha, 1977 and 1979
University of South Dakota, Vermillion, 1977, 1979,
 and 1990
Augustana State College, Sioux Falls, 1981
Contemporary Art Gallery, New Harmony, Ind., 1982
Monroe County Community School Corporation,
 Bloomington, Ind., 1985
Indiana University School of Law, Bloomington, 1992
Indiana University Alumni Association, Bloomington, 1992
Research and University Graduate School, Indiana
 University, Bloomington, 1994
Rochester Print Club, Rochester, N.Y., 1998
Indiana University School of Music (Starker Tribute)
 Bloomington, 1999
Heritage Society, Bloomington Hospital Foundation,
 Bloomington, Ind., 2000
Corcoran College of Art and Design, Washington, D.C., 2001

Commissions in Other Media

Nebraska Art Association, Lincoln, 1973 (porcelain plate)
Southern Illinois University, Carbondale, 1980
 (cast bronze sculpture)
Bloomington Hospital, Bloomington, Ind., 1983 (painting)
Indiana University, Jordan Hall, Bloomington, 1985
 (painting)
Indiana University, Beck Chapel, Bloomington, 1991
 (stained glass windows)
Purdue University, Art in the Classroom Project, Lafayette,
 Ind., 1995 (painted relief sculpture)
Indiana University Alumni Center, Bloomington, 1997
 (painted relief sculpture)

Public Collections

Ackland Art Museum, University of North Carolina,
 Chapel Hill
Addison Gallery of American Art, Phillips Academy,
 Andover, Mass.
Albion College, Albion, Mich.
Allen R. Hite Institute, University of Kentucky, Louisville
American Academy of Arts and Letters, New York
Anchorage Museum of History and Art
Art Institute of Chicago
Augustana College, Sioux Falls, S.D.
Belleville College, Belleville, Mich.
Berea College, Berea, Ky.
Biblioteque Nationale, Paris
Boston Public Library
Bowling Green State University, Ohio
Brooklyn Museum of Art, New York
Carleton College, Northfield, Minn.
CIA, Washington, D.C.
Cincinnati Art Museum
City and County Building of Honolulu
City Museum of Karlsruhe, Germany
Cleveland Museum of Art
Columbia University,
 Federico Castellon Memorial Collection, New York
Dallas Museum of Art
Dayton Art Institute
Depauw University, Greencastle, Ind.
Doane College, Crete, Nebr.
Duke University, Durham, N.C.
Dulin Gallery of Art, Memphis
Emory University, Atlanta
Evansville Museum of Arts and Science, Evansville, Ind.
Everson Museum of Art, Syracuse
First United Methodist Church, Dekalb, Ill.
Fogg Art Museum, Cambridge, Mass.
Fort Wayne Museum of Art, Fort Wayne, Ind.
Free Library of Philadelphia
Georgia State University, Atlanta
Hamline University, Saint Paul, Minn.
High Museum of Art, Atlanta
Honolulu Academy of Arts
Illinois State University, Normal
Indiana University Art Museum, Bloomington
Indiana University Campus Collection, Bloomington
Indianapolis Museum of Art
Institute of International Education, New York
Iowa State University, Ames
J. B. Speed Art Museum, Louisville
John Nelson Bergstrom Art Center, Neenah, Wis.
Joslyn Art Museum, Omaha
Kalamazoo Institute of Art
Kansas State University, Manhattan
Lessing J. Rosenwald Collection, Washington, D.C.
Library of Congress, Washington, D.C.
Los Angeles County Museum of Art
Malmo Museum, Malmo, Sweden
Marshall College, Huntington, W. Va.
Mesa Community College, Mesa, Ariz.
Miami University, Oxford, Ohio
Montclair State University, Montclair, N.J.

Mulvane Art Museum, Topeka
Munson-Williams-Proctor Institute, Utica, N.Y.
Museum of Art, Sydney, Australia
Museum of Art, University of Manitoba, Winnipeg, Canada
Museum of Fine Arts, Boston
Museum of Modern Art, New York
National Gallery of Art, Washington, D.C.
National Medical Library, Bethesda
Newark Art Museum
New Jersey State Museum
Norfolk Museum, Norfolk, Va.
Northern Illinois University, Dekalb
Norton Center at Centre College, Danville, Ky.
Ohio State University, Columbus
Otis Gallery, Otis College of Art and Design, Los Angeles
Pennsylvania Academy of the Fine Arts, Philadelphia
Philadelphia Museum of Art
Print Club, Philadelphia
Pushkin Museum, Moscow, Russia
Rahr Civic Center and Public Museum, Manitowac, Wis.
Residency Collection, Artists from the
 Roswell Artist-in-Residence Program, Roswell, N. Mex.
Richmond Art Association, Richmond, Ind.
Roswell Museum and Art Center, Roswell, N. Mex.
Saint Lawrence University, Canton, N.Y.
Saint Louis Art Museum
San Jose State University
Sheldon Memorial Art Gallery and Sculpture Garden,
 University of Nebraska, Lincoln
Sheldon Swope Museum of Art, Terre Haute, Ind.
Sigma Theta Tau, Indianapolis
Sioux City Art Center
Snite Museum of Art, University of Notre Dame,
 Notre Dame, Ind.
South Bend Art Center, South Bend, Ind.
Southern Illinois University, Carbondale
Southern Illinois University, Edwardsville
Springfield Art Association, Springfield, Ill.
Stanford University, Palo Alto
Starr King School for the Ministry, Berkeley
S.U.N.Y., Oswego, N.Y.
S.U.N.Y., Potsdam, N.Y.
Texas Tech University, Lubbock
Theodore Lyman Wright Art Center, Beloit, Wis.
Toronto Museum of Art
United States Information Agency, Washington, D.C.,
 overseas U.S. offices and embassies
University of Alabama, Tuscaloosa
University of California, Berkeley
University of California, Los Angeles
University of California, Riverside
University of Colorado, Boulder
University of Illinois, Champaign
University of Louisville Print Collection
University of Maine, Orono
University of Minnesota, Minneapolis
University of Missouri, Columbia
University of Northern Iowa, Cedar Falls
University of West Virginia, Creative Arts Center,
 Morgantown
University of Wisconsin, Green Bay

University of Wisconsin, Madison
Victoria and Albert Museum, London, England
Warren W. Shirey Memorial Collection,
 Indiana University, Bloomington
Wichita Art Association
Yale University Art Museum, New Haven

Corporate Collections
ABC Insurance Co., Bloomington, Ind.
American Savings and Loan Association, Hammond, Ind.
American States Insurance Co., Indianapolis
Arthur Andersen Inc., Chicago
Ashland Oil Co., Ashland, Ky.
Bloomington Hospital, Bloomington, Ind.
CBL Office Management, Indianapolis
Cincinnati Bell Information Systems, Inc., Cincinnati
Citizens National Bank, Evansville, Ind.
Clairol, Inc., New York
Conrad Hilton Hotel, New York
Cooke and Bache Co., Lafayette, Ind.
Coopers and Lybers Inc., Washington, D.C.
Eli Lilly Pharmaceutical Co., Indianapolis
Fairbury State Bank, Fairbury, Nebr.
Foursquare Company, Carmel, Ind.
Gem Savings, Dayton
General Electric, New York
Gould and Company, Chicago
Grace Shipping Lines, New York
Hallmark Collection, Kansas City, Mo.
Harcourt Management, Indianapolis
Holiday Inn Corporation, Tamaqua, Pa.
Hollister Corporation, Libertyville, Ill.
Indianapolis Power and Light, Indianapolis
Island Creek Co., Armand Hammer Building, Lexington, Ky.
J. C. Penney and Company
John Buck Corporation, Sears Tower, Chicago
John Deere and Co., Moline, Ill.
Kemper Insurance Co., Chicago
Lewis and Roca Law Firm, Phoenix
Lincoln National Corporation, Ft. Wayne, Ind.
Litton Industries, Los Angeles
Mayo Clinic, Rochester, Minn.
Pullman Leasing, Chicago
The Regional Medical Center, Orangeburg, S.C.
Reynolds Tobacco and Aluminum Co., Winston-Salem, N.C.
Richland Coal Co. Lexington, Ky.
Ruder & Finn, Inc., New York
Stone Oil Corporation, Cincinnati
Touche Rose Investments, Inc., Washington, D.C.
Yellow Freight Trucking, Kansas City, Mo.

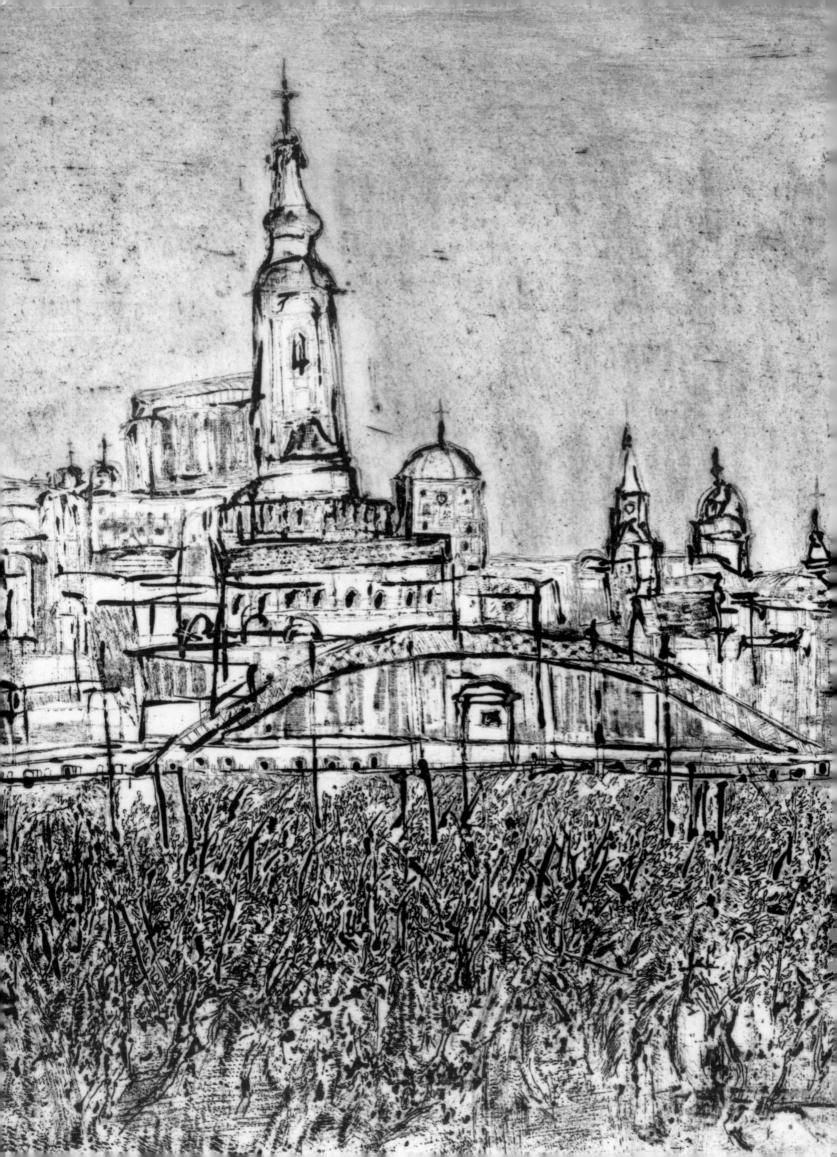

Bibliography

Publications by Pozzatti

"The Artist Asks, 'Why Art?'" *The Review. Indiana University Bulletin* 6, no. 1 (October 30, 1963): 36–41.

Artist's statement in *Colorprint U.S.A.* Lubbock: Texas Tech University, 1988.

Foreword to *The Complete Printmaker*. John Ross and Clare Romano. New York: MacMillan, Free Press, 1972.

"The History of Echo Press." In *Echo Press: A Decade of Printmaking*. Bloomington: Indiana University Art Museum, 1990.

Juror's statement in *Fifteenth Annual Statewide Print Competition*. Alma, Mich.: Alma College, 1995.

Juror's statement in *Pressed and Pulled VI: National Juried Printmaking Exhibition*. Milledgeville: Georgia College and State University, Blackridge Hall Gallery, 1997.

Juror's statement in *Tennessee Printmakers 1972*. Knoxville: Dulin Gallery of Art, 1972.

"My Russian Sketch Book." *Art Journal* 21, no. 2 (Winter 1961–62): 62–63 (illus.).

Preface in *1969–1991: Two Decades of Change*. Bloomington: Henry Radford Hope School of Fine Arts, Indiana University, 1992.

"Rudy Pozzatti." *Indiana Alumni Magazine*, July–August 1969, 22–24 (illus.).

Co-authored with Jimmy Ernst.
"Our Own Russian Diary." *Art Journal* 21, no. 2 (Winter 1961–62): 64–65 (illus.).

Illustrated by Pozzatti

Appleman, Philip. *Darwin's Ark*. Bloomington: Indiana University Press, 1984.

Barnstone, Willis, trans. *Physiologus Theobaldi de Naturis Duodecim Animlium (Bishop Theobald's Bestiary of Twelve Animals)*. Bloomington: Indiana University Press, 1964.

Ernst, Jimmy. "A Letter to Artists of the Soviet Union." *Art Journal* 21, no. 2 (Winter 1961–62): 67–68, 70–71.

Pozzatti, Rudy. *1982 Calendar*. Bloomington, Ind.: self-published, 1982.

Stations of the Cross. Bloomington, Ind.: self-published, 1977.

University of Colorado Department of Physics. *Upper Air Laboratory: Progress Report*. Boulder: University of Colorado, 1949.

Publications on Pozzatti (Books, magazine articles, exhibition catalogues, and brochures)

Bracken, Trisha. "Rudy Pozzatti: Artist in Academia." *Indiana Alumni Magazine*, April 1985, 13–14 (illus.).

Bronzes, Painting and Graphic Art by Pozzatti/67. Madison, Wis.: Jane Haslem Gallery, 1967 (exhibition brochure, illus.).

Carroll, Nancy. "A Visit with Rudy Pozzatti." *North Shore Art League News* (Winnetka, Ill.) 19, no. 6 (Feb. 1972): 4–7 (cover, illus.)

Cobb, Robert R. Catalogue note in *Eleven in Seventy-Seven*. Dekalb: Northern Illinois University, 1977.

Colaricci, Susan P. "Rudy Pozzatti Exhibition to Examine Four Decades of Printmaking." *Copia* (Evansville, Indiana), Summer 1993 (illus.).

Covi, Dario A. Introduction to *Pozzatti*. Louisville: Allen R. Hite Art Institute, University of Louisville Library, 1962 (exhibition brochure, illus.).

———. *Rudy Pozzatti: Four Decades of Printmaking*. Mount Vernon, Ill.: Mitchell Museum, 1992 (exhibition catalogue, illus.).

Elsen, Albert E. Catalogue note in *Pozzatti*. Washington, D.C.: Fine Arts Gallery, Jewish Community Center of Greater Washington, 1961.

———. "Paintings, Prints and Drawings by Rudy Pozzatti." In *Pozzatti*. Minneapolis: Walker Art Center, 1960 (exhibition brochure, illus.).

———. "Rudy Pozzatti." *Yes #11: A Magazine of the Creative Arts* (Bloomington, Ind.), May 1962 (illus.).

———. "The Second Life of Nature in the Art of Rudy Pozzatti." Typescript, Pozzatti vertical file, Indiana University Art Museum, n.d.

An Exhibition of Recent Paintings by Rudy Pozzatti. Louisville: J. B. Speed Art Museum, 1966 (exhibition brochure).

"Fine Arts: A Visual Love Affair—Rudy Pozzatti is a Most Uncommon Man." *Your Indiana University*, March–April 1978.

Finkelstein, Lydia Brown. "Arts in Review: Rudy Pozzatti." *Arts Indiana*, April 1992, 36 (illus.).

Geske, Norman. *Rudy Pozzatti, American Printmaker*. Lawrence: University of Kansas Press, 1971 (exhibition catalogue/catalogue raisonné, illus.).

Graphic Art of Rudy Pozzatti. Lincoln: Nebraska Art Association, 1969 (exhibition brochure, illus.).

The Graphic Art of Rudy Pozzatti. San Marcos, Tex.: Southwest Texas State College, 1968 (exhibition brochure, illus.).

Hamer, Mary Bob. "He Puts Some Pizzazz into Art." *IU Football Program*, September 23, 1972, 52–53 (illus.).

Harrison, Pegram, Wendy Calman, and Marvin Lowe. "Rudolph Otto Pozzatti." *To Honor Retiring Faculty* (Indiana University), April 9, 1991.

Humphrey, Susan E. "The New Rudy Pozzatti." *Indiana Alumni Magazine*, November 1977, 18–20 (illus.).

Italy 1964, Prints, Drawings, Sculpture and Paintings by Rudy Pozzatti. Bloomington: Indiana University Museum, 1964 (program brochure, illus.).

Kinsman, Robert D. Introduction to *Rudy Pozzatti*. Terre Haute: Sheldon Swope Art Gallery, 1979 (exhibition brochure, illus).

———. Introduction to *New Work by Rudy Pozzatti*. Terre Haute. Sheldon Swope Art Gallery, 1980 (exhibition brochure, illus).

Lane, Deborah. "Rudy Pozzatti at The Gallery." *Ryder Biweekly* (Bloomington, Ind.) Nov. 22–Dec. 5, 1991, 29 (illus).

Lehnen, Laura. "Arts in Review: Rudy Pozzatti." *Arts Indiana*, April 1988, 33 (illus.).

———. "Rudy Pozzatti: Staying on Course." *Arts Indiana*, Nov. 1989, 18–19 (illus.).

McKenna, George L. Catalogue note in *Pozzatti*. Louisville: Merida Gallery, 1967.

Moohl, Karl. "Rudy O. Pozzatti." *Journal of the Print World* 16, no. 4 (Fall 1993), 18 (illus.).

New Prints and Drawings by Rudy Pozzatti. New York: Weyhe Gallery, 1966 (exhibition brochure, illus.).

New Work by Rudy Pozzatti: Prints, Mixed Media, and Sculpture. Terre Haute: Sheldon Swope Art Gallery, 1980 (exhibition brochure, illus).

Page, A. F. Introduction to *An Exhibition of Recent Paintings by Rudy Pozzatti*. Louisville: J. B. Speed Art Museum, 1966 (exhibition brochure).

Paintings and Graphic Art by Pozzatti/66. Kansas City, Mo.: Nelson-Atkins Gallery, 1966 (exhibition brochure, illus.).

Paintings and Graphics by Rudy Pozzatti. San Francisco: Gumps Gallery, n.d. (exhibition brochure, illus.).

Pozzatti. Minneapolis: Walker Art Center, 1960 (exhibition brochure, illus.).

Pozzatti. Louisville: Allen R. Hite Art Institute, University of Louisville Library, 1962 (exhibition brochure, illus.).

Pozzatti. Louisville: Merida Gallery, 1967 (exhibition catalogue, illus.).

Pozzatti. Sioux City: Sioux City Art Center, 1986 (exhibition catalogue, illus.).

Pozzatti. Morrow, Ga.: Clayton Junior College Library, n.d. (exhibition catalogue, illus.).

"Pozzatti, A Man of Many Facets." *Your Indiana University*, March–April 1973, 4–6 (illus.).

Pozzatti: Prints and Drawings. Rochester, Mich.: Michigan State University-Oakland, 1963 (exhibition brochure).

Prasse, Leona E. Foreword to *Work of Rudy Pozzatti*. Cleveland: Print Club of Cleveland and Cleveland Museum of Art, 1955 (exhibition catalogue, illus.).

———. "An Exhibition of Work of Rudy Pozzatti." *Bulletin of the Cleveland Museum of Art* 42, no. 9 (November 1955): 198, 201–203 (illus.).

"The Print Collector: Rudy Pozzatti." *Art News* 54, no. 9 (January 1956): 16, 60 (illus.).

Prints by Pozzatti. Honolulu: Honolulu Academy of Arts, 1971 (exhibition catalogue, illus.).

Recent Prints and Collages: Rudy Pozzatti. New York: Weyhe Gallery, 1970 (exhibition brochure, illus.)

Recent Works. Mankato, Minn.: Mankato State University Conkling Gallery, 1985 (exhibition brochure, illus.)

Rudy Pozzatti. New York: Martha Jackson Gallery, ca. 1954 (exhibition brochure, illus.).

Rudy Pozzatti. Dowagiac, Mich.: Southwestern Michigan College Art Gallery, 1968 (exhibition brochure, illus.)

Rudy Pozzatti. Miami: Gloria Luria Gallery, 1972 (exhibition brochure, illus.).

Rudy Pozzatti. Franklin, Ind.: Franklin College Festival of the Arts, 1974 (festival brochure, illus.)

Rudy Pozzatti. New Orleans: Johnson-Whitty Gallery, 1976 (exhibition brochure, illus.).

Rudy Pozzatti. Terre Haute: Sheldon Swope Art Gallery, 1979 (exhibition brochure, illus).

Rudy Pozzatti. Peoria Heights, Ill.: Tower Park Gallery, 1980 (exhibition brochure, illus.).

"Rudy Pozzatti." *Roswell Museum and Art Center Quarterly Bulletin* 28, no. 2 and 3 (Summer 1980) (illus.).

Rudy Pozzatti. Roswell, N. Mex.: Roswell Museum and Art Center, 1980 (exhibition brochure, illus.).

Rudy Pozzatti. Fort Wayne, Ind.: Fort Wayne Museum of Art, 1985 (exhibition catalogue, illus.).

Rudy Pozzatti. Indianapolis: IPALCO Corporate Art Gallery, 1997 (exhibition brochure, illus.).

Rudy Pozzatti. Ames: Iowa State University, n.d. (exhibition catalogue, illus.)

"Rudy Pozzatti: Artist Illustrates Latin Treatise on Beasts." *Colorado Alumnus*, April 1966, 9.

Rudy Pozzatti: Drawings and Graphics. Kalamazoo: Kalamazoo Institute of Arts 1967 (exhibition brochure, illus.).

"Rudy Pozzatti: From Gifted Hands and Heart, a Gift of Art." *Developments* (Bloomington Hospital Foundation) Winter 2000, 1, 4 (newsletter, illus.).

Rudy Pozzatti: Four Decades of Printmaking. Bloomington, Ind.: The Gallery and John Waldron Arts Center 1995 (exhibition brochure, illus.).

Rudy Pozzatti: Gravador americano. Rio de Janeiro: The Museum of Modern Art, 1974 (exhibition catalogue, illus.)

Rudy Pozzatti: Incisioni, litografie. Florence, Italy: Galleria Mazzuchelli 1964 (exhibition brochure).

Rudy Pozzatti: Mid-States Tour. Ames: Iowa State Memorial Union, 1975 (exhibition brochure, illus.)

Rudy Pozzatti, New Works: Collages. Ann Arbor: Alice Simsar Gallery, 1985 (exhibition brochure).

Rudy Pozzatti: Paintings and Prints. Ann Arbor: Forsythe Gallery, 1965 (exhibition brochure, illus.).

Rudy Pozzatti: Printmaking in Italy. Athens: University of Georgia Studies Abroad in Cortona, Italy, 1987 (program brochure, illus.).

Rudy Pozzatti Prints. Sioux City: Sioux City Art Center, n.d. (exhibition brochure)

Rudy Pozzatti: A Retrospective Exhibit. Carbondale: Southern Illinois University, 1982 (exhibition brochure, illus.).

"Rudy Pozzatti: Program on October 19." *North Shore Art League News* (Winnetka, Ill.) 20, no. 2 (October 1972): 1 (illus.).

"Seventeenth Annual Old Orchard Fine Arts Festival." *North Shore Art League News* (Winnetka, Ill.) 22, no. 1 (September 1974): 7 (illus.).

Sommers, Joyce. "Rudy Pozzatti: The Power of Color." *Indianapolis Monthly*, May 1981, 122 (illus.).

Taff, Barbara, O. *Works on Paper—Rudy Pozzatti*. Washington, D.C.: Jane Haslem Gallery, 1975 (exhibition brochure, illus.).

Varner, Victoria Star. *Rudy Pozzatti: A Retrospective Exhibition*. Georgetown, Tex.: Southwestern University, and Austin, Tex.: Saint Edward's University, 1989 (exhibition review).

Wall, Kate. "A Gift from Rudy Pozzatti." *Images* (Bloomington, Ind., Hospital and Convalescent Center) Winter 1988 (newsletter, illus.).

Work by Rudy Pozzatti. Bloomington: Indiana University Art Center Gallery, 1957 (exhibition brochure).

Works on Paper—Rudy Pozzatti. Washington, D.C.: Jane Haslem Gallery, 1975 (exhibition catalogue).

Publications including Pozzatti (Books, magazine articles, exhibition catalogues, and brochures)

Albion College National Print and Drawing Exhibition 68. Albion, Mich.: Albion College, 1968 (exhibition catalogue, illus.).

Aman, Alfred C., Jr. "Celebrating Law and the Arts." *The Green Bag: An Entertaining Journal of Law* 2d Series, 2, no. 2 (Winter 1999): 129–30 (illus.).

American Drawing Annual XII. Norfolk, Va.: Norfolk Museum, 1954 (exhibition catalogue).

American Drawing Annual XVI. Norfolk, Va.: Norfolk Museum, 1956 (exhibition catalogue).

American Drawing Annual XVII. Norfolk, Va.: Norfolk Museum, 1957 (exhibition catalogue).

American Graphic Arts 1. Encino, Calif.: American Graphic Arts, n.d. (exhibition catalogue)

American Graphic Workshops: 1968. Cincinnati: Cincinnati Art Museum, 1968 (exhibition catalogue, illus.).

American Illustrated Books (1945–1965). New York: Spiral Press, 1965 (exhibition catalogue).

American Painting 1954. Richmond: Virginia Museum of Fine Arts, and Des Moines Art Center, 1954 (exhibition catalogue).

American Printmakers 1962. Syracuse: Syracuse University, 1962 (exhibition catalogue, illus.).

American Prints: 72. Ames: Iowa State University, Design Center Gallery, and Davenport Municipal Art Gallery, 1972 (exhibition catalogue, illus.).

Annual Exhibition Paintings, Sculpture, Watercolors, Drawings. New York: Whitney Museum of Art, 1955 (exhibition catalogue).

Appointment Calendar with Prints from the Collection of the Museum of Modern Art. New York: Museum of Modern Art, 1957 (illus.).

Arkansas Arts 89. Arkadelphia: Henderson State University, Russell Fine Art Center Gallery and Quachita University Mabee Fine Arts Center Gallery, 1989 (exhibition catalogue).

Arnason, H. Harvard. "Recent Art of the Upper Midwest: Universities as Centers of Art." *Art in America* 42, no. 1 (Winter 1954): 46–47, 72 (illus.).

Art and Liturgy: Seventh Annual Ecclesiastical Art Exhibit. Chicago: National Conference of Church Architecture, 1965 (exhibition catalogue, illus.).

Art Collection of the Indiana Memorial Union. Bloomington, 1970 (brochure).

El Arte moderno en los Estados Unidos. Barcelona: Museo de Arte Moderno, 1955 (exhibition catalogue).

Art "500": Fine Arts Exhibition. Indianapolis: Churchman-Fehsenfeld Galleries, 1976 (exhibition catalogue).

The Artist and Medicine. Bethesda: National Library of Medicine, 1973 (exhibition catalogue).

Artists Abroad. Institute of International Education, n.d. (exhibition catalogue, illus.).

Artists in Indiana, Then and Now: Works on Paper by Indiana Artists. Muncie: Ball State University, 1976 (exhibition catalogue, illus.).

Artists in the Trenches: An Invitational Print Show. Minneapolis: Katherine E. Nash Gallery, University of Minnesota (West Bank Campus), 1984 (exhibition catalogue).

Art Smart: New Vistas Two. Lafayette, Ind.: Greater Lafayette Museum of Art, n.d. (exhibition brochure, illus.).

The Bardstorm Invitational Exhibition. Bardstorm, Ky., 1973 (exhibition brochure, illus.).

Baro, Gene. *Thirty Years of American Printmaking* (including the 20th National Brooklyn Print Exhibition). Brooklyn, N.Y.: Brooklyn Museum, 1976 (exhibition catalogue, illus.).

Bay Printmakers' Society Fifth National Exhibition. Oakland: Oakland Art Museum, 1960 (exhibition catalogue).

Bay Printmakers' Society Fourth National Exhibition, Oakland: Oakland Art Museum, 1958 (exhibition catalogue).

Bay Printmakers' Society Third National Exhibition, Oakland: Oakland Art Museum, 1957 (exhibition catalogue).

Big Prints. Albany: Art Gallery, State University of New York, 1968 (exhibition catalogue, illus.).

Bill of Particulars. Bloomington: Indiana University School of Law, 1993 (brochure, illus.).

Black and White Exhibition. Philadelphia: The Print Club, 1969 (exhibition brochure).

The Blunted Edge, Problems in Psychotherapy. Roche Laboratories, n.d. (promotional brochure, illus.).

The Book as Art. Washington, D.C.: Fendrick Gallery, 1976 (exhibition catalogue).

"Books and Fine Arts." *Indiana Alumni Magazine,* April 1963.

Boston Printmakers. Duxbury, Mass.: Art Complex, 1974 (exhibition brochure).

Boston Printmakers Eighteenth Annual Print Exhibition. Boston: Museum of Fine Arts, 1966 (exhibition catalogue).

Boston Printmakers Eleventh Annual Print Exhibition, Boston: Museum of Fine Arts, 1958 (exhibition catalogue).

Boston Printmakers Fourteenth Annual Print Exhibition. Boston: Museum of Fine Arts, 1961 (exhibition catalogue).

Boston Printmakers Nineteenth Annual Exhibition. Boston: Museum of Fine Arts, 1967 (exhibition catalogue, illus.).

Boston Printmakers Seventeenth Annual Print Exhibition. Boston: Museum of Fine Arts, 1965 (exhibition catalogue, illus.).

Boston Printmakers Twenty-First Annual Exhibition. Boston: Museum of Fine Arts, 1969 (exhibition catalogue).

Boston Printmakers Twenty-Second Annual Print Exhibition. Boston: Copley Society, 1970 (exhibition catalogue).

Breverman Collection. Athens: Trisolini Gallery of Ohio University, 1992 (exhibition catalogue, illus.).

Brooklyn Museum Ninth National Print Annual. New York: The Brooklyn Museum, 1955 (exhibition catalogue).

California Monthly (Berkeley, California), May 1963, 25.

Carleton Centennial Print Invitational. Northfield, Minn.: Carleton College, 1966 (exhibition brochure).

Cast in Carbondale. St. Louis: Laumeier International Sculpture Park, 1982, and Alexandria, La.: Alexandria Museum Visual Art Center, 1982–83 (exhibition brochure, illus.).

Catalogue Raisonné: Tamarind Lithography Workshop, Inc., 1960–1970. Albuquerque: University of New Mexico Art Museum, 1989 (illus.).

A Celebration of the Arts. Bloomington: Indiana University, 1987 (program brochure, cover).

Centennial Exhibition American Association of Land Grant Colleges and Universities. Kansas City, Mo.: Nelson Gallery and Atkins Museum, 1961 (exhibition catalogue, illus.).

Chaet, Bernard. *Artists at Work.* Cambridge, Mass.: Webb Books, Inc., 1960 (illus.).

Christchurch Arts Festival International of Drawings. Christchurch, New Zealand: Robert McDougall Art Gallery, 1978 (exhibition catalogue).

Church Art Today: An Exhibition of Contemporary Ecclesiastical Arts. San Francisco: Grace Cathedral, 1957 (exhibition brochure).

The Cincinnati Biennial I. Cincinnati: Cincinnati Art Museum, 1967 (exhibition catalogue, illus.).

City on a Hill: Twenty Years of Artists at Cortona. Athens: Georgia Museum of Art, 1989 (exhibition catalogue, illus.).

"Collecting Original Art Prints." *Holiday*, February 1966.

Collectors Choice III: A Special Christmas Season Exhibition. Terre Haute: Sheldon Swope Art Gallery, 1965 (exhibition catalogue).

Collectors' Opportunities 1967. Atlanta: High Museum of Art, 1967 (exhibition brochure).

College Art Journal 15, no. 2 (Winter 1955): 163.

College Prints 1954. Youngstown: Butler Art Institute, 1954 (exhibition brochure).

"College Ties." *Time*, April 11, 1955, 92 (illus.).

Colorprint U.S.A. Lubbock: Texas Tech University, 1971 (exhibition catalogue).

Colorprint U.S.A. Lubbock: Texas Tech University, 1988 (exhibition catalogue, illus.).

Color Prints of the Americas: Thirty-First Annual Exhibition of the American Color Print Society. Philadelphia: American Color Print Society, 1970 (exhibition brochure).

Contemporary American Prints. Champaign: University of Illinois, Krannert Art Museum, 1970 (exhibition catalogue).

Contemporary American Prints. Williamsburg, Va.: Williamsburg Restoration, Inc., n.d. (exhibition brochure).

Contemporary Art Show. Indianapolis: Indiana State Museum, 1976 (exhibition catalogue).

Contemporary Arts of the United States. Pomona, Calif.: Los Angeles County Fair Association, 1956 (exhibition catalogue, illus.).

Contemporary Drawings from Twelve Countries (1945–1952). Chicago: Art Institute of Chicago, 1952 (exhibition catalogue).

Contemporary Masters—Drawings and Prints: Kane Memorial Exhibition. Providence, R.I.: Providence Art Club, 1963 (exhibition catalogue, illus.).

Contemporary Painting. Boulder: Fine Arts Gallery, University of Colorado, 1956 (exhibition catalogue).

Contemporary Printmaking: Intaglio (An Invitational Exhibition of Contemporary Intaglio Prints). Louisville: Allen R. Hite Art Institute, University of Louisville, 1981 (exhibition catalogue).

Contemporary Trends in Printmaking. Highland Heights, Ky.: Northern Kentucky University, 1990 (exhibition catalogue).

Dimensions (Simpson Lee Paper Co., Vicksburg, Mich.) 9, no. 3 (Fall 1996): 3 (newsletter, illus.).

Directions: The First All-Campus Fine Arts Faculty Exhibition from Indiana University. Bloomington: Indiana University Press, 1995 (exhibition catalogue, illus.).

Distinguished University Artists. Chapel Hill: Ackland Art Center, 1965 (exhibition catalogue).

Drawing: I.A.E.A. Directions. Chicago: Illinois Art Education Association, 1960 (conference catalogue, illus.).

Drawing Invitational. Baton Rouge: Louisiana State University, 1962 (exhibition catalogue, illus.).

Drawings from Seventeen States. Houston: Museum of Fine Arts, 1965 (exhibition catalogue).

Drawings/USA (First Biennial Exhibition). St. Paul: St. Paul Gallery and School of Art, 1961 (exhibition catalogue).

Editions in Bronze. New York: Associated American Artists, n.d. (purchase catalogue, illus.).

Eighth Annual Colorprint U.S.A. Lubbock: Texas Tech University, n.d. (exhibition catalogue).

Eighth Annual Contemporary Printmakers Exhibition. Greencastle, Ind.: Art Center, DePauw University, 1966 (exhibition brochure).

Eighth Annual Michiana Regional Art Exhibition. South Bend: South Bend Art Association, 1957 (exhibition brochure).

Eighth National Exhibition of Prints and Drawings. Oklahoma City: Oklahoma Art Center, 1966 (exhibition catalogue).

Eighty Prints. Lafayette, Ind.: Purdue University Fine Arts Gallery, 1972 (exhibition catalogue, illus.).

Eleven American Printmakers. University Park: Pennsylvania State University, 1959 (exhibition catalogue, illus.).

Eleven in Seventy-Seven (International Exhibition). Dekalb: Northern Illinois University, 1977 (exhibition catalogue, illus.).

Eleventh Annual Drawing and Small Sculpture Show. Muncie: Ball State University Art Gallery, 1965 (exhibition catalogue).

Engraving America 1974. St. Joseph, Mich.: Albrecht Art Museum, 1974 (exhibition catalogue, illus.).

An Exhibition of Contemporary Art from the Collection of Mr. and Mrs. Leslie L. Johnson. Cincinnati: Studio San Giuseppe, College of Mount St. Joseph, 1964 (exhibition brochure, illus.).

An Exhibition of Contemporary Art from the Collection of Mr. and Mrs. Leslie L. Johnson. Cincinnati: Studio San Giuseppe, College of Mount St. Joseph, 1967 (exhibition brochure, illus.).

Excellence 4, no. 2 (December 2000).

Exhibition of Annual Exhibitions. Canton, N.Y.: E.J. Noble Center Gallery and Griffiths Art Center Gallery, St. Lawrence University, 1968 (exhibition catalogue).

Exhibition of Contemporary Liturgical and Religious Art. Denver: Denver Art Museum, 1955 (exhibition catalogue).

An Exhibition of Prints by Invitation. Memphis: Brooks Memorial Art Gallery, 1960 (exhibition brochure).

Exhibition of Western Art. Denver: Schleier Gallery, Denver Art Museum, 1954 (exhibition catalogue).

Faculty and Staff Collect. Ames: Design Center Gallery, Iowa State University, 1975 (exhibition catalogue, illus.).

Faculty of the Indiana University Printmaking Program. Pomona, N.J.: Stockton State College Art Gallery, 1989 (exhibition brochure).

Festival of Contemporary Art. Springfield, Ohio: Springfield Art Center, 1968 (exhibition catalogue).

Festival of Religious Art Exhibit. Columbus: The Ohio Union, Ohio State University, 1956 (exhibition catalogue).

Festival of Religious Art Exhibit. Columbus: The Ohio Union, Ohio State University, 1957 (exhibition catalogue).

Festival of the Arts Nineteen-Fifty-Eight. Decatur, Ill.: Milliken University, 1958 (exhibition brochure, illus.).

Fifteen American Printmakers. Muncie: Ball State Art Gallery, 1964 (exhibition catalogue, illus.).

Fifteenth Artists West of the Mississippi. Colorado Springs: Colorado Springs Fine Arts Center, 1955 (exhibition catalogue, illus.).

Fifteenth Annual Missouri Exhibition. St Louis: City Art Museum of St. Louis, 1956 (exhibition catalogue).

Fifteenth Annual Statewide Competition. Alma, Mich.: Alma College, 1995 (exhibition catalogue, illus.)

Fifteenth National Bradley Print Show. Peoria: Bradley University, 1975 (exhibition catalogue).

Fifth Annual Southeastern Graphics Council Conference. Birmingham: University of Alabama in Birmingham, 1978 (workshop brochure).

Fifth Friends of Art Biennial Regional Exhibition. Manhattan: Kansas State College, 1958 (exhibition catalogue).

Fifth International Miniature Print Exhibition. New York: Pratt Graphic Center Gallery, 1975 (exhibition catalogue).

Fifth International Print Exhibition. St. Charles, Mo.: Lindenwood College, 1970 (exhibition catalogue).

Fifth National Print and Drawing Exhibition. Olivet, Mich.: Olivet College Festival of Fine Arts, 1965 (exhibition catalogue).

Fiftieth Annual International Exhibition: Watercolor, Prints, Drawings. Philadelphia: Pennsylvania Academy of the Fine Arts and the Philadelphia Watercolor Club, 1952 (exhibition catalogue).

Fifty American Printmakers. Lincoln, Mass.: DeCordova and Dana Museum, 1961 (exhibition catalogue, illus.).

Fifty Contemporary Printmakers, Second Biennial Exhibition. Champagne: University of Illinois, 1956 (exhibition catalogue, illus.).

Fifty-Eighth Annual Exhibition of the Society of Graphic Artists. New York: Fashion Institute of Technology, 1980 (exhibition catalogue).

Fifty-Eighth Western Annual Exhibition. Denver: Denver Art Museum, 1952 (exhibition catalogue)

Fifty-Fifth Annual Indiana Artists Exhibition. Indianapolis: Herron Museum of Art, 1962 (exhibition catalogue, illus.).

Fifty-Fifth National Exhibition of the Society of American Graphic Artists. New York: Associated American Artists Gallery, 1977 (exhibition catalogue).

Fifty-Fifth National Exhibition of the Society of American Graphic Artists: Traveling Show. New York: Associated American Artists Gallery, 1977 (exhibition catalogue, illus.).

Fifty-First Annual Exhibition: Watercolors, Prints, Drawings. Philadelphia: Pennsylvania Academy of the Fine Arts and the Philadelphia Watercolor Club, 1953 (exhibition catalogue).

Fifty Indiana Prints. Indianapolis: Herron Museum of Art, 1960 (exhibition brochure, illus.).

Fifty Indiana Prints. Indianapolis: Herron Museum of Art, 1962 (exhibition brochure).

Fifty Indiana Prints 1966 Eighth Biennial Exhibition. Indianapolis: Herron Museum of Art, 1966 (exhibition brochure).

Fifty-Ninth Annual Exhibition of the Society of Graphic Artists. New York: Galleries at the Cooper Union, 1982 (exhibition catalogue).

Fifty-Second Annual Print Exhibition of the Society of American Graphic Artists. New York: Associated American Artists Gallery, 1973 (exhibition catalogue).

Fifty-Third Annual Print Exhibition of the Society of American Graphic Artists. New York: Azuma Galleries, 1975 (exhibition catalogue, illus.).

Fifty-Third Annual Print Exhibition of the Society of American Graphic Artists: Traveling Exhibition. Montpelier, Vt.: Wood Art Gallery, 1975 (exhibition catalogue, illus.).

First Annual Exhibition of the "500" Festival of the Arts. Indianapolis: "500 Festival of the Arts" Committee and Indianapolis Art League Foundation, 1966 (exhibition catalogue).

First Graphics Exhibition. El Paso: Texas Western College, 1955 (exhibition catalogue).

First Hawaii Print Exhibition. Honolulu: Honolulu Academy of Arts, 1971 (exhibition catalogue, illus.).

First National Annual Invitational Exhibition. Los Angeles: Otis Art Institute of Los Angeles County, 1962 (exhibition catalogue, illus.).

First National Exhibition of Prints. Oakland: Bay Printmakers Society, Oakland Art Museum, 1955 (exhibition catalogue).

First National Print Exhibition. Clinton, N.J.: Hunterdon County Art Center, 1957 (exhibition catalogue).

First Provincetown Arts Festival: American Art of Our Time. Provincetown: 1958 (exhibition catalogue).

First Wisconsin Print Show International. Madison: Madison Art Center and the Ellison Bay Festival of the Arts, 1968 (exhibition catalogue, illus.).

"500" Arts Exhibition. Indianapolis: Indiana Convention-Exposition Center, 1973 (exhibition catalogue).

Folio (Bloomington, Ind.) 25, no. 2 (Spring 1960).

Fortieth American Color Print Society Exhibition. Jenkintown, Pa.: Abington Art Center, 1984 (exhibition catalogue).

Fortieth Anniversary Exhibition. Philadelphia: The Print Club, 1955 (exhibition catalogue).

Forty-Seven Midwestern Printmakers. Chicago: 1020 Art Center, 1956 (exhibition catalogue, illus.).

Forty-Seventh Annual Exhibition of the SAGA. New York: Society of American Graphic Artists, 1966 (exhibition catalogue).

Forty-Sixth Annual Exhibition of the Society of Graphic Artists. New York: Associated American Artists Gallery, 1965 (exhibition catalogue).

Four Brothers Press, 1980–87. Chicago, Ill.: University of Illinois at Chicago, n.d. (exhibition brochure).

Four Midwest Printmakers. Dekalb: Northern Illinois University, 1970 (exhibition brochure).

Four Printmakers. Jonesboro: Arkansas State University Art Gallery, 1969 (exhibition brochure, illus.).

Fourteenth Annual Missouri Exhibition. St. Louis: City Art Museum, 1955 (exhibition brochure).

Fourteenth Annual National Exhibition of Prints and Drawings. Oklahoma City: Oklahoma Art Center, 1972 (exhibition catalogue).

Fourteenth Artists West of the Mississippi. Colorado Springs: Colorado Springs Fine Arts Center, 1953 (exhibition catalogue).

Fourteenth Christocentric Arts Festival: An Invitational Exhibition of Contemporary Christian Liturgical Art. Champaign: Lewis Gallery, University of Illinois, 1964 (exhibition catalogue).

Fourteenth National Exhibition of Prints Made during the Current Year. Washington, D.C.: Library of Congress, 1956 (exhibition catalogue).

Fourth Annual Color Print U.S.A. Lubbock: Texas Tech University, 1973 (exhibition catalogue, illus.).

Fourth Annual Drawing and Small Sculpture Show. Muncie: Ball State Teachers College Art Gallery, 1958 (exhibition catalogue).

IV Biennale di pittura americana. Citta' di Bordighera Pallazzo del Parco, 1957 (exhibition catalogue).

IV Bienal americana de artes gráficas/IV American Biennial of Graphic Arts. Cali, Colombia: Museo de Arte Moderno la Terulia, 1981 (exhibition catalogue, illus.).

Fourth Biennial Exhibition: Fifty Indiana Prints. Indianapolis: John Herron Art Museum, 1958 (exhibition catalogue, illus.).

Fourth Biennial Exhibition of Painting and Prints. Minneapolis: Walker Art Center, 1954 (exhibition catalogue, illus.).

Fourth Dulin National Print and Drawing Competition. Knoxville: Dulin Gallery of Art, 1968 (exhibition catalogue, illus.).

Fourth Midwest Biennial. Omaha: Joslyn Art Museum, 1956 (exhibition catalogue, illus.).

IV Mostra internazionale di bianco e nero. Italy, 1956 (exhibition catalogue, illus.).

Fourth National Invitational Drawing Exhibition. Green Bay: University of Wisconsin, 1973 (exhibition catalogue, illus.).

Fourth Regional Friends of Art Biennial. Manhattan: Kansas State College, 1956 (exhibition catalogue).

Friends of Art: Third Biennial Regional Exhibition. Manhattan: Kansas State College, 1954 (exhibition catalogue).

Fulbright Painters. Washington, D.C.: Traveling Exhibition Service, Smithsonian Institution & Institute of International Education, 1958–59 (exhibition catalogue, illus.).

A Gift of Time: Twentieth Anniversary, The Art-in-Residence Program. Roswell, N. Mex.: Roswell Museum and Art Center, 1987 (exhibition catalogue, illus.).

Grabados originales, Coleccion Pennell. San Salvador, Central America: Biblioteca del Congreso de los EE, UU, Centre El Salvador, Estados Unidos, Oct. 1961 (exhibition catalogue).

Graphic Arts Loan Collection. Berkeley: University of California General Library, 1964 (brochure).

Graphic Arts USA. Champaign: University of Illinois, 1954 (exhibition catalogue, illus.).

Graphics Biennial. Miami: Metropolitan Museum and Art Center, 1975 (exhibition catalogue).

Graphics from the Collection of Mr. and Mrs. Leslie L. Johnson. San Diego: Fine Arts Gallery of San Diego, 1972 (exhibition catalogue).

Graphics from the Collection of Mr. and Mrs. William A. Combs. Kalamazoo: Kalamazoo Institute of Arts, 1970 (exhibition catalogue).

Graphics '59. Lexington: University of Kentucky Art Gallery, 1959 (exhibition catalogue).

Graphics '61. Lexington: University of Kentucky Art Gallery, 1961 (exhibition catalogue).

Graphics '62. Lexington: University of Kentucky Art Gallery, 1962 (exhibition catalogue, illus.).

La Gravure americaine d'aujourd'hui. Paris: Centre Culturel Americain, Print Council of America, ca. 1959 (exhibition catalogue).

Haas, Irvin. "The Print Collector." *Art News* 54, no. 9 (Jan. 1956): 16.

Heller, Jules. *Printmaking Today.* New York: Holt, Rinehart, and Winston, 1972 (illus.).

Henry Radford Hope School of Fine Arts: 1991 Faculty Exhibition. Bloomington: Indiana University Art Museum, 1991 (exhibition catalogue, illus.).

Heusen, Mildred. "Introducing Some Boston Printmakers." *Connoisseur* 164, no. 661 (March 1967): 199.

Hooton, Bruce, and Nina Kaiden, eds. *Mother and Child in Modern Art.* New York: Duell, Sloan and Pearce, 1963 (illus.).

Howard S. Wilson Memorial Collection. Lincoln, Neb: Sheldon Memorial Art Gallery, 1966 (exhibition catalogue, illus.).

Hults, Linda, C. *The Print in the Western World: An Introductory History.* Madison: University of Wisconsin Press, 1996 (illus.).

I Borsisti Fulbright. Saletta USIS, Borgo San Sepolcro, Italy, 1964 (exhibition brochure).

IGAS Bulletin, May 1964, no. 59 (illus.).

IIE News Bulletin 33, no. 4 (Dec. 1957): 26–27 (illus.).

Important Prints. Washington, D.C.: Jane Haslem Gallery, n.d. (exhibition catalogue, illus.).

Impressions: A Magazine of the Graphic Arts, Dec. 1957, no. 2.

Inaugural Fine Arts Exhibition. Indianapolis: Indiana State Museum, 1974 (exhibition catalogue).

In Celebration of Prints. Philadelphia: Print Club of Philadelphia and Philadelphia Art Alliance, ca. 1980 (exhibition catalogue).

"In the Course of a Day." *Indiana Alumni Magazine,* May/June 1995, 16 (illus.).

Indiana Artists Exhibition. Indianapolis: Herron Museum of Art, 1962 (exhibition catalogue, illus.).

Indiana/Illinois Bicentennial Painting Exhibition. Hammond, Ind.: Northern Indiana Art Association, 1976 (exhibition catalogue, illus.).

Indianapolis Open-Air Gallery. Indianapolis: Indianapolis Art League, 1978 (exhibition catalogue, illus.).

Indiana Printmakers: Traveling Show. Indianapolis: Indiana Arts Commission, 1974–75 (exhibition catalogue).

Indiana University: Distinction in the Heartland. Bloomington: Indiana University Foundation, n.d. (fundraising brochure, illus.).

Indiana University: Faculty and Student Print Show. Franklin, Ind.: Washington Gallery, 1973 (exhibition brochure).

The Innovators: Renaissance in American Printmaking. Washington, D.C.: Jane Haslem Gallery, 1973 (exhibition catalogue).

Instructors and Their Students: An Exhibition of Works on Paper. Lubbock: Texas Tech University, 1978 (exhibition catalogue).

International Invitational Print Exhibition. St. Louis: Washington University and University of Minnesota, 1955–56 (exhibition catalogue).

International Print Exhibition. Portland, Oreg.: Portland Art Museum, 1997 (exhibition catalogue).

Invitational American Drawing Exhibition. San Diego: Fine Arts Gallery, 1977 (exhibition catalogue).

Italian American Painters. New York: Harry Salpeter Gallery, 1959 (exhibition catalogue).

J. B. Speed Art Museum Bulletin 25, no. 3 (Sept. 1965): 13.

Johnson, Una E. *Ten Years of American Prints 1947–1956/Brooklyn Museum Tenth National Print Annual*. Brooklyn, N.Y.: Brooklyn Institute of Arts and Science, 1956 (exhibition catalogue).

Judith Brown/Rudy Pozzatti. Plattsburg, N.Y.: John P. Myers Fine Art Gallery, State University College of Arts and Science, 1972 (exhibition brochure, illus.).

Kansas National Invitational Print Exhibition. Lawrence: University of Kansas Museum of Art, 1964 (exhibition catalogue).

Kentuckiana Painters Invitational Exhibition. Elizabethtown, Ky.: Phelps Dodge Communication Co., 1975 (exhibition catalogue).

Leach, Frederick D. "Ultimate Concerns." *Ohio University Review* 2 (1960): 81–83 (illus.).

"Lecturers, Performers, Add to Interest of Pilot Group in Humanities Seminar." *INSITE Reporter* (School of Education, Indiana University) 1, no. 1 (June 1966): 4–6 (newsletter, illus.).

Lending Gallery Collection. Columbus, Ohio: Columbus Gallery of Fine Arts, 1961–62 (brochure).

Leroy Burket/Rudy Pozzatti. Norman: University of Oklahoma Museum of Art, 1956 (exhibition brochure, illus.).

The Liberal Context (Boston, Mass.), Winter 1962 (illus.).

Library of Congress, Prints and Photographs Division. *American Prints in the Library of Congress: A Catalog of the Collection*. Baltimore: Johns Hopkins Press, 1970 (illus.).

Living Prints. Philadelphia: Free Library of Philadelphia, 1964 (exhibition brochure).

Lowe/Pozzatti. Belgrade, Yugoslavia: American Embassy Gallery, 1976 (exhibition brochure, illus.).

Lowe/Pozzatti. New Harmony, Ind.: New Harmony Gallery of Contemporary Art, 1976 (exhibition brochure, illus.).

Malone, Robert R., Zuo Yingxue, and Scott Wampler. *Contemporary Printmaking*. Changehun, China: Jilin Fine Arts Publishing House, 1999 (illus.).

McNeese National Printmaking Invitational. Lake Charles, La.: Abercrombie Gallery, McNeese State University, 1995 (exhibition catalogue, illus.).

Miami Collects. Oxford, Ohio: Miami University Art Museum, 1984 (exhibition catalogue).

Mid-States Art Exhibition: Twenty-Eighth Annual Competition. Evansville: Evansville Museum of Arts and Science, 1975 (exhibition catalogue).

Midwestern Printmakers. Madison: University of Wisconsin Department of Art Education Galleries, 1953 (exhibition catalogue).

Midwestern University Print Makers. Lawrence: University of Kansas Museum of Art, 1958 (exhibition catalogue).

Mitchell, Breon. *Beyond Illustration: The Livre d'Artiste in the Twentieth Century*. Bloomington, Ind.: Lilly Library, 1976 (exhibition catalogue, illus.).

Modern Masters of Intaglio. New York: Queens College, City University of New York, n.d. (exhibition catalogue).

"More Art than Money." *Vogue*, December 1955, 139 (illus.).

"More Exhibitions." *Art Journal* 27, no. 4 (Summer 1968): 428 (illus.).

The Museum of Modern Art Bulletin 22, no. 4.

Music and Art. Minneapolis: University of Minnesota Art Gallery, and Grand Rapids: Grand Rapids Art Gallery, 1958 (exhibition catalogue).

National Academy of Design: One-Hundred-Sixty-Sixth Annual Exhibition. New York: National Academy of Design, 1991 (exhibition catalogue).

National Invitational Printmaking Exhibition. Green Bay: Neville Public Museum, 1969 (exhibition catalogue).

National Invitational Prints. Anchorage: Anchorage Historical and Fine Arts Museum, 1972 (exhibition catalogue, illus.).

National Invitational Prints 2. Anchorage: Anchorage Historical and Fine Arts Museum, 1974 (exhibition catalogue, illus.).

National Invitational Print Show. Long Beach: California State College at Long Beach Art Gallery, n.d. (exhibition catalogue, illus.).

National Print and Drawing Exhibition. Dekalb: Northern Illinois University, 1968 (exhibition catalogue).

National Printmaking IUP Invitational. Indiana, Pa.: Kipp Gallery, Indiana University of Pennsylvania, 1984 (exhibition catalogue).

National Prize Print Exhibition. Dallas: Dallas Museum of Fine Arts, 1954 (exhibition brochure).

"Nationwide Notes: Northwest Printmakers." *Art Digest* 29, no. 13 (April 1, 1955): 17 (illus.).

Nebraska Art Association Seventy-Fourth Annual Exhibition. Lincoln: Sheldon Memorial Art Gallery, University of Nebraska Art Galleries, 1965 (exhibition catalogue).

Nebraska Art Association Sixty-Fourth Annual Exhibition. Lincoln: University of Nebraska, 1954 (exhibition catalogue, cover).

Nebraska Art Today: A Centennial Invitational Exhibition. Lincoln: Sheldon Memorial Art Gallery, and Omaha: Joslyn Art Museum, 1967 (exhibition catalogue, illus.).

"New Acquisitions." *Nebraska Art Association Quarterly* (Sheldon Memorial Art Gallery) 2, no. 2 (Fall 1972): 8 (illus.).

New Directions in American Printmaking. Hempstead, N.Y.: Emily Lowe Gallery, Hofstra University, n.d. (exhibition catalogue, illus.).

Nineteen-Fifty-Eight Louisville Art Center Annual Exhibition of Art. Louisville: J. B. Speed Museum, 1958 (exhibition catalogue).

Nineteen-Fifty-Nine Louisville Art Center Annual Exhibition of Art. Louisville: Art Center Association of Louisville, J. B. Speed Museum, 1958 (exhibition catalogue, illus.).

Nineteen-Fifty-Six Annual Exhibition of Contemporary American Sculpture, Watercolors and Drawings. New York: Whitney Museum of Art, 1956 (exhibition catalogue).

Nineteen-Fifty-Six Biennial of Paintings, Prints and Sculpture from the Upper Midwest. Minneapolis: Walker Art Center, 1956 (exhibition catalogue, illus.).

Nineteen-Fifty-Three Baltimore National Water Color Exhibition. Baltimore: Baltimore Museum of Art, 1953 (exhibition catalogue).

1952 All Nebraska Exhibition. Omaha: Joslyn Art Museum and Lincoln: University Art Galleries, Morrill Hall, 1952 (exhibition brochure).

Nineteen-Fifty-Two Annual Exhibition of Contemporary American Painting. New York: Whitney Museum of American Art, 1952–53 (exhibition catalogue).

Nineteen-Sixty-Seven Wisconsin Printmakers. Menomonie, Wis.: Stout State University, 1967 (exhibition catalogue).

Nineteenth-and-Twentieth-Century American and European Portraits and Heads from the Dadée and George Burk Collection. Evansville: Evansville Museum of Arts and Science, 1991 (exhibition catalogue).

Nineteenth Annual All-Nebraska Show of Nineteen-Fifty-Five. Omaha: Joslyn Memorial Art Museum, 1955 (exhibition catalogue).

Nineteenth Annual Midyear Show. Youngstown: Butler Institute of American Art, 1954 (exhibition catalogue).

Nineteenth Annual National Exhibition of Prints. Washington, D.C.: Library of Congress, Prints and Photographs Division, 1963 (exhibition catalogue).

Ninth Annual Color Print U.S.A. Lubbock: Texas Tech University, 1980 (exhibition brochure, illus.).

Ninth Annual Contemporary American Printmakers Exhibition. Greencastle, Ind.: DePauw University, 1967 (exhibition brochure).

Ninth Annual Exhibition of Oil Painting by Artists of the Missouri Valley. Topeka: Mulvane Art Museum, Washburn University, 1955 (exhibition catalogue).

Ninth Michiana Regional Art Exhibition, Paintings—Prints— Drawings. South Bend: Art Center, 1958 (exhibition catalogue, illus.).

Northwest Printmakers Fortieth International Exhibition. Seattle: Seattle Art Museum, and Portland: Portland Art Museum, 1969 (exhibition brochure).

Northwest Printmakers Twenty-Eighth International Exhibition. Seattle: Seattle Art Museum, and Portland: Portland Art Museum, 1965 (exhibition brochure).

Northwest Printmakers Twenty-Seventh International Exhibition. Seattle: Seattle Art Museum, 1955 (exhibition brochure, illus.).

Notes and Comment from the Walker Art Center 6, no. 1 (November 1951).

Oklahoma Printmakers Society First National Exhibition of Contemporary American Graphic Art. Oklahoma City: Oklahoma City University, 1959 (exhibition catalogue, illus.).

One Hundred: An Exhibition of Contemporary Art. Dayton: University of Dayton, 1965 (exhibition brochure).

One-Hundred-and-Fifty-Fourth Annual Exhibition: Watercolors, Prints and Drawings. Philadelphia: Junior Art Gallery, 1959 (exhibition catalogue).

One-Hundred-and-Fifty-Second Annual Exhibition (Watercolors—Paintings—Sculpture). Philadelphia: Pennsylvania Academy of Fine Arts, 1957 (exhibition catalogue).

One-Hundred-and-Forty-Ninth Annual Exhibition of Painting and Sculpture. Philadelphia: Pennsylvania Academy of the Fine Arts, 1954 (exhibition catalogue).

One-Hundred-and-Forty-Sixth Annual Exhibition of Painting and Sculpture. Philadelphia: Pennsylvania Academy of Fine Arts, 1951 (exhibition catalogue).

One-Hundred-and-Sixtieth Annual Exhibition. Philadelphia: Pennsylvanian Academy of Fine Arts, 1965 (exhibition catalogue).

One-Hundred-and-Sixty-Fourth Annual Exhibition. Philadelphia: Pennsylvania Academy of Fine Arts, 1969 (exhibition catalogue).

One Hundred Prints of the Year, 1962. New York: Society of American Graphic Artists, Inc., 1963 (exhibition catalogue, illus.).

Pacific Print II. Costa Mesa, Calif.: Orange Coast College, 1966 (exhibition catalogue, illus.).

Paintings, Drawings, Prints from the Collection of Mr. and Mrs. Leslie L. Johnson. Richmond, Ind.: Earlham College, 1964 (exhibition brochure).

Paintings for Young Collections. Dallas: Dallas Museum of Fine Arts, 1955 (exhibition catalogue).

Perspectives in Color: A National Invitational Color Print Exhibition. Madison, Wis.: Madison Art Center, 1966 (exhibition brochure; also served as an exhibition brochure for the traveling-show component of the same name).

Peterdi, Gabor. *Printmaking: Methods Old and New.* New York: Macmillan, 1959 (illus.).

The Plain Brown Wrapper Hard Times National Print Exhibition. Atlanta: Georgia State University Gallery, 1978 (exhibition catalogue).

Potsdam Prints 1967. Potsdam: State University College, 1967 (exhibition catalogue).

Potsdam Prints 1968. Potsdam: State University College, 1968 (exhibition catalogue, illus.).

Potsdam Prints 1972. Potsdam: State University College, 1972 (exhibition catalogue).

Potsdam Prints 1974. Potsdam: State University College, 1974 (exhibition catalogue).

Prasse, Leona E. *IGAS Bulletin* no. 33 (March 1959) (illus.).

Preview '71. Cincinnati: College of Mount St. Joseph Studio San Guiseppe, 1970 (exhibition catalogue).

Pressed and Pulled VI: National Juried Printmaking Exhibition. Milledgeville: Georgia College and State University, Blackbridge Hall Gallery, 1997 (exhibition catalogue).

Prima biennal interamericana de pintura y grabado. Mexico: Instituto Nacional De Bellas Artes, 1958 (exhibition catalogue).

Print 1/500: International Printmaking Invitational. San Bernardino: California State College, 1983 (exhibition catalogue, illus.).

Print Club Permanent Collection. Philadelphia: The Print Club, 1980 (gallery brochure).

Print Exhibitions Calendar. New York: Print Council of America, 1965.

Printmakers of Indiana. Fort Wayne: Art Education Association of Indiana, n.d. (exhibition catalogue, illus.).

Printmaking USA. Lafayette, Ind.: Fine Arts Gallery, Purdue University, 1966 (exhibition catalogue, illus.).

Print National Invitational. Reno: University of Nevada Arts Festival, 1970 (exhibition catalogue, illus.).

Prints. St. Louis: Gallery 288, n.d. (exhibition brochure).

Prints by College Artist-Teachers. Philadelphia: Philadelphia Art Alliance, 1959 (exhibition catalogue).

Prints on a Synthetic Fabric. Duluth: Tweed Gallery, University of Minnesota, 1963 (exhibition catalogue, illus.).

Prize Winning Graphics. Fort Lauderdale: Allied Publications, Inc., 1963 (exhibition catalogue, illus.).

Ray French, Dean Meeker, Rudy Pozzatti, Benton Spruance: Group Print Show. Durham, N.C.: The Art Gallery, 1965 (calendar of events).

Recent Drawings USA. New York: Museum of Modern Art, 1956 (exhibition catalogue).

Regional Painting: Friends of Art Second Biennial. Manhattan: Kansas State College, 1952 (exhibition catalogue).

Research Expo '87'. Bloomington: Indiana University Memorial Union, 1987 (program brochure, illus.).

Return Engagement. Philadelphia: Philadelphia Art Alliance, 1966 (exhibition brochure).

La Revue moderne, January 1, 1957, 17.

Ross, John, and Clare Romano. *The Complete Printmaker*. New York: Free Press, a division of MacMillan Publishing, 1972 (illus.).

Rudy Pozzatti/Brian Baker. Louisville: Byck Gallery, 1977–78 (exhibition brochure, illus.).

Sales and Rental Gallery Exhibition. Austin: Laguna Gloria Art Museum, 1965–66 (exhibition catalogue).

School of Fine Arts Faculty Exhibition. Bloomington: Indiana University Art Museum, 1984 (exhibition catalogue, illus.).

Second Annual Exhibition of Lithography. Tallahassee: Florida State University, 1965 (exhibition catalogue).

Second Annual Print and Drawing Competition. Dekalb: Northern Illinois University, 1969 (exhibition catalogue, illus.).

Second Dulin National Print and Drawing Competition. Knoxville: Dulin Gallery of Art, 1966 (exhibition catalogue).

Second Interior Valley Competition. Cincinnati: Contemporary Art Center Cincinnati Art Museum, 1958 (exhibition catalogue, illus.).

Second International Invitational Print Show. Ypsilanti: Eastern Michigan University, n.d. (exhibition brochure).

Second Invitational Print Exhibition. Minneapolis: University of Minnesota Gallery of Art, 1954 (exhibition brochure).

Second National Invitational Print Exhibition. Los Angeles: Otis Art Institute of Los Angeles County, 1963 (exhibition catalogue, illus.).

Second National Print Exhibition. Clinton, N.J.: Hunterton County Art Center, 1958 (exhibition catalogue).

Selected Works from the Collection of Mrs. A. B. Sheldon. Lincoln, Nebr.: Sheldon Art Gallery, 1970 (exhibition catalogue, illus.).

Selections from the Charles R. Penney Collection. Wanakah, N.Y.: Lakeview Gallery, 1970 (exhibition brochure).

Selections from the Sioux City Art Center Permanent Collection. Sioux City: Sioux City Art Center, 1986 (exhibition catalogue).

Seventeenth Annual New Year Show. Youngstown: Butler Art Institute, 1952 (exhibition catalogue, illus.).

Seventeenth National Exhibition of Prints Made during the Current Year. Washington, D.C.: Library of Congress, 1959 (exhibition catalogue).

Seventh Annual Color Print U.S.A. Lubbock: Texas Tech University, n.d. (exhibition catalogue).

Seventh Annual Exhibition of Oil Painting by Artists of the Missouri Valley. Topeka: University of Topeka Mulvane Art Museum, 1953 (exhibition brochure).

Seventh Eiteljorg Museum Biennial Exhibition. Indianapolis: Eiteljorg Museum, 2000 (exhibition catalogue, illus.).

Seventh National Exhibition of Contemporary Art. Oklahoma City: Oklahoma Printmakers Society Oklahoma Art Center, 1965 (exhibition catalogue).

Seventh National Print and Drawing Exhibition. Olivet, Mich.: Olivet College Festival of Fine Arts, 1967 (exhibition catalogue).

Shapiro, David, and Cecile Shapiro. "Lakeside Studio: Conserving the Printmaking Tradition." *Art News* 76, no. 3 (March 1977): 52–53 (illus.).

Shobaken, Bruce, George W. Zoretich, and Edwin W. Zeller. *Prints and Printmaking* (Series B). University Park: Pennsylvania State University Center for Continuing Liberal Education, 1960 (illus.).

Siouxland Watercolor Show. Sioux City: Sioux City Art Center, 1955 (exhibition catalogue).

Six Printmakers Revisited. Kalamazoo: Kalamazoo Institute of Arts, 1973 (exhibition catalogue).

Sixteenth Annual Drawing and Print Exhibition of the San Francisco Art Association. San Francisco: San Francisco Museum of Art, 1952 (exhibition catalogue).

Sixth International Miniature Print Exhibition. New York: Pratt Graphic Center Gallery, 1977 (exhibition catalogue).

Sixth Mid-America Annual Exhibition. Kansas City, Mo.: Nelson Gallery-Atkins Museum, 1956 (exhibition catalogue).

Sixth National Print and Drawing Exhibition. Olivet, Mich.: Olivet College, 1966 (exhibition catalogue).

Sixth National Print Annual Exhibition. New York: Brooklyn Museum, 1952 (exhibition catalogue).

Sixth National Print Exhibition. New Canaan, Conn.: Silvermine Guild of Artists, Inc., 1966 (exhibition brochure).

The Sixtieth Society of American Graphic Artists National Print Exhibition: A Dual Show. Greenvale, N.Y.: C.W. Post College Hutchins Gallery, 1983 (exhibition catalogue).

Sixty-First Annual Exhibition of the Society of American Graphic Artists. Garden City, N.Y.: Nassau Community College Firehouse Gallery, 1985 (exhibition catalogue).

Sixty-First Western Annual. Denver: Denver Art Museum, 1955 (exhibition catalogue).

Sixty-Second Annual for Western Artists. Denver: Denver Art Museum, 1956 (exhibition catalogue).

Sixty-Seven Wisconsin Printmakers. Menomonie, Wis.: Stout State University, 1967.

Sixty Square Inches Maximum, Small Print Exhibition. Lafayette, Ind.: Purdue University Fine Arts Gallery, 1986 (exhibition catalogue, illus).

The Society of Washington Printmakers Twenty-First Exhibition. Washington, D.C.: United States National Museum, 1954 (exhibition catalogue).

Southwestern Michigan College Art Gallery. Dowagiac, Mich., 1968 (exhibition brochure, illus.).

Stampe di due mondi/Prints of Two Worlds: An Exhibition of American and Italian Printmaking. Philadelphia: Philadelphia Museum of Art, ca. 1967 (exhibition catalogue).

Stampe di due mondi/Prints of Two Worlds: An Exhibition of American and Italian Printmaking. Rome: Tyler School of Art in Rome, 1967 (exhibition catalogue).

Stubbe, Wolf. *Graphic Arts in the Twentieth Century.* New York: Frederick A. Praeger, 1963.

"A Symposium on Post World War II American Printmaking." *The Print Collector's Newsletter* 24, no. 5 (Nov.–Dec. 1993).

Synthesis. Newark, Del.: Curtis Paper Co., 1969 (promotional brochure, illus.).

Tennessee Printmakers 1972. Knoxville: Dulin Gallery of Art, 1972 (exhibition catalogue, illus.).

Tenth Anniversary Exhibition: Current Painting Styles and Their Sources. Des Moines: Des Moines Art Center, 1958 (exhibition catalogue).

Tenth Annual Color Print U.S.A. Lubbock: Texas Tech University, 1983 (exhibition catalogue, illus.).

Tenth Annual Christocentric Arts Festival. Champaign, Ill.: Newman Foundation Galleries, n.d. (exhibition catalogue).

Tenth Annual National Exhibition of Prints and Drawings. Oklahoma City: Oklahoma Art Center, 1968 (exhibition catalogue).

Tenth National Exhibition of Prints Made during the Current Year. Washington, D.C.: Library of Congress, 1952 (exhibition catalogue).

Third Annual Colorprint U.S.A. Lubbock: Texas Tech University, 1972 (exhibition catalogue, illus.).

Third Annual Contemporary American Printmakers. Greencastle, Ind.: DePauw University, 1961 (exhibition brochure, illus.).

Third Annual Drawings and Small Sculpture Show, Muncie, Ind.: Ball State Teachers College Art Gallery, 1957 (exhibition catalogue, illus.).

Third Annual Exhibition of the "500" Festival of the Arts. Indianapolis: Downtown Indianapolis, 1968 (exhibition catalogue).

Third Annual Invitational Exhibition: American Drawings and Prints. Salt Lake City: University of Utah, n.d. (exhibition catalogue).

Third Annual Tippecanoe Regional Exhibition. Lafayette, Ind.: Lafayette Art Center, 1965 (exhibition catalogue).

Third Biennial Exhibition of Paintings and Prints from the Upper Midwest. Minneapolis: Walker Art Center, 1951 (exhibition catalogue).

Third Biennial Invitational Exhibition, Recent American Prints. Champaign: University of Illinois, 1958 (exhibition catalogue).

Third Biennial National Invitational Print Exhibition. Los Angeles: Otis Art Institute of Los Angeles County, 1967 (exhibition catalogue, illus.).

Third Biennial Printmaking Symposium Guest Artist Exhibition. Des Moines: The Art Gallery, Harmon Fine Arts Center, 1979 (exhibition catalogue).

Third Hawaii National Print Exhibition. Honolulu: Honolulu Academy of Arts, 1975 (exhibition catalogue, illus.).

Third Interior Valley Competition: Painting, Sculpture, Drawing. Cincinnati: Contemporary Arts Center Cincinnati Art Museum, 1961 (exhibition catalogue).

Third International Miniature Print Exhibition. New York: Pratt Graphic Center Gallery, 1968 (exhibition catalogue, illus.).

Third Invitational Print Annual. Memphis: Brooks Memorial Art Gallery, 1962 (exhibition catalogue, illus.).

Third National Exhibition: Oklahoma Printmakers. Oklahoma City: Oklahoma Art Center, 1961 (exhibition brochure).

Thirteenth Annual Missouri Exhibition. St. Louis: City Art Museum of St. Louis, 1954 (exhibition brochure).

Thirteenth Bradley National Print Show. Peoria: Bradley University and the Peoria Art Guild, 1971 (exhibition catalogue, illus.).

Thirty Contemporary American Prints. New York: IBM Gallery, 1964 (exhibition catalogue).

Thirty-Fifth National Exhibition of the American Color Print Society. Philadelphia: Philadelphia Art Alliance, 1976 (exhibition catalogue).

Thirty-Second National Graphic Arts and Drawing Exhibition. Wichita: Wichita Art Association, 1965 (exhibition catalogue).

Thirty-Sixth National Exhibition of American Color Print Society. Philadelphia: Philadelphia Art Alliance, 1978 (exhibition catalogue).

Touchstone: 200 Years of Artists' Lithographs. Cambridge: Harvard University Art Museums, 1998 (exhibition catalogue, illus.).

Treasures of Island Creek: Mixed Media from Corporate Headquarters. Louisville: Actors Theater, 1979 (exhibition catalogue).

Twelfth Annual National Exhibition of Prints and Drawings. Oklahoma City: Oklahoma Art Center, 1970 (exhibition catalogue).

Twelfth Bradley National Print Show. Peoria: Bradley University, 1968 (exhibition catalogue, illus.).

Twelfth National Exhibition of Prints Made during the Current Year. Washington, D.C.: Library of Congress, 1954 (exhibition catalogue).

Twentieth Annual Midyear Show. Youngstown: Butler Institute of American Art, 1955 (exhibition catalogue).

Twentieth-Century Prints from the Miami University Collection. Oxford, Ohio: Miami University, Heinstand Gallery, 1968 (exhibition catalogue).

Twentieth National Exhibition of Prints. Washington, D.C.: Library of Congress, Prints and Photographs Division, 1966 (exhibition catalogue).

Twenty-First American Drawing Biennial. Norfolk, Va.: Norfolk Museum of Fine Arts and Sciences, 1965 (exhibition catalogue).

Twenty-First National Exhibition of Prints. Washington, D.C.: Library of Congress, 1969 (exhibition catalogue).

Twenty-Five, A Tribute to Henry Radford Hope in Celebration of His Twenty-Fifth Year as Chairman of Indiana University's Department of Fine Arts. Bloomington: Indiana University Art Museum, 1965 (exhibition catalogue, illus.).

Twenty-Fourth Annual American Graphic Arts and Drawing Exhibition. Wichita: Wichita Art Association, 1955 (exhibition catalogue).

Twenty-Ninth Annual Exhibition of the American Color Print Society. Philadelphia: American Color Print Society, 1968 (exhibition brochure).

Twenty-Second Annual Exhibition. Springfield, Mich.: Springfield Art Museum, 1952 (exhibition catalogue, illus.).

Twenty-Second North Dakota Print and Drawing Annual. Grand Forks: University of North Dakota Art Galleries, 1979 (exhibition catalogue).

Twenty-Sixth International Exhibit. Seattle: Northwest Printmakers, Seattle Art Museum, 1954 (exhibition catalogue).

Twenty-Third Annual Graphic Arts and Drawing Exhibition. Wichita: Wichita Art Association, 1954 (exhibition catalogue).

Twenty Years of Collecting: The Wabash College Permanent Collection of Contemporary Art 1974–1994. Crawfordsville, Ind.: Wabash College, 1994 (exhibition brochure).

Ultimate Concerns, Graphics 1968. Athens: Ohio University, 1968 (exhibition catalogue).

Ultimate Concerns, Second National Exhibit. Athens: Ohio University Gallery, 1961 (exhibition catalogue, illus.).

Ultimate Concerns, Seventh National Exhibit. Athens: Ohio University, 1966 (exhibition brochure).

Ultimate Concerns, Sixth National Exhibition. Athens: Ohio University, 1965 (exhibition catalogue).

Ultimate Concerns, Third National Exhibit. Athens: Ohio University Gallery, 1962 (exhibition catalogue, illus.).

USA Printmakers. Indiana, Pa.: Indiana University of Pennsylvania, Kipp Gallery, 1989 (exhibition catalogue).

USD/Art: National Invitational Printmaking Exhibition. Vermillion, S. Dak.: University of South Dakota Warren M. Lee Center for the Fine Arts, University Art Gallery, 1978 (exhibition catalogue, illus.).

U.S. Drawings. Lubbock: Texas Tech University, n.d. (exhibition catalogue, illus.).

Walker, Barry, et. al. *Echo Press: A Decade of Printmaking.* Bloomington: Indiana University Art Museum, 1990 (exhibition catalogue, illus.).

Western Arts Association Bulletin 46, no. 3 (April 1962)

What Makes a Print? An Exhibition of Etchings, Woodcuts, Lithographs, Silk Screen Prints. Louisville: The Junior Art Gallery, 1958 (exhibition catalogue).

Works on Paper. Evansville: Krannert Gallery, n.d. (exhibition brochure, illus.).

Works on Paper: An Exhibition of Works on Paper by the Faculty of Indiana University and Purdue University, 1986 (exhibition catalogue, illus.).

Works on Paper Partnership International. Rio Grande do Sul, Brazil: 1983 (exhibition catalogue, illus.).

Works on Twinrocker Homemade Paper. Indianapolis: Indianapolis Museum of Art, 1975 (exhibition catalogue).

Xylon: 3rd Internationale Ausstellung von Holzschnitten. Schaffhausen, Switzerland: Museum zu Allerheiligen, 1959 (exhibition catalogue).

Young America 1960. New York: Whitney Museum of American Art, 1960 (exhibition catalogue, illus.).

Young American Printmakers. New York: Museum of Modern Art, 1952–54 (exhibition catalogue).

Publications on Pozzatti (Newspaper articles)

"Auf der Suche seines Erbes: Rudy Pozzatti in der Galerie Daberkow." *Neue Presse* (Frankfurt, Germany), 18 Jan. 1969.

Bloomfield, A. J. "Colorado Artist, Italian Accent." *San Francisco News-Call Bulletin*, 14 July 1960.

"The Book as an Artist's Medium: Theobald's Bestiary." *Publishers' Weekly*, 1 Feb. 1965 (illus.).

Brown, Theodore M. "Pozzatti Work is Rich in Content and Form." *Courier-Journal* (Louisville), 18 Nov. 1962 (illus.).

Burrows, Carlyle. "Art Shows in New Volume." *Herald Tribune* (New York), 15 Jan. 1961 (illus.).

Campofiorito, Quirino. " Pintura e decorocao de Gilberto." *Jornal do Commercio* (Rio de Janeiro, Brazil) 29 May 1974 (illus.).

Canaday, John. "A Broader Canvas: The Whitney Explores America Once More." *New York Times*, 18 Sept. 1960 (illus.).

———."Trees, Sky, Etc.: The Revival of Interest in Landscape Shows Up in Some Fine Prints." *New York Times*, 11 Aug. 1963 (illus.).

Carter, Ann. "Pozzatti, An Artist's Artist." *Atlanta Journal and Constitution*, 9 Oct. 1966 (illus.).

"Classicism Remembered at Bergstrom Art Center." *Daily Northwestern* (Oshkosh, Wis.), 9 April 1965 (illus.)

Cole, John R., Jr. "Rudy Pozzatti, American Printmaker: Prints Convey Essence of Man for All Seasons." *Advocate-Messenger/Weekend Section* (Danville, Ky.), 25 Jan. 1985 (illus.).

Collier, Alberta. "Print Artist, Educator Pozzatti—Newcomb Art Program Guest." *Times-Picayune* (New Orleans), 31 Oct. 1976 (illus.).

Deener, William. "Art Avoids Ruts, Runs Over Works." *North Texas Daily*, 9 Oct. 1974 (illus.).

Denny, Dann. "Disappearing Ink." *The Herald-Times* (Bloomington, Ind.), 6 April 2000 (illus.)

———."Offering More than Meets the Eye." *Sunday Herald Times* (Bloomington, Ind.), 22 Oct. 2000 (illus.).

"Diligence, Talents of Pozzatti Pay Off." *Montrose* [Colo.] *Daily Press*, 16 May 1966.

Donahoe, Victoria. "Art News." *Philadelphia Inquirer*, 6 Sept. 1964 (illus.).

Finkelstein, Lydia B. "Pozzatti and His Bag of Tricks." *Herald-Times* (Bloomington, Ind.), 17 Nov. 1991 (illus.).

———."Pozzatti Explains Differences in Prints." *Sunday Herald-Times* (Bloomington, Ind.), 17 Oct. 1999.

———. "Rudy Pozzatti Answers Common Art Questions." *Sunday Herald-Times* Bloomington, Ind.), 3 Oct. 1999 (illus.).

Frankenstein, Alfred. "A Modern Print Maker with an Ancient Theme." *San Francisco Chronicle*, 20 Dec. 1967 (illus.).

Frost, Larry Don. "Visiting Artist Serves Country through Practicing His Art." *Daily Siftings Herald* (Arkadelphia, Ark.), 2 March 1981.

Getlein, Frank. "Rudy Pozzatti Almost Impressionist." *Milwaukee Journal*, 2 Nov. 1958 (illus.).

Gregory, Linda. "'Bestiary of Theobaldus Bishop' to be Published Here Soon." *Indiana Daily Student* (Indiana University), 15 Dec. 1964 (illus.).

Gumberts, William. "Art Exhibition 'Stirring'." *Evansville* [Ind.] *Press*, 2 June 1972 (illus.).

Haggie, Helen. "Pozzatti Portraits on Display." *Lincoln* [Nebr.] *Sunday Journal and Star*, 31 Jan. 1965 (illus.).

Harada, Jane. "Consistent Artistic Skill." *Washington Post*, 25 Jan. 1970 (illus.).

Harrison, Helen A. "Adventurous Printmaking in Academia." *New York Times*, 28 Oct. 1985.

Harrison, Pegram. "Pozzatti's Painting Depicts Time's Cycles." *Sunday Herald-Times* (Bloomington, Ind.), 8 Nov. 1983 (illus.).

———."Rudy Pozzatti's Food Drawings a Treat." *Sunday Herald-Times* (Bloomington, Ind.), 21 Nov. 1982.

Haynes, Helen Mary. "Versatile Rudy Pozzatti Opens Show at Morrill Hall." *Journal* (Lincoln, Neb.), n.d.

"An Honored Printmaker." *Wichita Eagle-Beacon*, 20 Feb. 1965.

"Italian Study, One-Man Show Highlight Pozzatti's Career." *Durango* [Colo.] *Herald*, 21 July 1957.

"IU Printmaker Has Works on Display in Nebraska." *Sunday Tribune and Star Courier* (Bloomington, Ind.), 26 Oct. 1969 (illus.).

"IU's Rudy Pozzatti Selected for Budapest Cultural Forum." *Herald-Telephone* (Bloomington, Ind.), 7 Oct. 1985 (illus.).

Jensen, Eileen. "Pozzatti and His Works Appearing at the Swope." *Tribune-Star* (Terre Haute, Ind.), 7 Jan. 1979 (illus.).

Key, Donald. "Pozzatti Work Links Old Ideas with New." *Milwaukee Journal*, 21 Oct. 1962 (illus.).

Kinchen, Dave. "Pozzatti in City." *Topix*, 14 May 1967 (illus.).

King, Mary. "3 Printmakers' Works Are Shown." *St. Louis Post-Dispatch*, 21 March 1965.

Kirkwood, Marie. "Print Club Hails Work of Pozzatti." *Cleveland News*, 29 Oct. 1955 (illus.).

Kirstein, Jan. "New Workshops Boost IU Printmaking." *Indiana Daily Student* (Indiana University), 8 Feb. 1975.

Kutner, Janet. "Printmaking No Easy Task, 'Even If You Know It Well.'" *Dallas Morning News*, 29 March 1977 (illus.).

Lafky, Sue. "Pozzatti, Many Laurels Won But He's Not Resting." *Sunday Herald-Times* (Bloomington, Ind.), 20 Dec. 1981 (illus.).

Lansdell, Sarah. "In Art, 'A Lot Depends on the Moral Insides.'" *Courier-Journal and Times* (Louisville), 11 Feb. 1973 (illus.).

———."Pozzatti at Merida." *Courier-Journal and Times* (Louisville), 2 April 1967.

———."Printmaker as Painter: Pozzatti at Speed." *Courier-Journal* (Louisville), 22 May 1966 (illus.).

Larson, Katie. "New Pozzatti Works on Exhibit." *Courier-Tribune* (Bloomington, Ind.), 8 Oct. 1971 (illus.).

Macrorie, Joyce T. "Printmakers Revisited." *Kalamazoo Gazette*, 7 Jan. 1973 (illus.).

McIlveen, Rose. "Pozzatti Windows Keep Wedding Memories Alive for Couple" *IU News* (Bloomington, Ind.) 27 March 1992.

Mills, Kathleen. "Drawing to a Close [Echo Press]." *Sunday Herald-Times* (Bloomington, Ind.), 6 Aug. 1995 (illus.).

———. "More than Art: Pozzatti Family Exhibit Reflects Influence, Respect." *Sunday Herald-Times* (Bloomington, Ind.), 13 June 1993 (illus.).

———."Rockefeller Grant Prepares Artist to Tackle 'Labors of Hercules.'" *Sunday Herald-Times* (Bloomington, Ind.), 26 Feb. 1995 (illus.).

"Moderne aus Amerika." *Offenbach Post* (Germany), 14 Jan. 1969 (illus.).

Morrissey, Sally. "Rudy Pozzatti: A Leading Artist Likes to Come Home." *Durango-Cortez* [Colo.] *Herald*, 4 June 1972 (illus.).

Muck, Gordon F. "Gordon F. Muck Reports on The Arts." *Post-Standard* (Syracuse, N.Y.), 11 April 1965.

Oliver, Myrna. "Art Prof Works Hard at His Trade." *Daily Herald-Telephone* (Bloomington, Ind.), 24 June, 1960 (illus.).

Orlove, Karen D. "Art is Man's Nature." *Roswell* [N. Mex.] *Daily Record*, 24 Feb. 1980. (illus.).

"Outstanding Print Show on View at Academy." *Suburban Press* [Honolulu], 17 Feb. 1971.

Pellet, Dorothea. "Controlled Power in Pozzatti's Art." *Topeka Daily Capital*, 7 Oct. 1956.

Penner, Gary. "I.U.'s Cultural Atmosphere Inspires Artist's Work." *Indiana Daily Student* (Indiana University), 19 May 1978 (illus.).

Pittman, Bill. "I.U. Echo Press Moves Up Notch on Prestige Level." *Indianapolis News*, 12 May 1981 (illus.).

———."Pozzatti is Artist of Many Talents." *Indianapolis News*, 11 July 1968 (illus.).

———. "Rudy Pozzatti to Get Arts Award." *Indianapolis News*, 31 Jan. 1981 (illus.).

Power, Fremont. "An Artist, 52, Looks Ahead." *Indianapolis News*, 30 Nov. 1977.

"Pozzatti Donates Works to Hospital Ball." *Bloomington-Bedford* [Ind.] *Times*, 11 May 1975 (illus.).

"Pozzatti Has One-Man Show at Bladen Gallery." *Messenger and Chronicle* (Fort Dodge, Iowa), 7 June 1957.

"Pozzatti Show at Brooks Has Mark of Greatness." *The Commercial Appeal* (Memphis, Tenn.), 20 Jan. 1957 (illus.).

"Pozzatti Wins Top Honors in Print Show." *Indianapolis Star*, 11 May 1958 (illus.).

"Print Maker Opens Showing." *Sou'western* (Southwestern Michigan College), 8 April 1968 (illus.).

"A Printmaker's Pilgrimage." *Sentinel* (Winston-Salem, N.C.), 31 March 1979.

"Printmakers." *Washington Sunday Star*, 21 Jan. 1962.

"Rome 1997." *Sunday Herald Times* (Bloomington, Ind.), 15 Feb. 1998 (illus.).

"Rudy Pozzatti and Ron Sterkel Are Finalists in Competition for Mural." *Star Courier* (Bloomington, Ind.), August 14, 1958 (illus.).

"Rudy Pozzatti: Creatively Active Man." *Daily Herald-Telephone* (Bloomington, Ind.), 28 Sept. 1972 (illus.).

Seldis, Henry J. "New Techniques and Names in Print Show." *Los Angeles Times*, 3 Feb. 1963 (illus.).

Seltzer, Gladys. "New Swope Exhibit Features Works by Acclaimed Artist." *Star* (Terre Haute, Ind.), 30 Dec. 1978 (illus.).

Smith, Griffin. "Integrity in Print." *Miami Herald*, 10 Dec. 1972 (illus.).

Smith, John. " Museum Show…From Powerful Lithograph with Political Overtones to Fun-filled Mixed Media Series." *Evansville* [Ind.] *Press*, 17 Aug. 1983 (illus.).

Thomas, Linda. "Rudy Pozzatti: Printmaker Dedicated to His Art." *Sunday Herald-Times* (Bloomington, Ind.), 30 April 1989 (illus.).

Thornton, Henrietta. "Unique Stations of the Cross." *Criterion* (Indianapolis Archdiocese), 22 Sept. 1978 (illus.).

"Time Is an Artist's Greatest Need—Pozzatti." *Daily Herald-Telephone* (Bloomington, Ind.), 17 Jan. 1974.

"To Dedicate Lithographs." *Herald-Telephone* (Bloomington, Ind.), 23 Sept. 1978 (illus.).

"To Unite Mankind with Love and Feeling for One Another." *South Omaha Sun*, 25 Dec. 1968 (illus.).

Ulrich, Linda. "Art's Latest 'ism,' Eclecticism, Reflected in Pozzatti's Work." *Sunday Journal-Star* (Lincoln, Nebr.), 12 Oct. 1986 (illus.).

"University of Nebraska Will Display One-Man Show by Zooming Young State Artist." *Sunday World-Herald* (Omaha, Neb.), 8 April, 1956 (illus.).

Ward, Ann. "Rudy Pozzatti's Work Reveals 'Consummate Skill.'" *Kokomo* [Ind.] *Tribune*, 26 April 1970 (illus.).

Documentary Films

Artists in America, *Rudy Pozzatti*, half-hour color film produced by Richard Taylor for WTIU, Indiana University. Released nationally as part of the National Educational Television (N.E.T.) series, originally aired Sept. 1971.

Treasures of Indiana, a half-hour color video produced by WTIU, Indiana University, 1991.

Radio Broadcasts

Profiles, a one-hour interview with Pozzatti produced by WFIU, Indiana University, originally aired August 5, 2000.

Archives

Archives of American Art, Smithsonian Institution. Pozzatti Papers 1952–1978; 334 items. Copies of seventeen letters recommending the artist for rank of distinguished professor, 1972; a brief biographical sketch; two photographs of the artist; exhibition catalogues and announcements, 1956–1978; clippings and articles; thirteen lecture and workshop brochures; six circulars; and four interviews on tape.

Indiana University Archives, Bloomington, Indiana. The Pozzatti Papers span the years from 1951 to 1996 and consist largely of newspaper clippings and articles about the artist and his work. Also included are transcripts of two interviews with Pozzatti (conducted by Dennis Barrie, 1977, and Pamela J. Pierce, 1987), a student paper on Pozzatti (Leila McConnell Daw, Wellesley College, 1962), and three awards or citations received by the artist. The papers are divided into five sections: records about Pozzatti and his work; artwork, photos, and publications by Pozzatti; correspondence files; show and exhibition material; and photographic prints and negatives of Pozzatti's artwork.

Pozzatti's Chop Mark

Printers have traditionally used an embossed seal, or "chop mark," to personalize their work. Pozzatti designed his distinctive mark in 1963 and had it made by a Florentine jeweler. The imagery includes three domes—symbols of the Holy Trinity—over the artist's initials "RP" in script. The central motif is encircled by a snake. Despite its evil connotations, Pozzatti has always been drawn to the animal's shape-shifting form, surface texture, and references to medieval iconography. This chop mark has appeared in the bottom right-hand corner of all of Pozzatti's prints since 1964.

Colophon

This book was designed and set in type by Brian Garvey. It was printed by Metropolitan Printing Service on Gleneagle paper and bound by Franklin Bindery. The text and display face is Bodoni. 1,500 copies were printed on the occasion of the exhibition, March 2002.